Capture the Moment

THE PULITZER PRIZE PHOTOGRAPHS

UPDATED EDITION

EDITED BY

Cyma Rubin and Eric Newton

PRESENTED BY

W. W. NORTON

NEW YORK · LONDON

PRESENTED BY
THE FREEDOM FORUM NEWSEUM, INC.

Charles Overby	*Chairman and chief executive officer*
Peter Prichard	*President*
Joe Urschel	*Executive director and senior vice president*
Margaret Engel	*Managing editor*

ACKNOWLEDGMENTS

Jay Anning	*Designer*
Hal Buell	*Photography consultant*
Katherine Rosenbloom	*Production consultant*
Don Ross	*Copy editor*
Ann Rauscher	*Proofreader*

SPECIAL THANKS

Seymour Topping	*Administrator, The Pulitzer Prizes 1993–2002*
Sig Gissler	*Administrator, The Pulitzer Prizes*
Chuck Zoeller	*Director, The Associated Press News Photo Library*
Ron Brenne	*Senior researcher, Corbis*

The Freedom Forum Newseum Library

Columbia University

. . . and all the Pulitzer photographers and their families, photo editors, librarians, agencies and publishers who graciously made it possible to assemble the photographs and text.

CONTENTS

CONTENTS

INTRODUCTION
Seymour Topping

This catalogue records the first major exhibition in the United States of Pulitzer Prize-winning photographs, many of which are cited around the world as classics of photojournalism.

The 132 newspaper photographs reprinted in these pages capture defining moments in the tumultuous second half of the 20th century.

Typically published on front pages, these are the pictures that influenced our thinking in times of crisis and sometimes stirred us to action. They still bear stark witness against the brutalities of war, racism and despotism. Others are exemplars of heroism, compassion and the strivings of ordinary people for a better life under the burdens of poverty and crime. Among these are indelible images that, in coming centuries, will inevitably be used as flashbacks to illustrate the triumphs and tragedies of our era.

Consider Joe Rosenthal's World War II photograph of the raising of the flag over Mount Suribachi on Iwo Jima, an image that is a memorial to the more than 6,000 Marines who died in the battle for that small Pacific island. Or Robert Jackson's photograph of Jack Ruby killing Lee Harvey Oswald, recalling the anguish and mystery of the assassination of President John F. Kennedy. Moneta Sleet's picture of Coretta Scott King, cradling her disconsolate daughter, at her assassinated husband's funeral, preserved as an icon of the civil rights movement. There is no more graphic testimony to the inhumanity of the Vietnam War than Nick Ut's photograph of a Vietnamese girl fleeing a napalm blast, running to him for safety. And Ron Edmonds' photographs of the attempted assassination of Ronald Reagan remind us once again of the vulnerability of our presidents.

JOSEPH PULITZER

The photographs record that we have lived in a violent age. But the Pulitzer photojournalists also reached out for tender and compassionate moments, as in Brian Lanker's pictures of joyous parents at the birth of their child, Scott Shaw's photographs of the prayerful rescue of the little girl trapped in a deep well, Ron Olshwanger's photograph of a black firefighter giving mouth-to-mouth resuscitation to a blond baby pulled from a burning building, the innocence in William Beall's photograph of a young policeman at a parade cautioning a small boy against venturing into a busy street, or the sorrow in Stephanie Welsh's picture of a woman enduring genital circumcision in Kenya.

Every Pulitzer photographer has a gripping story to tell of how he or she did it. Modestly, some of the photographers confess in interviews published in this catalogue to pure luck or blind instinct that put them in the right position to win their profession's most prestigious award, of shots taken without benefit of viewfinder or by subterfuge, of not knowing what they had managed to get on film. Other tales, implicit in photographs themselves, are revealing of extraordinary skill, enterprise, dedication and courage.

Some of the winners cannot speak of the nightmares suffered in recollection of what they beheld or what happened to the people they photographed. There was Frank Filan, landing with the Marines under gunfire on Tarawa, losing his equipment, acting as a stretcher bearer for the wounded, borrowing a camera, and then photographing the devastation in which nearly 1,000 Americans and about 2,800 Japanese soldiers died. And Eddie Adams, dogged by remorse, unwilling for two years to look at his

famous photograph of the South Vietnamese police chief executing a Viet Cong prisoner with a pistol shot to the head. And John Filo, knowing his photograph traumatized the life of the girl who knelt screaming beside the body of a student slain during an anti-Vietnam War demonstration on the campus of Kent State University.

We view the appalling image of a line of blindfolded Kurdish rebels, bodies sagging, being executed by Iranian Revolutionary Guards—and the caption reads, "photographer unnamed."

The Pulitzer Prizes are bestowed each year after a rigorous selection process. The two prizes in photography, spot news (now called breaking news) and feature, are among the 21 awards in newspaper journalism, books, music and drama. The prizes are awarded for distinguished photography "in black and white or color, which may consist of a photograph or photographs, a sequence or an album."

The competition is open to all comers who adhere to the rules. Non-American photographers are eligible if their pictures have been published in a U.S. newspaper during the calendar year. The first foreign winner was Yasushi Nagao, for his 1960 photograph of the sword assassination of a Japanese politician in Tokyo.

From about 150 entries, a jury of five noted newspaper editors and photographers select three nominees in each of the two photography categories. The nominations are submitted to the Pulitzer Prize Board, 19 eminent journalists and academics who meet in New York each April to determine the winners. Nothing of the judging process is disclosed until the president of Columbia University, who is a member of the board, announces the winners at a news conference in the Graduate School of Journalism. Winning the coveted prize often changes the lives of winners and their families, bringing them under unaccustomed pressures as they are thrust into the glare of national prominence. The cash award of $5,000 is usually the least of the benefits, which include lifelong recognition and new career opportunities. It is an oft-repeated joke that the distinction follows a winner to the grave with unfailing mention in obituaries.

The independent Pulitzer Board derives its authority and original endowment from the 1904 will of Joseph Pulitzer (1847–1911), publisher of *The New York World*
and the *St. Louis Post-Dispatch*. Of an endowment to Columbia University of $2 million, three-fourths was for the establishment of a School of Journalism and the balance for "prizes or scholarships for the encouragement of public service, public morals, American literature and the advancement of education."

In his will Pulitzer specified only four awards in journalism, four in letters and drama, one in education and four traveling scholarships. Over the years, boards have increased and modified prize categories in keeping with evolutionary changes in culture and professional techniques. The prize in photography was first awarded in 1942 and in every succeeding year, except 1946, when the Pulitzer Board, exercising its authority to overrule any of the juries, deemed no nomination sufficiently worthy. In 1968, the board added a second photo category, feature photography, allowing for awards less related to breaking news and tending more to the documentary. This encouraged a trend to storytelling with a collection of photographs rather than a single frame. After 1970, when Dallas Kinney won the Pulitzer for a collection of pictures of impoverished migrant workers, entries of portfolios became common.

Joseph Pulitzer certainly would have applauded the board's decision to make awards in photography, for he was among the first to make extensive use of illustrations in daily newspapers. In 1883, he told a group of journalists:

"They call me the father of illustrated journalism. What folly! I never thought of any such thing. I had a small newspaper, which had been dead for years, and I was trying in every way to build up its circulation. What could I use for bait? A picture, of course. On Page One, in a position that would make *The World* stand out as the paper lay folded on the newsstand . . . a picture of someone prominent in the news of the day.

"There was a talented Russian artist in New York with a real genius for making portraits—Valerian Gribayedoff. Could he, with a photograph for model, draw a portrait so that it could be printed in *The World*? He could. Next day and every day thereafter, we showed on the upper-right-hand section of our first page the picture of a statesman, a blushing bride, a fugitive absconder, or a murderer on occasion—whoever was most prominent in the day's doings. Circulation grew by the thousands."

In those days, Pulitzer had to rely on engraved illustrations since halftone photo-reproduction was just being developed. But he already was building the foundation for modern news photography. One can speculate that Pulitzer, a brilliant innovator, would have been inclined earlier than the board to make awards in photography.

The 1942 inaugural prize, for work done in 1941, went to Milton Brooks' picture of Ford Motor Co. strikebreakers in a brutal clash with union pickets in Detroit. After the entry of the United States into World War II, the board responded to the hunger of Americans for images of their soldiers overseas. With the introduction by The Associated Press of Wirephoto, battle pictures were being transmitted for next-day publication. The AP, of course, did more than transmit photos: It employed Pulitzer-winning photographers, beginning in 1943, when the award went to Frank Noel's photograph of the faces of doomed men begging for water in the drifting lifeboat of a torpedoed freighter in the Pacific.

Pulitzer recognition often thereafter went to combat photographers in action in the Korean and Vietnam wars, and more recently in covering the genocidal ethnic and regional struggles, particularly in Africa. Kevin Carter's tragic image—a Sudanese girl starving and a vulture waiting nearby—appealed to the world's collective conscience and brought needed aid. American troops were withdrawn from their peacekeeping mission in Somalia after the publication of Paul Watson's photograph of the body of a U.S. Army Ranger, one of 18 killed in a firefight with guerrillas, being dragged through the streets of Mogadishu by a mob of jeering Somalis.

The catalogue concludes with the 1999 awards to portfolios by Associated Press photographers of two very different news events, both shocking to the American psyche. In spot news, the prize went to images of the terrorist bombing of the American embassies in Kenya and Tanzania and in feature photography, for a collection of photographs of key players and events stemming from President Clinton's affair with Monica Lewinsky and the ensuing impeachment hearings.

Joseph Pulitzer sought in establishing his prizes to create incentives for quality performance in journalism and the arts. Most journalists and educators agree that his dream has been realized.

In pursuit of excellence, photojournalists over the past half-century have looked for ultimate recognition to the Pulitzer Prizes. Judges have adhered to the highest standards whether work is done by a newspaper staffer, a freelancer, or, indeed, even by an amateur. (The amateur Virginia Schau won the 1954 Pulitzer with her Box Brownie for a stunning photograph of a truck and driver dangling from a bridge.) The scope of photojournalism has been broadened as professionals have gravitated from the cumbersome Speed Graphic, used by Joe Rosenthal on Iwo Jima, to high speed 35 mm color digital cameras employing a variety of lenses and loaded with computer disks, not film. In the last decade, 17 of the 20 Pulitzer awards have gone to color photography.

The Pulitzer Board has barred the increasingly common practice of computer manipulation. The Plan of Award states that "no entry whose content is manipulated or altered, apart from standard newspaper cropping and editing, will be deemed acceptable."

Because of their integrity and universality of themes, the Pulitzer photographs have appealed to viewers across barriers of time, place and language. A recent traveling exhibit of Pulitzer photographs in Japan sponsored by Nippon Television attracted more than 1,000,000 visitors. This new selection of Pulitzers is brought to the American people thanks to the commitment to excellence in journalism of the staff of the Newseum and the generosity of The Freedom Forum.

— SEYMOUR TOPPING
Administrator of The Pulitzer Prizes
Columbia University, New York
1993–2002

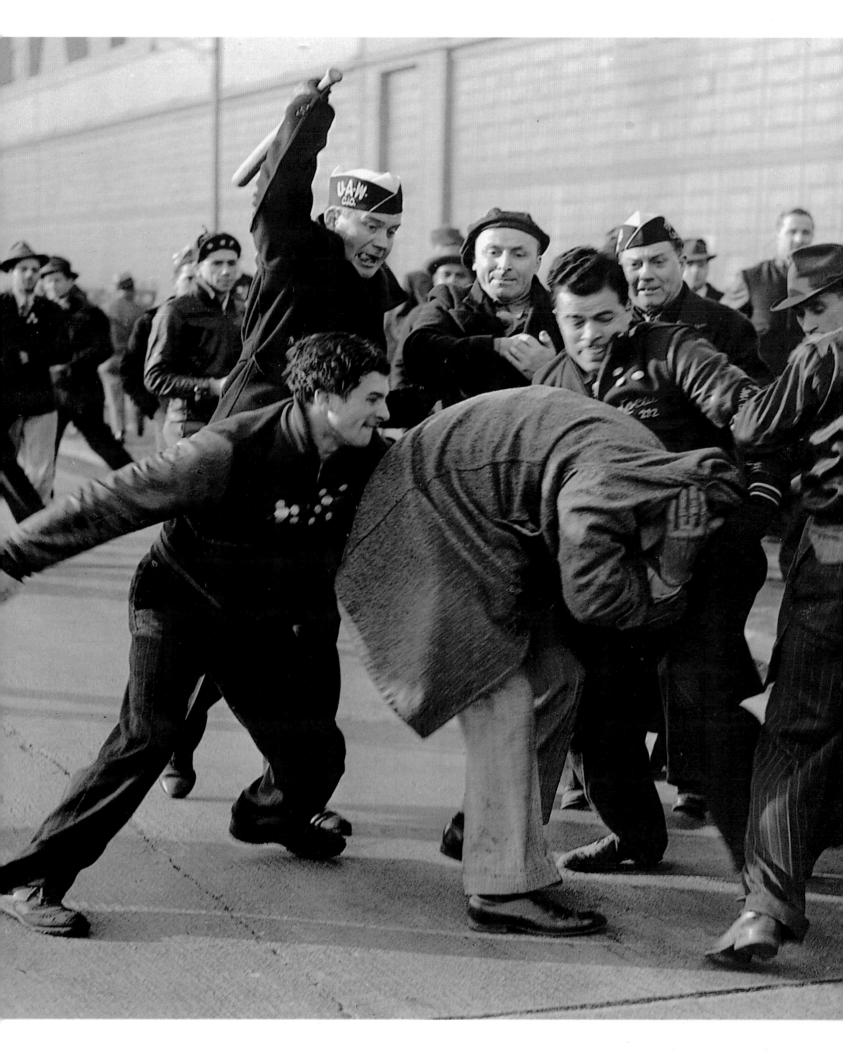

'There would be trouble soon'

It's April 3, 1941, day two of the first United Auto Worker's strike at the Ford Motor Co. factory in Detroit. Lines of pickets have closed off all access to the factory. Production has ground to a halt; 120,000 workers are idle. Tensions are running high.

Photographer Milton Brooks joins a crowd of journalists outside the gates. Brooks is an unusual news photographer: Unlike his colleagues, he rarely takes more than one picture at any event, preferring to stand patiently until the most newsworthy image presents itself. Today, as cameras snap and roll all around him, Brooks waits.

Finally, the photographer sees his chance. "I saw a man pick a fight with some of the pickets," he says. "He had the wrong of the argument and I could tell from what he said that there would be trouble soon." Fists are clenched, clubs raised. Brooks snaps a single photograph: eight strikers, faces contorted; a lone dissenter, crouching low, his coat pulled over his head. "I took the picture quickly, hid the camera under my coat and ducked into the crowd. A lot of people would have liked to wreck that picture."

1942

THE PICKET LINE
Milton Brooks

April 3, 1941, Detroit, Michigan

The Detroit News

4 x 5 Speed Graphic, standard lens, Kodak film

Courtesy of *The Detroit News*

'One torpedoing— no charge'

January 1942. The war in the Pacific is heating up. The Japanese have leveled Pearl Harbor and are now sweeping the Malayan Peninsula. Frank "Pappy" Noel is in Singapore, photographing the war for The Associated Press, when Japanese bombers attack. The city is so unprepared that streetcars keep running throughout the raid.

Noel escapes aboard a freighter bound for Burma. The Japanese torpedo the vessel. Trapped in his cabin, Noel uses a heavy chair to batter down the door. He flees with a handful of shipmates. For five days, they drift across the Indian Ocean in flimsy lifeboats, without food or water, baking in the tropical sun.

On day three, another lifeboat comes close: Indian sailors, tired and desperate, beg for water. Noel and his group have none to give. Ill with malaria, exhausted by the ordeal, Noel nonetheless raises his camera and shoots. The boats drift apart. The Indian sailors are never heard from again.

Noel's lifeboat eventually reaches Sumatra. The photographer and his camera are rescued. Making out his expense report, he writes "One torpedoing — no charge."

1943

WATER

Frank Noel

January 1942, Indian Ocean

The Associated Press

4 x 5 Speed Graphic, standard lens, Kodak film

Courtesy of The Associated Press

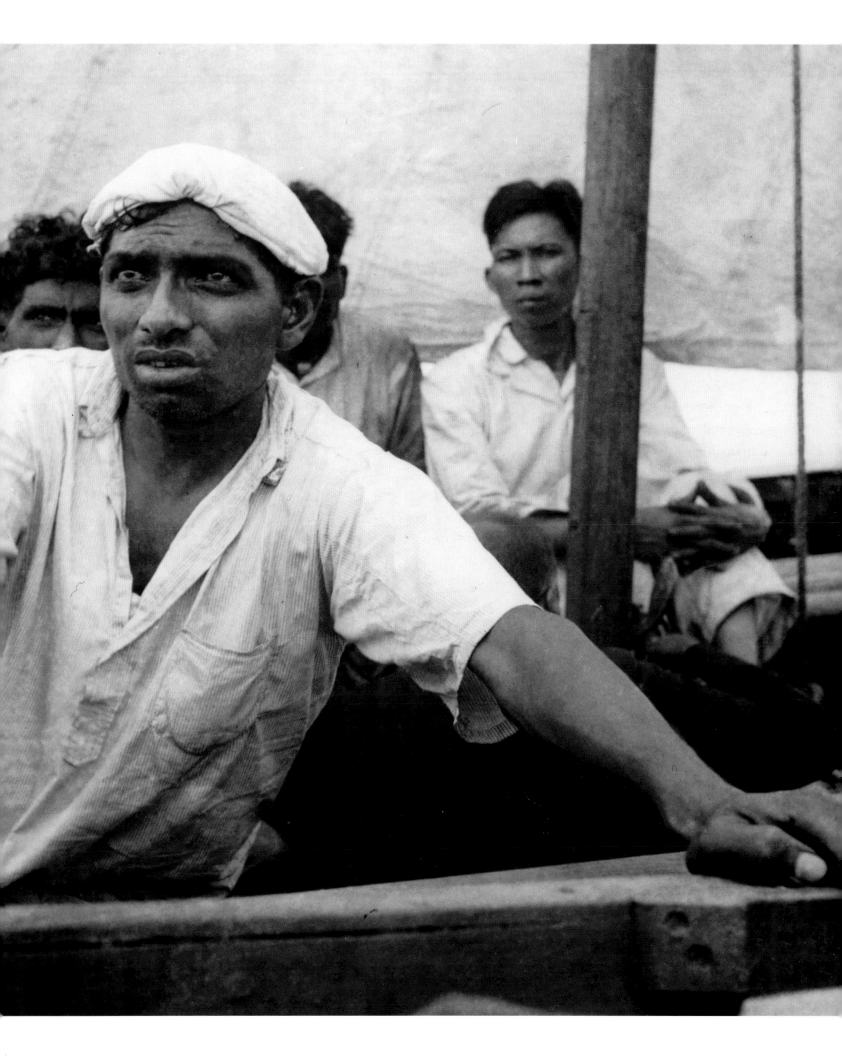

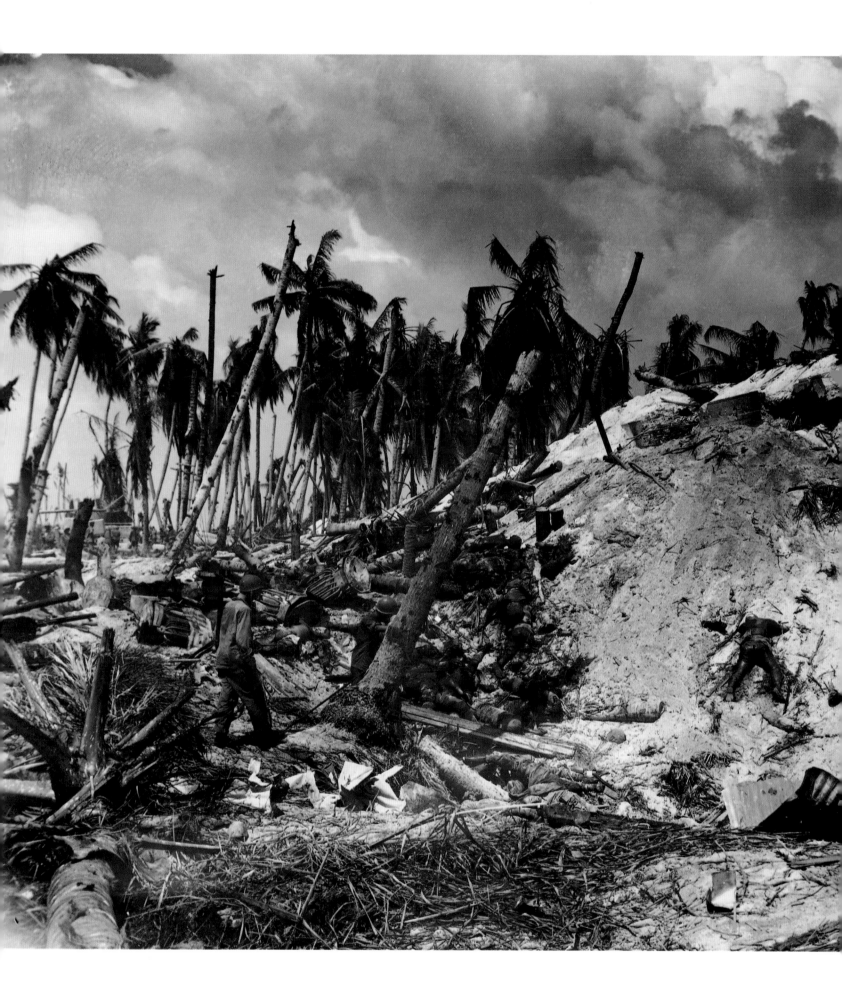

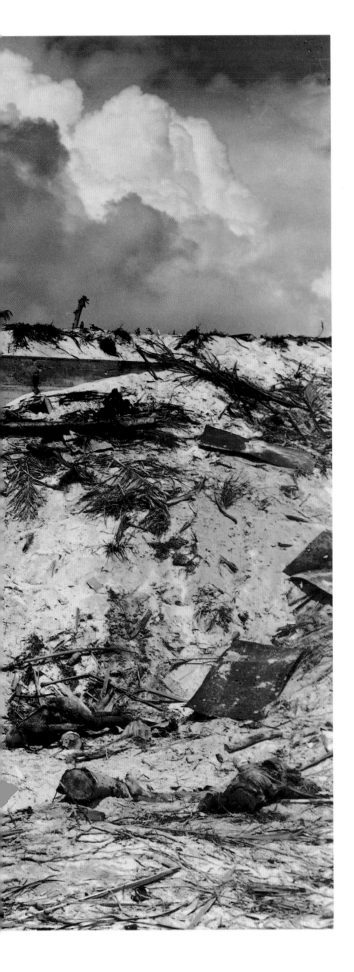

'Not a thing to take a picture with'

Tarawa was once a South Pacific gem — coral reefs, crystal waters. By 1943, the tiny atoll bristles with Japanese weaponry. In November, the Allies decide to take control.

Associated Press photographer Frank Filan covers the U.S. Marine invasion. "Daylight found us in our landing boats about seven miles off the island," writes Filan. "The naval bombardment was under way. I shot the battleships firing and...as we neared the beach, the dive bombers and new Hellcat fighters strafing enemy positions."

Suddenly, Filan's landing craft explodes, destroyed by a Japanese shell. Photographer and Marines scramble toward shore, dodging machine-gun fire, mortars and snipers. Many do not make it. Filan does, but his cameras and film do not. "After about 600 yards of dunking, both cameras were...filled with sand and water. There I was, with a war going on all around...and not a thing to take a picture with."

That night Filan works the stretchers, aiding wounded Marines. The next day, he borrows a camera and photographs the island. It is a scene of devastation: In just three days, nearly 1,000 Marines have been killed and 2,100 wounded; 2,800 Japanese soldiers and 2,000 Korean construction workers have lost their lives. Filan photographs grotesque heaps of twisted debris and scorched bodies — a savage slaughter in a brutal war.

1944

TARAWA

Frank Filan

November 22, 1943, Tarawa
Atoll, South Pacific

The Associated Press

4 x 5 Speed Graphic, standard
lens, Kodak film

Courtesy of The Associated Press

'Timeless picture of the returning soldier'

America entered World War II just 18 months ago. But already there are too many sons, brothers and husbands who will never see home again. So it is with great joy that the entire town of Villisca, Iowa, gathers on a sparkling July day to celebrate the return of one of its own: Lt. Col. Robert Moore. In North Africa, Moore and his battalion held off two of Gen. Erwin Rommel's fierce German Panzer divisions. Moore was wounded and was awarded the Distinguished Service Cross.

Omaha World-Herald photographer Earle Bunker is at the Villisca station when Moore's train pulls in. The door opens; Lt. Col. Moore steps out. Bunker presses the shutter. The flashbulb fails. Bunker curses, then jams in a new bulb. He peers through the viewfinder: Moore is right in front of him. The war hero is bent over, face hidden, his young daughter clasped tightly in his arms. There is a flash, but it's weak. Bunker is not sure he got the shot.

He did. Bunker's photograph captivates a war-weary America. *Time* magazine calls it a "timeless picture of the returning soldier." The war continues for another two years. In Villisca, Iowa, a little girl grows up with her father.

1944

A HERO'S RETURN

Earle L. Bunker

July 15, 1943, Villisca, Iowa

The Omaha World-Herald

4 x 5 Speed Graphic, standard lens, Kodak film

Courtesy of *The Omaha World-Herald*

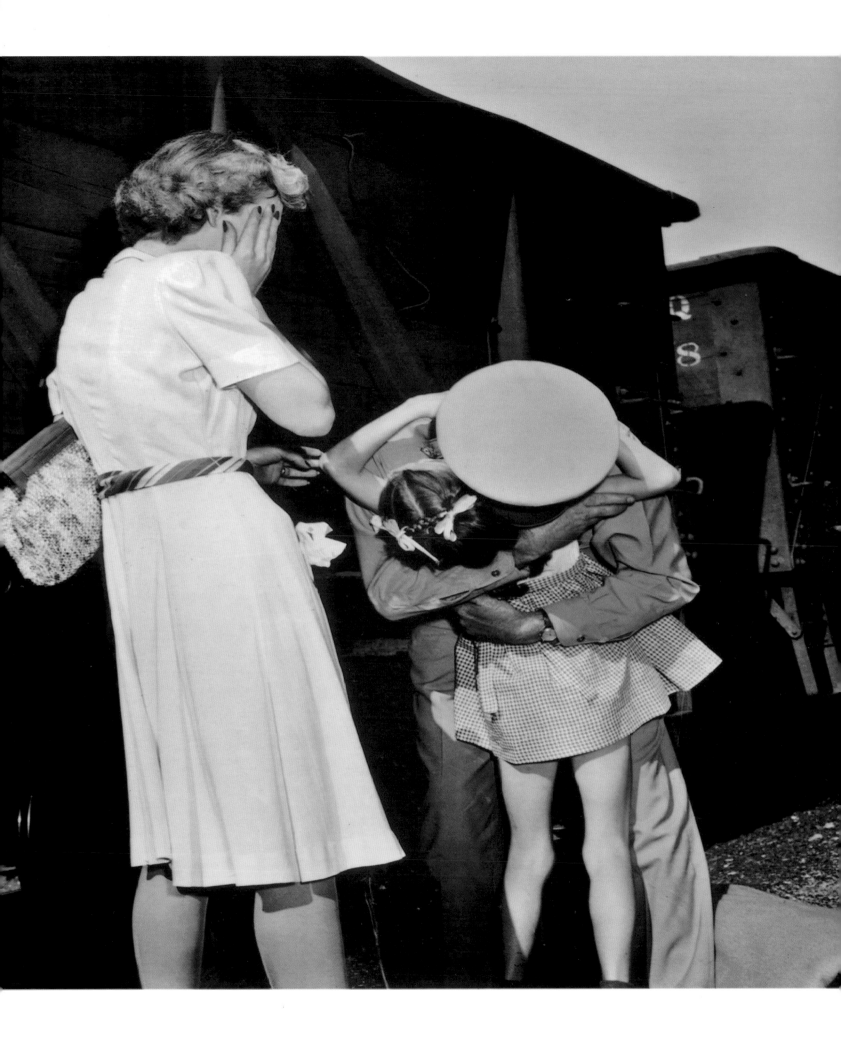

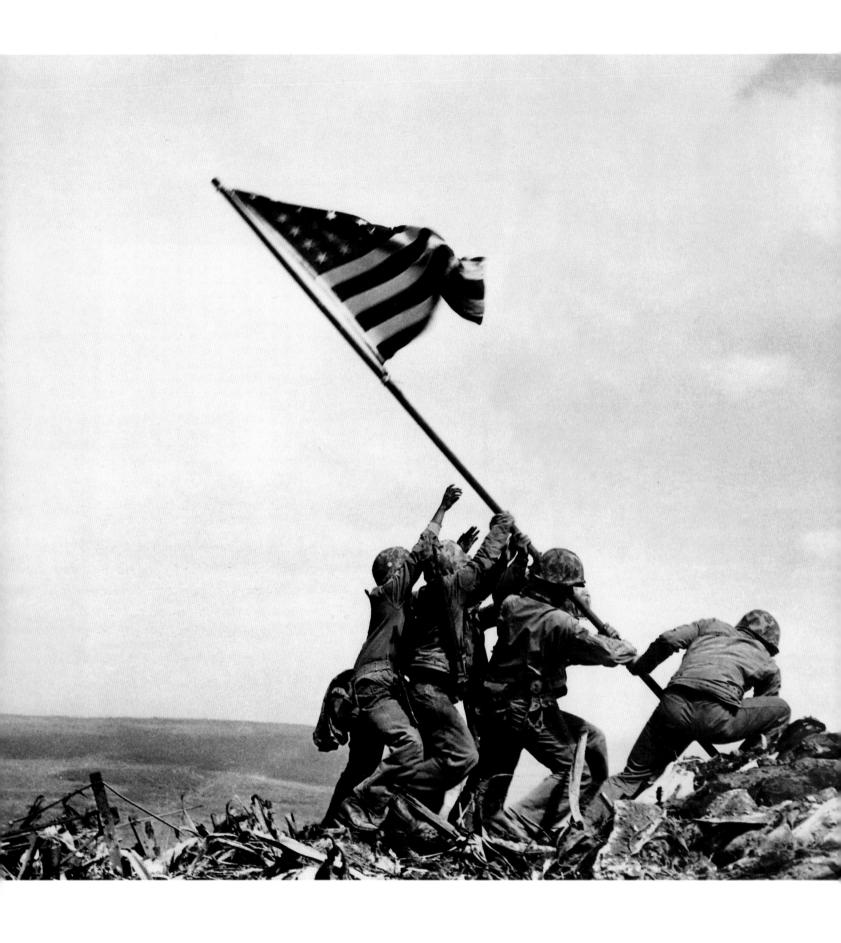

'Just the one flag going up'

Feb. 23, 1945. It's been four days since Joe Rosenthal landed on the Pacific island of Iwo Jima in a hail of Japanese fire. The bombardment has not let up. Rosenthal finds himself photographing one of the bloodiest battles of World War II. Finally, U.S. Marines capture Mount Suribachi, a volcano on the island's southern end. Jubilant at any small victory, they raise an American flag.

Rosenthal is trudging up the mountain when the flag is raised. When he reaches the top, he learns that the Marines are planning to substitute a larger flag that can be seen all over the island. Rosenthal considers: "I thought of trying to get a shot of the two flags, one coming down and the other coming up, but I couldn't line it up. I decided to get just the one flag going up."

Rosenthal begins setting up. Marines mill about; a newsreel cameraman gets ready nearby. Suddenly, "out of the corner of my eye...I had seen the men start the flag up. I swung my camera and shot the scene."

The battle for Iwo Jima rages 31 more days. The toll is horrendous: 6,821 American troops are killed, including three of the Marines in the photograph. But Rosenthal's picture endures—in posters, on postage stamps and as a sculpture atop the U.S. Marine Corps War Memorial near Arlington National Cemetery.

1945

OLD GLORY GOES
UP ON MOUNT
SURIBACHI
Joe Rosenthal

February 23, 1945, Iwo Jima,
South Pacific

The Associated Press

4 x 5 Speed Graphic between ƒ/8
and ƒ/11 1/400 second, standard
lens, Agfa film

Courtesy of The Associated Press

'Men, women and children screamed'

It's Friday night. Arnold Hardy, like most of his fellow college students, is out having a good time. He arrives home in the early hours of the morning to hear fire trucks racing through the streets. An amateur photographer, Hardy grabs his camera, jumps into a taxi and hurries to the blaze. "I came upon it all at once. Fire was raging from the upper floors. From almost every window, men, women and children screamed for help."

The Winecoff Hotel has no fire escapes, no fire doors, no fire stairs. The hotel is 15 stories high; the ladders of the Atlanta Fire Department do not reach above the ninth floor. The blaze spreads rapidly. Guests on the upper floors have no way out. "The trapped victims," remembers Hardy, "were descending ropes of blankets and bed sheets in desperate attempts to reach the fully extended ladders." The sheets tear; people plunge to the pavement. Other guests try jumping to the building next door; most fall to the street below.

As Hardy watches, he hears a woman shriek. "I looked up, raising my camera. A woman was plummeting downward. As she passed the third floor, I fired, using my last flashbulb."

The woman is lucky: Her fall is broken by a pipe and a railing. She lives.

In all, 119 people lose their lives in the December 7 Winecoff fire — including owner W. F. Winecoff, found dead, along with his wife, in his luxury suite on the 14th floor.

1947

DEATH LEAP FROM
BLAZING HOTEL
Arnold E. Hardy

December 7, 1946, Atlanta, Georgia

The Associated Press

2¼ x 3¼ Speed Graphic, 101 mm
F4.5 lens, Kodak Super X film

Courtesy of The Associated Press

'Wondering if the kid would shoot me'

June 23, 1947—just a routine summer day. News photographer Frank Cushing sits in his car, waiting for an assignment. The police radio comes alive: a gun battle in progress; an officer injured; a hostage taken. Cushing hurries to the scene.

Just minutes earlier, Boston police stopped 15-year-old Ed Bancroft and questioned him about a robbery. Bancroft pulled out a pistol and opened fire, wounding an officer. Then he took off running—grabbing another boy, William Ronan, and holding him hostage.

Cushing finds the suspect trapped in an alley, surrounded by police officers, threatening to shoot his terrified hostage. But the photographer isn't close enough to get a good shot. The police move in. Bancroft fires wildly. Cushing finds a house near the action. He talks his way past the owner and creeps along a sunporch. Very carefully, he releases the shutter. "I was wondering if the kid would shoot me," says Cushing. "But I wanted that picture."

Moments later, an officer sneaks behind Bancroft and clobbers him with the butt of his pistol. The boy gunman goes down. The hostage is freed.

1948
TEEN-AGE
SHOOTER
Frank Cushing

June 23, 1947, Boston, Massachusetts

Boston Traveler

Speed Graphic, 135 mm lens, Kodak film

Courtesy of Kevin Cole, *Boston Herald*

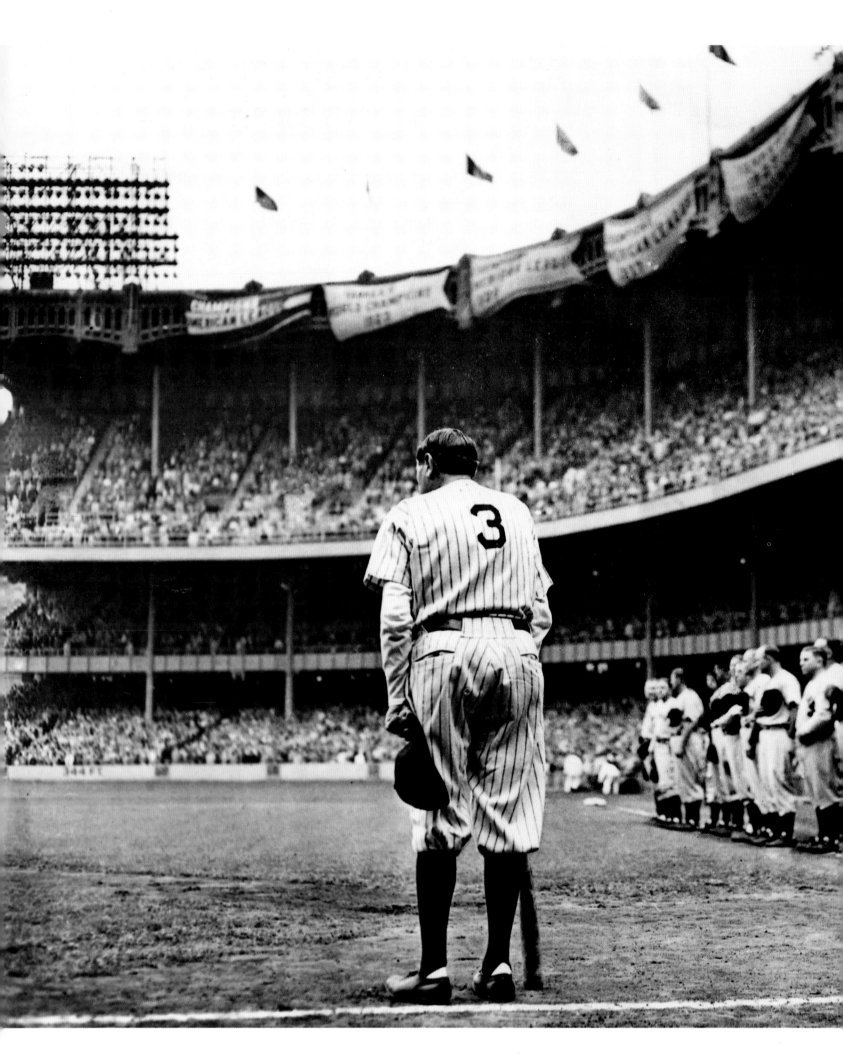

'His uniform, #3 . . . was the shot'

Yankee Stadium, June 13, 1948. The stands are packed. But the fans aren't here just for a baseball game. They've come out to honor one of the greats, baseball's most beloved player: Babe Ruth.

Down on the field, *New York Herald Tribune* photographer Nat Fein has a close-up view of the home run hero, slumped in the dugout, weakened by illness. "He looked tired, very tired; the power that had been his in his youth and manhood was slowly ebbing away." But as Ruth slowly makes his way onto the field, the crowd goes wild. They give "The Sultan of Swat" a thunderous standing ovation.

Fein takes several pictures, but he isn't satisfied. So he walks around to the other side. "I saw Ruth standing there with his uniform, #3, the number that would be retired, and knew that was the shot. It was a dull day, and most photographers were using flash bulbs, but I slowed the shutter and took the picture without a flash."

The thick shock of hair, the famous number, the cheering fans — Fein's photograph tells the whole story of the Babe's bittersweet finale.

1949

BABE RUTH
RETIRES NO. 3
Nathaniel Fein

June 13, 1948, New York,
New York

New York Herald Tribune

4 x 5 Speed Graphic, Carl Zeiss
5¼ inch lens, Super Pan Press film
Courtesy of the Nat Fein Estate

'I...hoped I caught the near miss'

At the Oakland Airport in Northern California, a ragtag assortment of airplanes fills the sky — one-seaters, prop planes, biplanes, even bombers, all performing in the airport's annual air show. Sixty thousand spectators pack the bleachers, spilling out onto the runway. Among them is photographer Bill Crouch, covering the show for *The Oakland Tribune*.

Crouch shoots wing walkers, stunt pilots and daredevils as they perform breath-stopping tricks in the sky. The final stunt belongs to crop duster Chet Derby. Crouch remembers: "I saw this stunt pilot, and put my camera on him — I had a 20-inch lens to bring him up close."

Crouch's bulky camera tracks Derby's fragile plane as it performs elegant loop-the-loops, leaving circles of smoke in the flawless sky. The crowd watches in silence. Suddenly, a squadron of bombers thunders overhead. The big planes are the show's grand finale — and they are one minute too early. The crowd leaps to its feet, gasping. Crouch clutches his camera. One bomber hurtles straight for Derby's hapless biplane...

At the last second, the little plane slips beneath the bomber's wing. "The stunt plane zoomed past," says Crouch. "I snapped the trigger and hoped I caught the near miss. I did."

1950

AIR SHOW
HIGH DRAMA

Bill Crouch

October 2, 1949, Oakland, California

The Oakland Tribune

4 x 5 Speed Graphic, 20-inch lens, Kodak film

Courtesy of *The Oakland Tribune*

'All these people clambering'

In October 1950, photographer Max Desfor packs up his 4 x 5 Speed Graphic, straps on a parachute and jumps out of an airplane for the first time. He is covering the Korean War for The Associated Press. "As a war correspondent, I was attached to a military unit," says Desfor. "Whichever one I chose." Desfor picks the 187th Regiment, which parachutes deep into North Korea to try to liberate U.N. prisoners.

The jump is successful; the rescue is not. Desfor stays with his unit, covering its movements in the north. But on Nov. 25, 300,000 Chinese troops swoop across the border to aid their North Korean allies. Within weeks, U.N. troops are in retreat, abandoning the North Korean capital of Pyongyang. "Our troops could no longer hold the capital city," remembers Desfor. "We could hear the explosions. Fires raged. I was in a jeep with a couple of other correspondents and we were retreating along with everybody else."

Desfor and his colleagues head south, crossing the Taedong River on a military pontoon bridge. As they race down the other side of the river, they come upon a bridge that has been bombed into ruin. Undaunted, hundreds of refugees crawl over the twisted metal. The weather is bitter cold; the wind, piercing.

Says Desfor: "It was a fantastic sight. All these people clambering over the girders and the broken girders were dipped down into the icy water." Fingers numbed by cold, Desfor takes only a few shots. One frames the desperation — and determination — of the refugees' flight.

1951

KOREAN WAR
Max Desfor

December 12, 1950, Taedong River, North Korea

The Associated Press

4 x 5 Speed Graphic, Ektar F4 7-inch lens, Kodak Tri-X film

Courtesy of The Associated Press

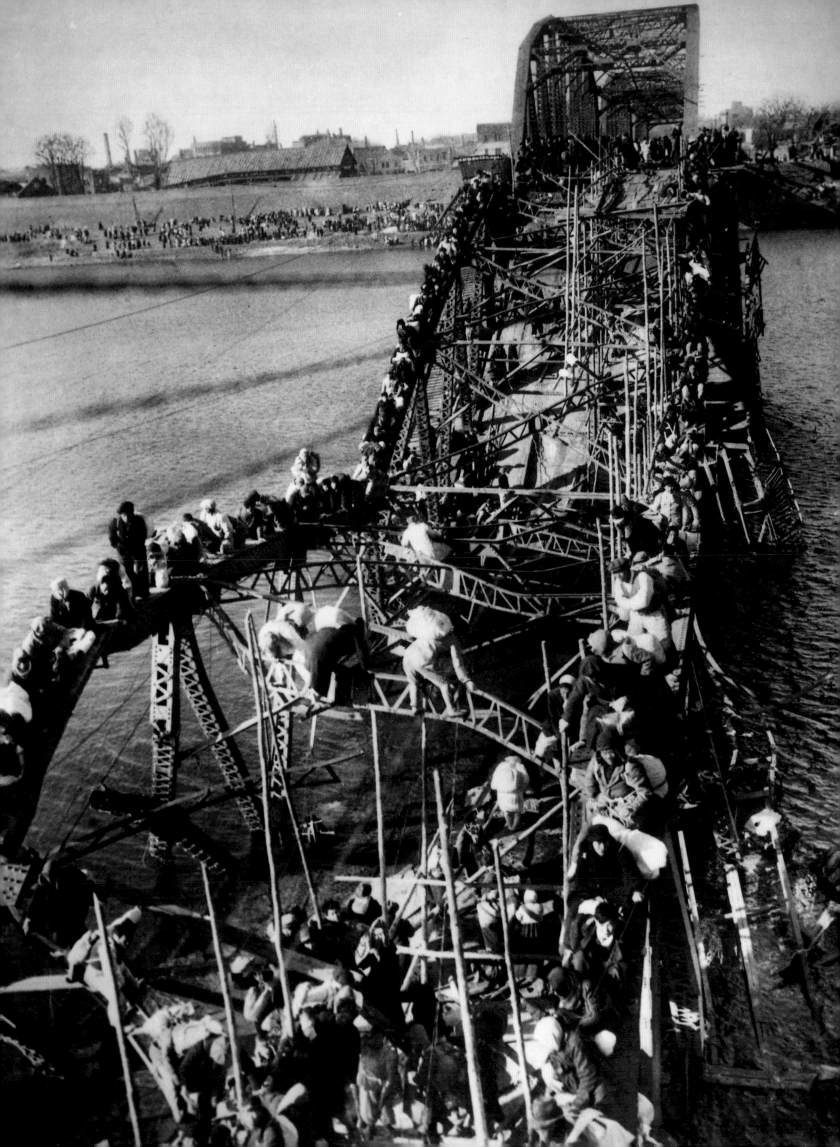

'A black man wasn't really accepted'

On Oct. 21, 1951, *Des Moines Register* photographers Donald Ultang and John Robinson travel to Stillwater, Okla., to cover a college football game.

The Oklahoma Aggies, an all-white Southern team, are up against the Drake University Bulldogs, an integrated Northern team. The Bulldogs are undefeated. They are also fielding halfback Johnny Bright, a talented black athlete who has gained more yards than any player in collegiate history. Donald Ultang remembers: "Bright was in a very special position at that game. He was going onto a field where a black man wasn't really accepted." Rumors flood the Oklahoma campus that "the black man will not finish the game."

It's the kickoff. Ultang follows the action with his Howitzer, a very long lens that captures half the field in a single frame. Robinson uses an Eyemo movie camera modified to take a series of stills. The Bulldog center snaps the ball to Johnny Bright; Bright hands off to the fullback. "At the end of the play," says Ultang. "Bright was lying on the ground, unconscious as it turned out."

After a brief rest, Bright keeps on playing—and keeps going down. Finally, he is carried off the field, jaw broken. Nobody has seen exactly what happened. But the *Register* cameras have recorded it all. Ultang and Robinson's pictures show Bright being slugged repeatedly in the jaw by Aggie defensive end Wilbanks Smith.

The photographs cause an enormous sensation. "The racial angle captured the imagination of the country," says Ultang. "Nobody had realized that a black man could be pummeled the way he was and deliberately run out of the game." Bright recovers and plays professional football in the Canadian Football League.

1952

RACIAL ATTACK ON NCAA CHAMPION
Donald T. Ultang and John R. Robinson

October 21, 1951, Stillwater, Oklahoma

Des Moines Register and Tribune

4 x 5 Speed Graphic, and a Bell & Howell Eyemo Motion Picture Camera, F4.7 16½ inch and F4.5 10 inch lenses, Kodak Panchro-Press Type B and Super XX films

Courtesy of *Des Moines Register and Tribune*

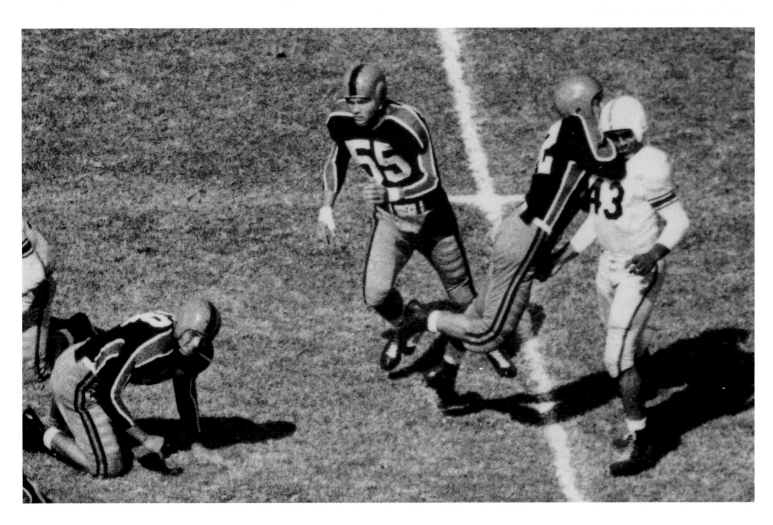

'I couldn't miss seeing the hole'

The 1952 U.S. presidential campaign pits World War II hero Dwight D. Eisenhower against Adlai Stevenson, governor of Illinois. Gen. Eisenhower has an impeccable military record; Stevenson is a man of vision, widely respected for his integrity, intellect and sharp wit. There is one problem: Stevenson doesn't want the nomination. But the Democrats want Stevenson. Over the governor's protests, he is drafted at the Democratic convention.

One of the new candidate's first campaign stops is a Labor Day rally in Flint, Mich., where autoworkers offer a bedrock of Democratic support. *The Flint Journal* photographer William Gallagher is on the dais with Stevenson, looking for good pictures.

As Stevenson waits to be introduced, Gallagher squats directly in front of him. "As I was kneeling there he started going over the notes of his speech and casually crossed his legs. This brought the shoe up right in front of me. I couldn't miss seeing the hole. As quietly as I could, I pre-focused my camera and set it on the floor at arm's length. I had to spot the camera by guesswork because it was impossible for me to lie on the floor."

Gallagher gets his shot; Stevenson loses the election. When he wins the Pulitzer Prize, Gallagher receives a congratulatory cable, vintage Stevenson: "Glad to hear you won with a hole in one."

1953

ADLAI BARES
HIS SOLE
William M. Gallagher

September 2, 1952, Flint, Michigan

The Flint Journal

4 x 5 Speed Graphic, standard lens, Kodak film

Courtesy of *The Flint Journal*

'For God's sake, get us out of here'

It's a beautiful California day. Virginia and Walter Schau and Virginia's father, Henry Brown, are going fishing. As they drive up the winding road to Lake Shasta, they slow to a crawl behind a tractor-trailer. At the wheel is Paul Overby who, along with Henry Baum, is headed for Oregon with a load of produce.

Overby starts across the Pit River Bridge, high over the lake. Suddenly, the truck swerves. Overby fights for control. But the truck's steering has gone out. The cab tears through the steel rail, plunges over the side, then jerks to a stop. Overby and Baum find themselves looking straight down at the rocky shoreline 70 feet below.

Walter Schau grabs a rope, jumps out of his car and races toward the disabled truck. The trapped men plead, "For God's sake, get us out of here." Virginia and her father watch as Schau and another motorist lower the rope over the side.

Brown reminds his daughter of *The Sacramento Bee*'s weekly photo contest, which pays $10 for the best news photo. Virginia grabs her camera. Overby grabs the rope. When Overby is within arm's reach of his rescuers, Virginia clicks the shutter.

Hank Baum is still trapped. Burning diesel fuel trickles down; smoke fills the cab. Baum is halfway out the window trying to catch a breath when the rope comes down again.

Just as Baum and Overby are reunited on the bridge, the truck cab bursts into flame and crashes onto the rocks below. Virginia Schau wins the photo contest — and the Pulitzer Prize.

1954

RESCUE ON PIT RIVER BRIDGE

Virginia Schau

May 3, 1953, Redding, California

The Sacramento Bee

Kodak "Brownie" Box Camera, Meniscus lens, Kodak film

Courtesy of Kurt Schau

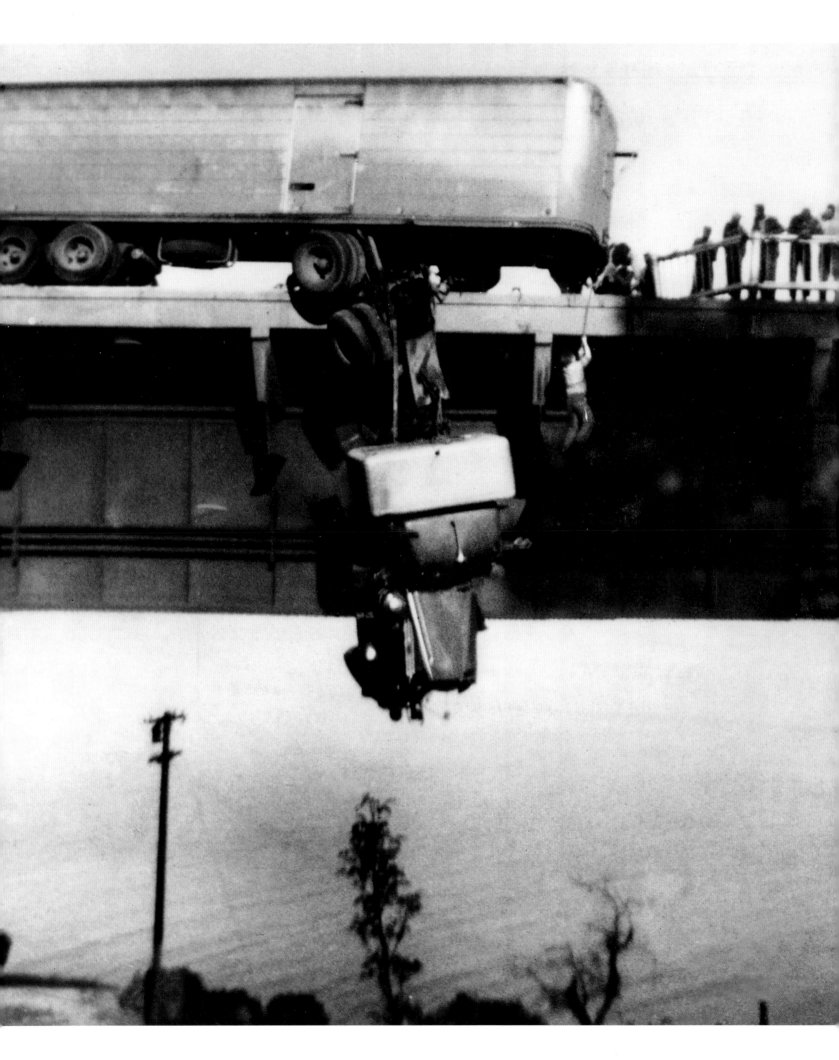

'I grabbed a Rolleiflex camera and ran'

April 2, 1954. *Los Angeles Times* photographer John Gaunt lounges in his front yard in Hermosa Beach, Calif., enjoying the sun. Suddenly, a neighbor calls out. "There was some excitement on the beach," says Gaunt. "I grabbed a Rolleiflex camera and ran."

Down by the water, Gaunt finds a distraught young couple by the shoreline. Moments before, their 19-month-old son was playing happily in their yard. Somehow, he wandered down to the beach. He was swept away by the fierce tide.

The little boy is gone. There is nothing anyone can do. Gaunt, who has a daughter about the same age, takes four quick photographs of the grieving couple. "As I made the last exposure, they turned and walked away," he says. The little boy's body is later recovered from the surf.

1955

TRAGEDY BY THE SEA
John L. Gaunt, Jr.

April 2, 1954, Hermosa Beach, California

Los Angeles Times

Rolleiflex *f*/16, 1/250 second, 80 mm lens, Kodak film

Courtesy of *Los Angeles Times*

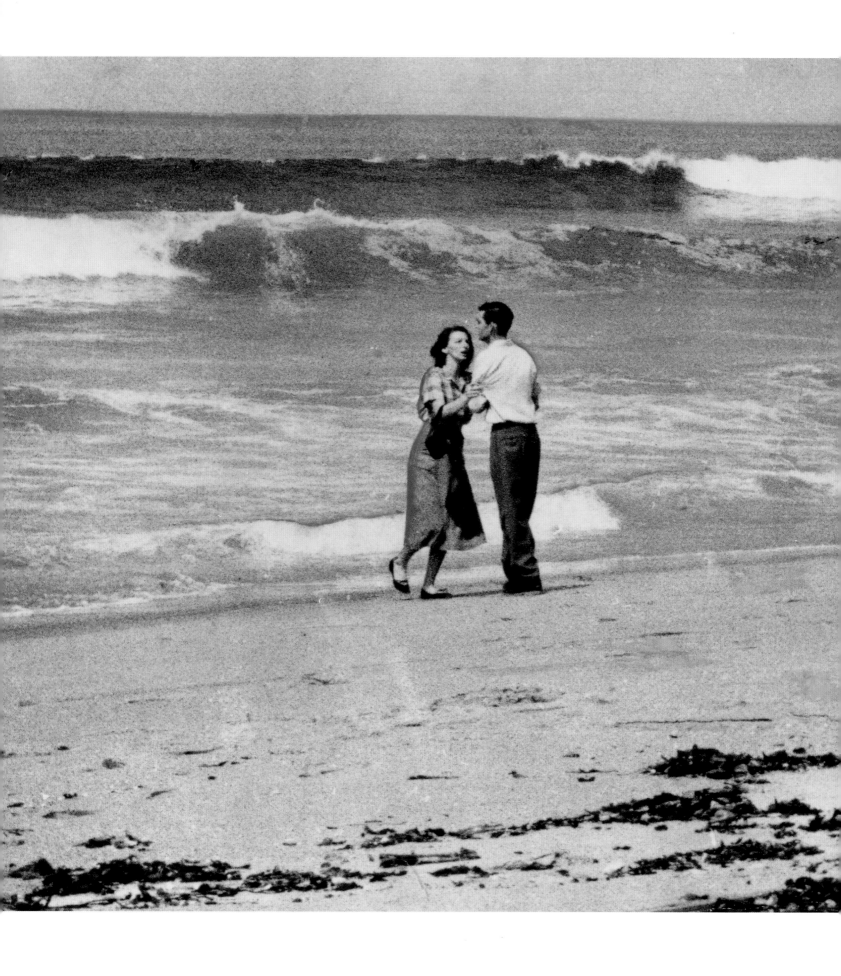

'Better be ready for it'

Long Island, New York: home to hundreds of carefully groomed suburbs, with their golf courses and shopping centers, and one Air Force base, with its Quonset huts and airfields. On Nov. 2, 1955, an accident lands these incongruous neighbors on top of each other.

Photographer George Mattson is aboard a New York *Daily News* airplane when he notices thick smoke rising. His pilot heads in for a closer look. They find, not a house on fire, nor even a car, but the flaming wreck of a B-26 bomber.

The Air Force pilot is on a routine training run when he reports trouble. He tries to make it back to the base. Instead, he crashes right into a neat suburban yard. A wing bangs against the house; the roof catches fire. The pilot and his sergeant are killed; no one on the ground is injured.

The inhabitants — mother, father, 5-year-old daughter — are not at home.

The *Daily News* pilot circles low. Mattson gets his shot. "When a news photographer reports for work, he is sure about one thing," Mattson says. "He doesn't know where his next picture is coming from, but he better be ready for it." Mattson is ready for this one. On the ground, he calls in the story. The newspaper sends out more photographers. The entire *Daily News* photo layout, with Mattson's picture at the center, wins the Pulitzer Prize.

1956

BOMBER BURNS
AFTER CRASH
IN YARD

Daily News staff

November 2, 1955, Long Island, New York

New York *Daily News*

Hasselblad, unknown lens, Kodak film

© New York *Daily News*, L.P. used and reprinted with permission

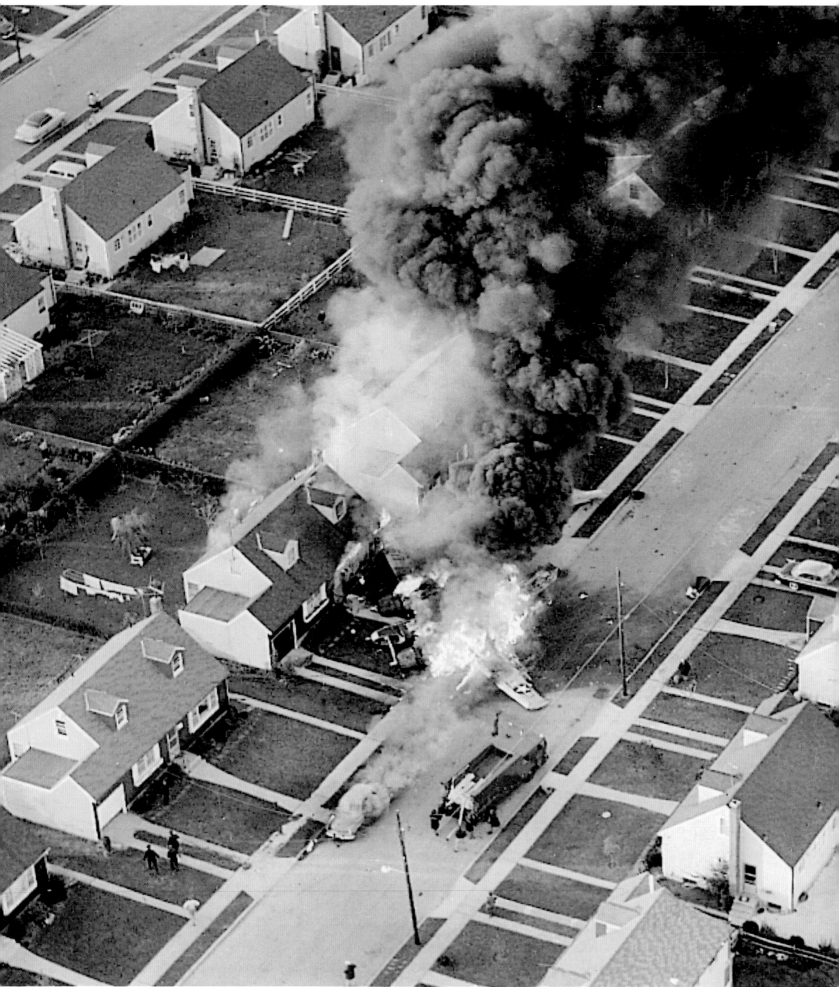

George Mattson

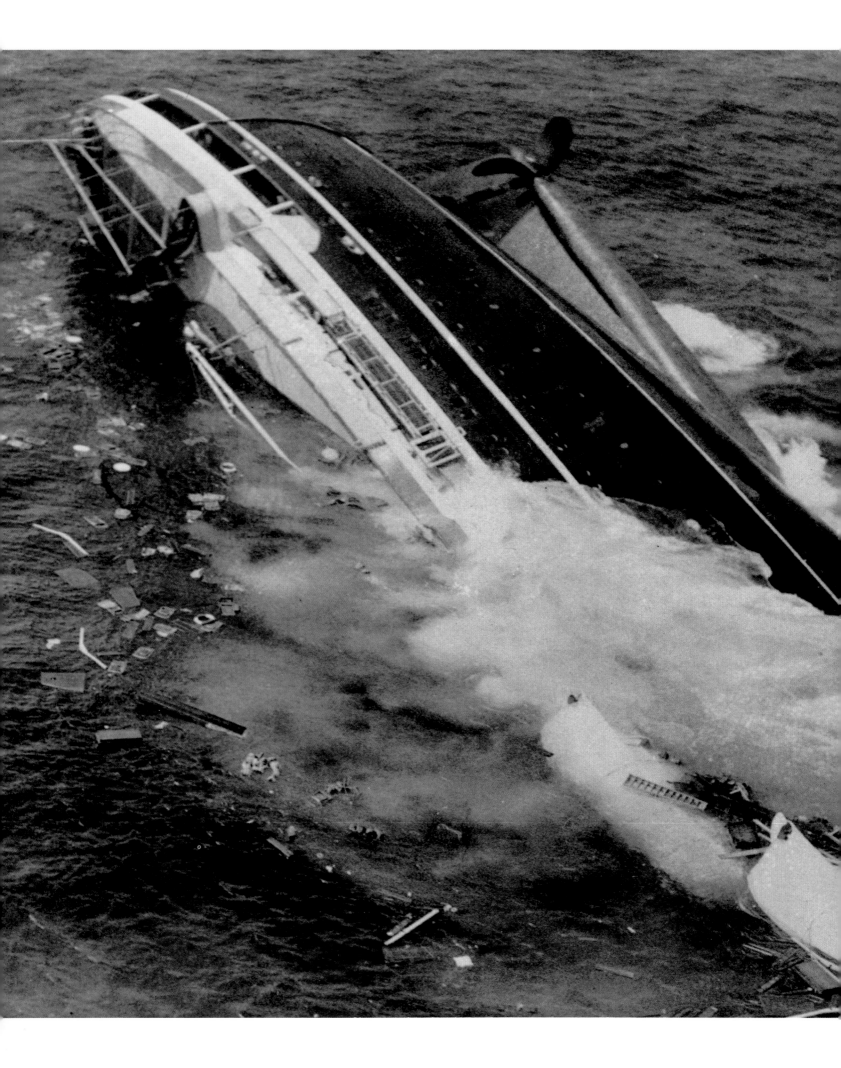

'In nine minutes, it was all over'

Its passengers are enjoying their last night at sea—dining, dancing, playing cards—as the luxury liner Andrea Doria sails through fog-bound waters. It is 11 p.m., July 25, 1956. The ship is just off Nantucket; it should be in New York by morning.

Cruising out of New York harbor is the Stockholm, a Swedish-American liner, its prow heavily reinforced against winter ice. Each ship spots the other on radar. Both radar screens indicate they will pass safely.

Within minutes something goes horribly wrong. With a sudden shock of impact and screech of ripping metal, the Stockholm tears a 40-foot hole in the Andrea Doria's starboard side. Water gushes in. Passengers race about. The crew lowers lifeboats. A massive evacuation begins.

The next morning, a chartered Beechcraft Bonanza circles low over the abandoned liner. Inside is *Boston Traveler* photographer Harry Trask, who missed an earlier journalists' flyover. As the tiny plane dips and turns, Trask becomes violently airsick. He shoots anyway.

"I asked the pilot to make several passes . . . so I could record it with my Graphic. As we circled, I could see the stack gradually sink below the surface. As the air from the cabins rose to the surface, the water foamed. Debris and empty lifeboats were scattered everywhere. In nine minutes, it was all over." The tardy, airsick news photographer takes 16 photographs. One shows the Andrea Doria, propeller aloft, just before it sinks in 225 feet of water.

Sixteen hundred and fifty passengers survive the wreck. Fifty-one others are lost beneath the sea.

1957

SINKING OF ANDREA DORIA
Harry A. Trask

July 26, 1956, Atlantic Ocean off Nantucket Island, Massachusetts

Boston Traveler

4 x 5 Speed Graphic *f*/5.6, Kodak Ektar 127 mm lens, Kodak Royal Pan 400 ASA film

Courtesy of Kevin Cole, *Boston Herald*

'I suddenly saw the picture'

It's a sleepy, Indian-summer kind of afternoon. Not a bad day to be out photographing the Chinese Merchants Association parade in the nation's capital, and that's what William Beall is doing, on assignment for the *Washington Daily News*. There is plenty to shoot: People line the sidewalk. Chinese dancers and paper dragons roam the streets. Firecrackers pop and sizzle all around.

Out of the corner of his eye, Beall sees a very small boy step into the street. In front of the boy—a dancing Chinese lion. Between the boy and the lion—a tall young policeman. The policeman intercepts the boy, cautioning him back from the busy parade. Says Beall: "I suddenly saw the picture, turned and clicked." The photographer fires off one shot, freezing forever a moment of childhood innocence.

1958
FAITH AND
CONFIDENCE
William C. Beall

September 10, 1957,
Washington, D.C.

Washington Daily News

4 x 5 Speed Graphic,
standard lens, Kodak Super
Pan film

Courtesy of Scripps Howard
News Service

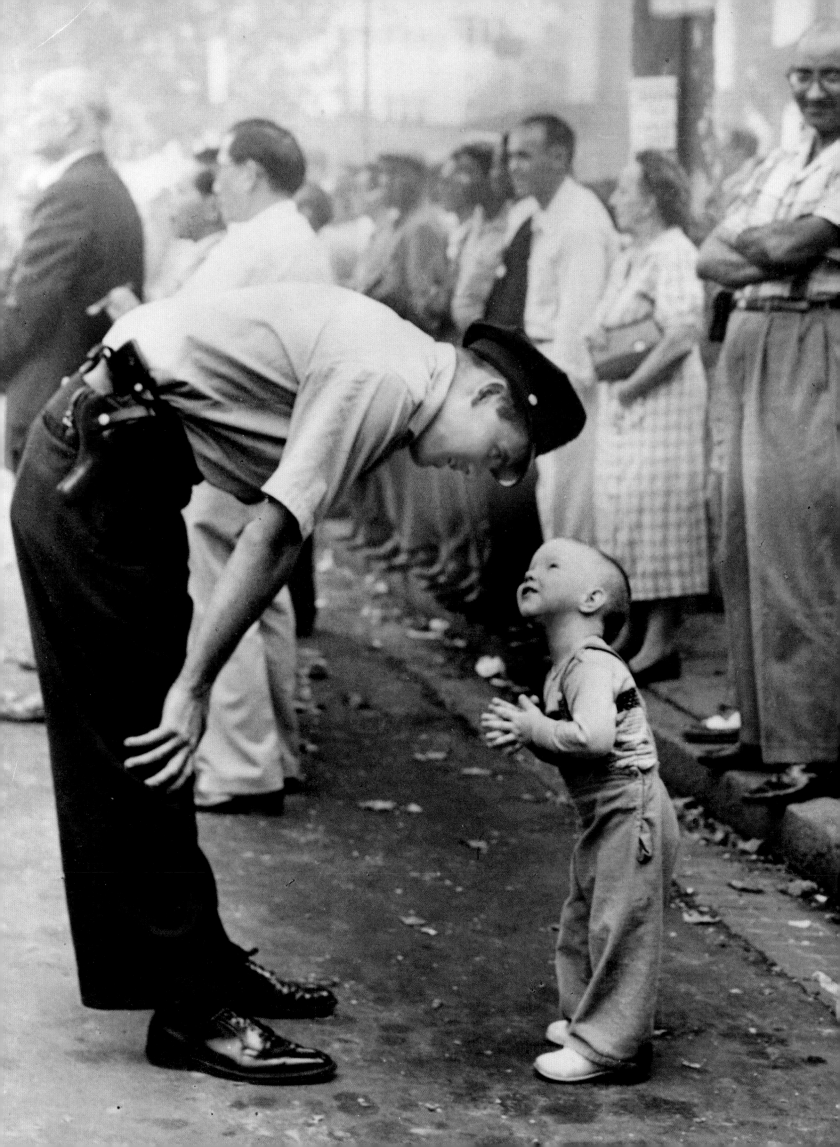

'I was about to shout a warning'

William Seaman, photographer for the *Minneapolis Star and Tribune,* is driving the streets of Minneapolis. It's a mellow spring day but Seaman is hoping for excitement: a crime, a fire, something unusual to photograph. What he gets is sadder than he could have dreamed.

Seaman stops for a red light. A young boy starts to cross the street, pulling a red wagon. Seaman is especially attentive; he has a son about the same age. "I was about to shout a warning to him and even considered getting out and helping him, but he made it back to the curb all right, so I drove on."

One block, two. Moments later, Seaman's police radio chatters to life: A young boy has been hit by a garbage truck. Dread clenching his stomach, Seaman races to the intersection — and spots the broken wagon. The scene he photographs conveys the bitter pain of overwhelming loss.

1959

WHEELS OF
DEATH

William Seaman

May 16, 1958, Minneapolis,
Minnesota

Minneapolis Star and Tribune

Rolleiflex, Xenotor 80 mm F2.8
lens, Kodak Tri-X film

Courtesy of William Seaman and
The Minneapolis Star and Tribune

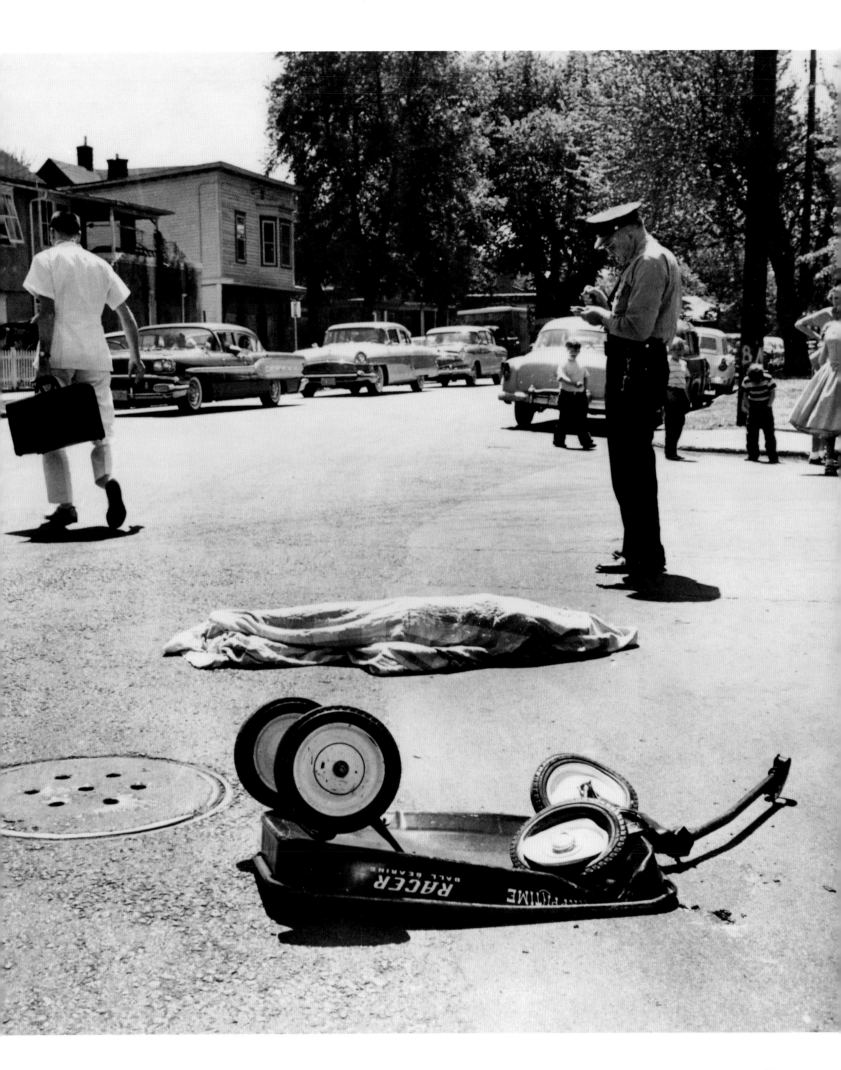

'Get on with their business and shoot this guy'

Jan. 17, 1959: Fidel Castro and his guerrillas — known as *Barbudos,* or "Bearded Ones" — parade through the streets of Havana, celebrating the fall of dictator Fulgencio Batista.

United Press International photographer Andrew Lopez heads for the war crimes tribunal at the San Severino Castle, where hundreds of Cubans are on hand, eager to testify at the trial of brutal Batista army corporal Jose Rodriguez, known as "Pepe Caliente."

"The place was jammed with people," remembers Lopez. "The entire trial took two hours. It took one minute for three tribunal judges to condemn Pepe to death. They lined Pepe against the wall in the courtyard. He dropped to his knees, and a priest came over to give him religious comfort and last rites. Pepe reached over to kiss the cross before he was to be executed. It was a tragic moment."

The prosecutor, rebel major Willy Galvez, screams at Lopez, saying he can't take pictures. "I was standing there arguing with him, and in the background I could see eight or nine *Barbudos* who were waiting for all this to come to an end so they could get on with their business and shoot this guy."

The prosecutor demands Lopez's film. Lopez reaches into his pocket and pulls out a roll. "I gave it to him and they let us go. I kept the roll of film with Pepe on it."

1960

CASTRO FIRING
SQUAD EXECUTION
Andrew Lopez

January 17, 1959, Matanzas, Cuba

United Press International

Rolleiflex, 80 mm lens, Kodak Tri-X
film

Courtesy of Corbis

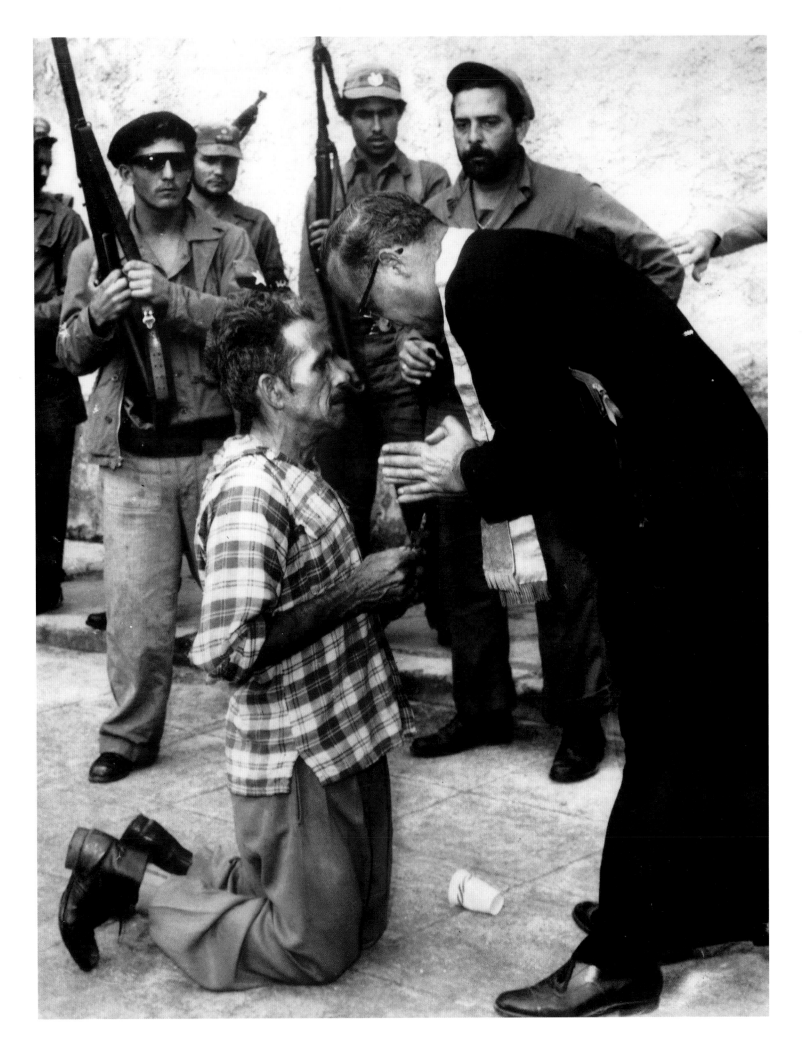

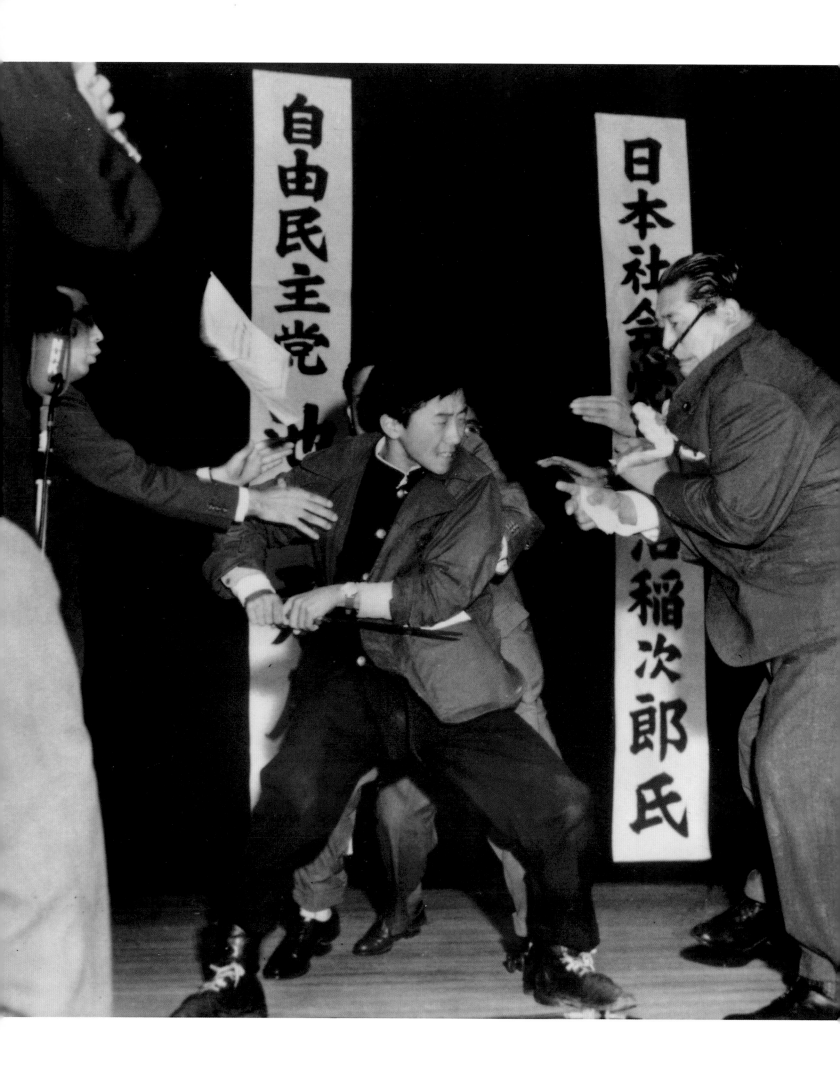

'Carrying a brown stick to strike'

It's election season in Japan — time for discussion, argument and debate. On Oct. 12, 1960, 3,000 people cram Tokyo's Hibiya Hall to hear Socialist Party Chairman Inejiro Asanuma battle it out with Liberal-Democratic Prime Minister Hayato Ikeda. Reporters, TV crews and photographers crowd the stage; one of them is Yasushi Nagao, photographer for the *Mainichi Shimbun*.

Chairman Asanuma lambastes the Japanese government for its mutual defense treaty with the United States. Right-wing students begin to heckle and shout, throwing wads of paper at the burly party chairman. The police rush to quell the unrest. The press follows, except for Nagao, who, with only one shot left in his camera, stays close to the stage.

Suddenly, right-wing student Otoya Yamaguchi rushes out. "I thought Yamaguchi was carrying a brown stick to strike Asanuma," Nagao remembers. With a jolt, Nagao realizes the slender figure is wielding a Japanese samurai sword. Before anyone can stop him, Yamaguchi plunges the sword into the chairman. Asanuma staggers. Yamaguchi pulls out the blade. Nagao lifts his camera. As the photographer uses his last frame, Yamaguchi spears Asanuma again — through the heart.

1961

ASSASSINATION
OF ASANUMA

Yasushi Nagao

October 12, 1960, Tokyo, Japan

The Mainichi Newspapers

4 x 5 Speed Graphic, standard lens, Kodak film

Courtesy of The Mainichi Newspapers

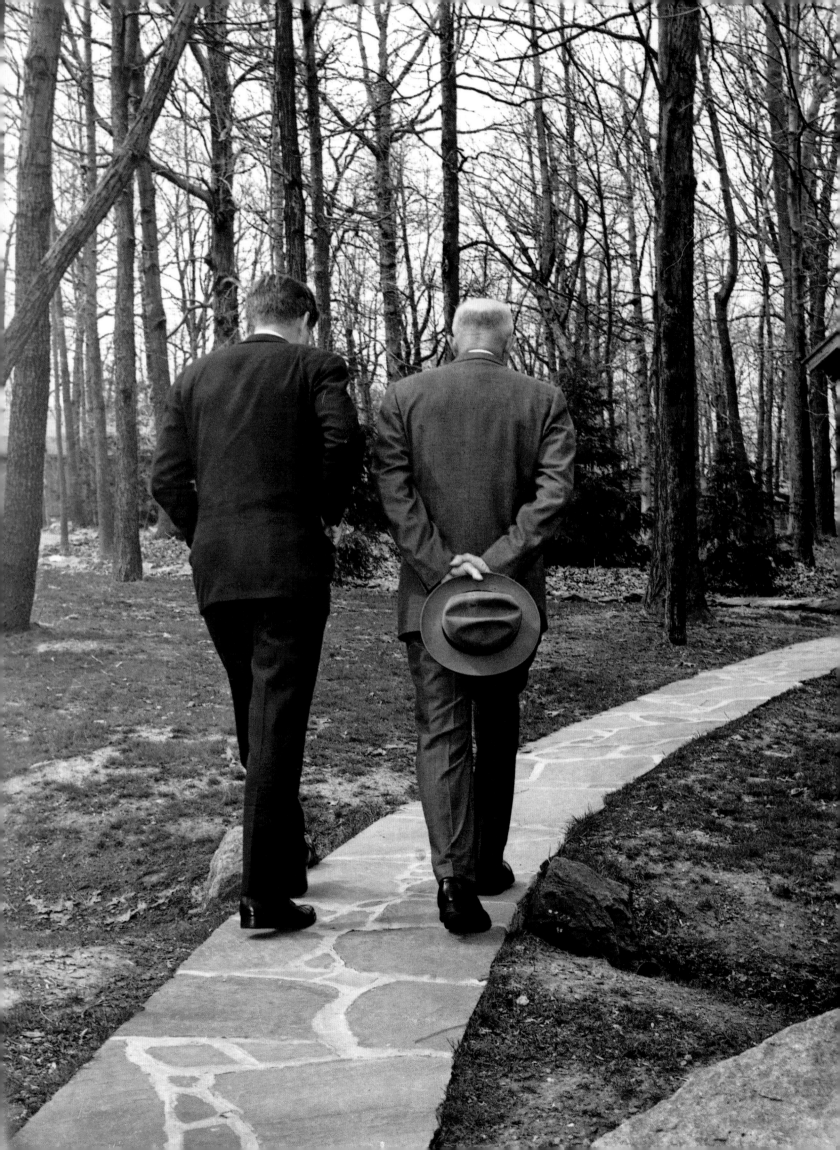

'Just two of them...
They looked so lonely'

In April 1961, the young administration of John F. Kennedy is wobbling. The disastrous Bay of Pigs invasion is generating fallout worldwide: Cuba's Fidel Castro is furious. Soviet leader Nikita Krushchev presses the advantage. Americans question Kennedy's ability to lead.

Seeking counsel, Kennedy retreats to Camp David with his predecessor, Dwight D. Eisenhower. The two leaders pose for photographs. Associated Press photographer Paul Vathis takes the requisite shots. "I was right in front of them," says Vathis. "I heard Ike tell Kennedy, 'I know a place where we can talk.'" The new president and the former general head away from the throng.

Most of the reporters and photographers are on their way out. But as Vathis kneels to pack his camera, he glances up. "There were just two of them, all by themselves, their heads bowed, walking up the path. They looked so lonely."

Press Secretary Pierre Salinger says no more pictures. But Vathis can't resist. He grabs his camera and gets off two quick shots—right between the legs of a surprised Secret Service agent. The press secretary is not pleased.

"Pierre said 'I told you guys to leave this alone,' and I said, 'I'm just changing my film.'" Vathis has captured a rare, unguarded moment—a young president, the weight of the world on his shoulders, and the man he replaced, lending a hand.

1962

TWO MEN WITH
A PROBLEM
Paul Vathis

April 22, 1961, Camp David,
Maryland

The Associated Press

Hasselblad, 180 mm lens, Kodak
Tri-X film

Courtesy of The Associated Press

'Bullets were flying when the priest appeared'

June 1962. Venezuela's new constitution is a year old, but already there have been two attempts to overthrow the government. A third comes this month, when 500 rebel marines seize the naval base at Puerto Cabello. Sixty miles away, in Caracas, news photographer Hector Rondon gets wind of the rebellion.

Rondon arrives in Puerto Cabello to a scene of open warfare. Government tanks smash through the town. Troops engage in fierce hand-to-hand combat with the rebels. Rondon creeps alongside the tanks, ducking for cover when he can.

"I found myself in solid lead for 45 minutes," Rondon remembers. "I was flattened against the wall and the bullets were flying when the priest appeared." The priest is the Rev. Luis Padilla, chaplain at the naval base. He moves among the wounded, aiding and comforting, seemingly oblivious to the bullets smashing around him.

As Rondon watches, a wounded soldier pulls himself up, clinging to the priest's cassock. A rebel looses a steady barrage of machine-gun fire but the priest stays put, giving last rites to the desperate soldier. "Lying on the ground, the bullets were whistling. The truth is, I don't know how I took those pictures."

1963
AID FROM THE PADRE
Hector Rondon

June 4, 1962, Puerto Cabello Naval Base, Venezuela

La Republica, Caracas, Venezuela

Leica, 105 mm lens, Kodak Tri-X film

Courtesy of The Associated Press

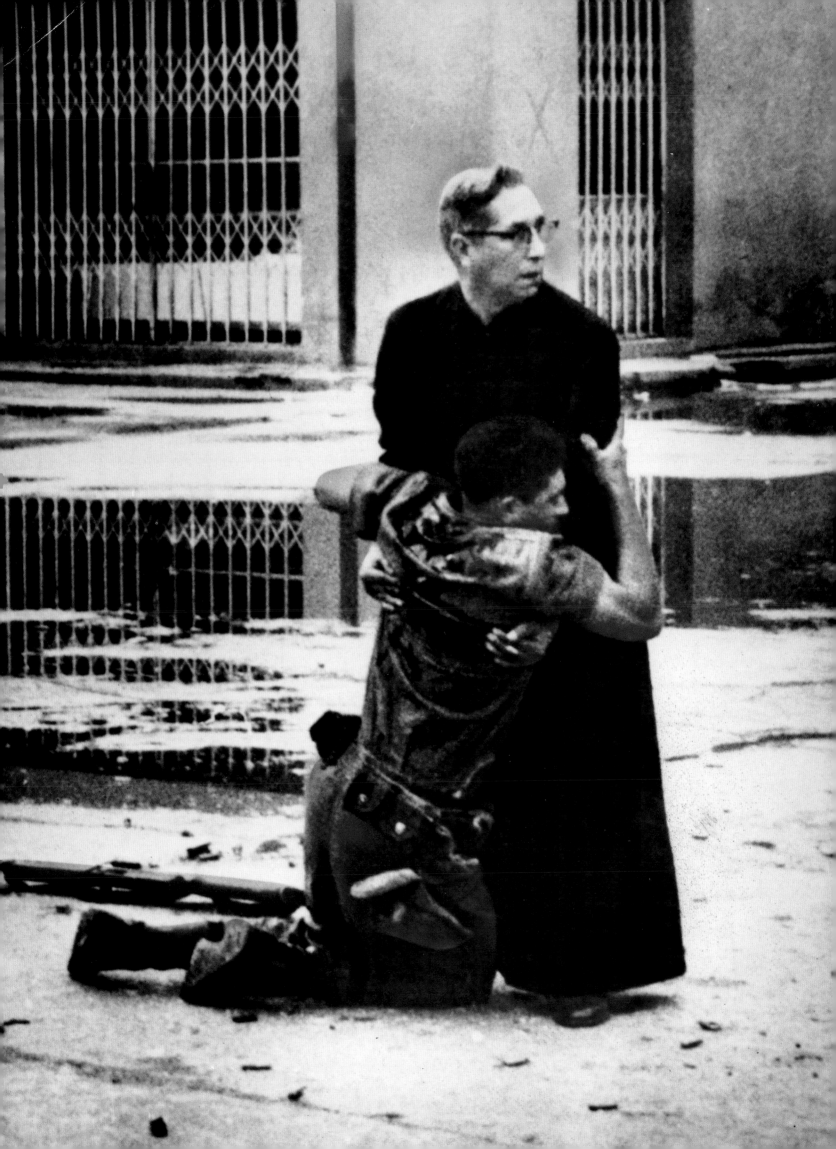

'Ruby took two steps and fired'

Nov. 22, 1963. *Dallas Times Herald* photographer Robert Jackson is riding through the streets of Dallas in President John F. Kennedy's motorcade. "I'd only been at the paper three years, so I was pretty new at it all," remembers Jackson. "It was a really exciting time."

The crowd is cheering, flags are flying, Jackson is snapping photographs. He stops to change film. In that instant, the world changes. Jackson hears a shot. Then another, and another. Bedlam erupts. "The scene was confusion, people running, covering up their kids," says Jackson. "I knew somebody was shooting at the president." Looking up at the Texas School Book Depository, Jackson sees a rifle at a window. But he has no film in his camera. Less than an hour later, the president is dead.

Throughout the weekend, Jackson pursues the story. On Sunday, he shows up at Dallas police headquarters to photograph suspect Lee Harvey Oswald being transferred to the county jail. "I walked right in. There was no security to speak of. Nobody checked my press pass."

In the basement garage, Jackson picks his spot. "I prefocused on about 10 feet where I knew that I would be able to get a clean shot. They said, 'Here he comes' and they brought him out." Jackson raises his camera. Suddenly, someone steps in front of him. "My first reaction was, 'This guy's getting in my way.' Ruby took two steps and fired—and I guess I fired about the same time."

Jackson's photograph shows Jack Ruby killing Lee Harvey Oswald—for many, a final denouement in one of the most tragic events in American history.

1964

JACK RUBY SHOOTS LEE HARVEY OSWALD

Robert H. Jackson

November 24, 1963, Dallas, Texas

Dallas Times Herald

Nikon S3, 35 mm F2.5 lens, Kodak Tri-X film

Courtesy of Robert H. Jackson

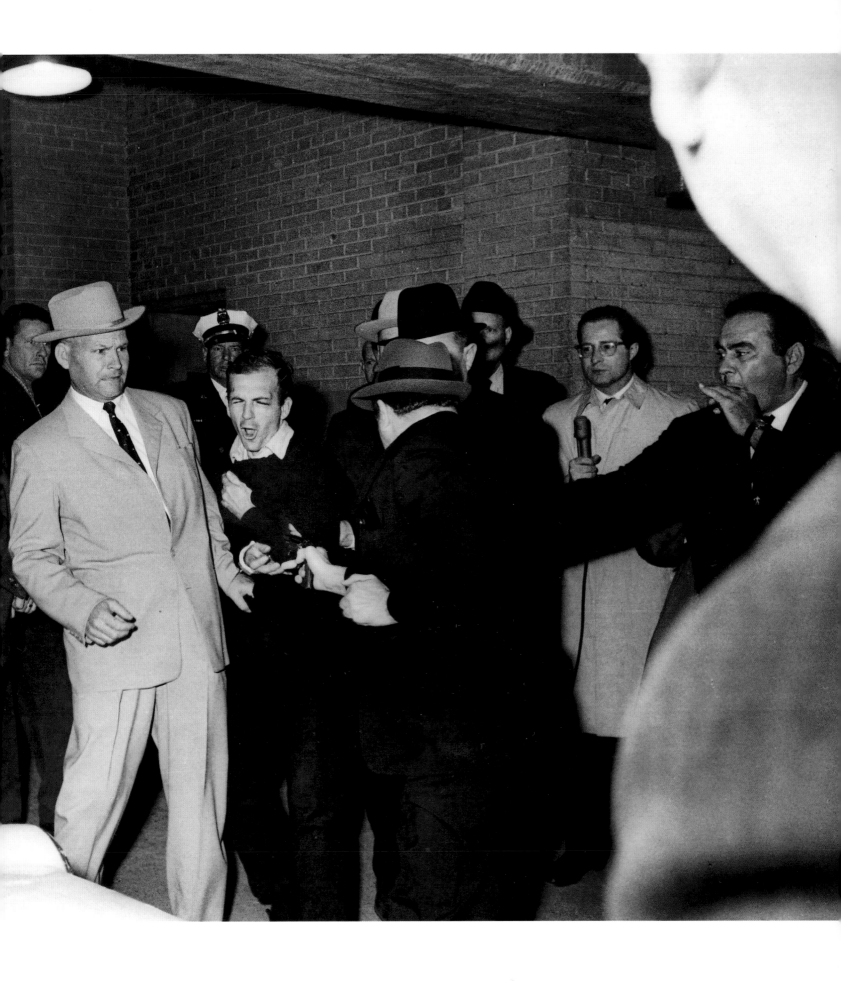

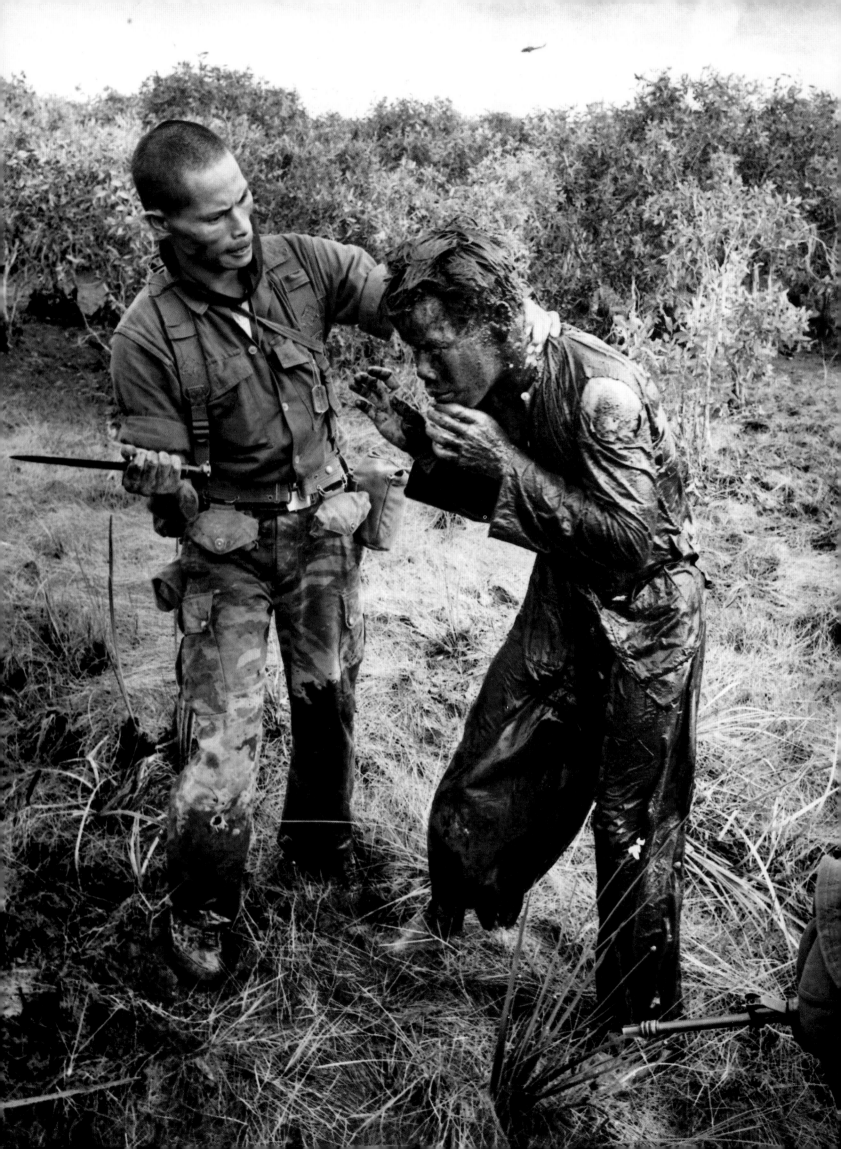

'The knife was a threat—and I think he used it'

For more than 10 years, Horst Faas covers the Vietnam War for The Associated Press. He jumps out of helicopters into battlefields. He tramps through villages, rice paddies and jungles. He witnesses street fighting, interrogations and executions. "I would always travel alone," he says. "Let myself be accepted by the troops. I wouldn't participate, I wouldn't comment; it was a question of taking a few pictures and then disappearing."

One day, Faas and a South Vietnamese unit come across a suspected Viet Cong collaborator. "The soldiers who were assigned to interrogate usually went over these people quite roughly," says Faas. "If the prisoner didn't talk, they would be hurt and even if they did talk they would be hurt or killed. In this case, the knife was a threat—and I think he used it."

Faas says he developed his own "kind of code" to decide whether his war photos were too graphic. "If it was a really exceptional event, one crazy man, then we wouldn't use it. But this event was not a singular event, not even occasional. It was a routine event. That's the story that pictures like this told newspaper-reading people during the weary days of the war."

Faas' photographs also reveal the suffering of civilians: more than 1 million would die during the Vietnam War. "The early war in particular was fought in population centers. As a photographer you would go into villages with the troops after the air bombardments. The attacks would be against the Viet Cong, but civilians got in the way. Casualties among civilians were the worst of the war."

1965

VIETNAM—
CRIME AND
PUNISHMENT

Horst Faas

January 1964, South Vietnam

The Associated Press

Leica M2, 35 mm lens, Kodak film

Courtesy of The Associated Press

'I'm not ready to die yet'

By the end of 1965, almost 200,000 U.S. combat troops are in Vietnam, trying to dislodge the Viet Cong. Caught up in the offensive: four million men, women and children, forced out of their homes, their crops defoliated, their villages destroyed. The plight of one small group is captured by United Press International photographer Kyoichi Sawada.

Sawada has been in Vietnam only six months, but already he is familiar with the harsh reality of war. He writes: "As I helped nurse injured American soldiers, I also photographed their deaths.... The first one I saw was a private. In his pockets were four letters from his family. He hadn't had time to open and read two of them."

On Sept. 6, Sawada is with an American unit when U.S. planes drop bombs and napalm on a village nearby. As villagers flee across the river, Sawada spots two families swimming for their lives. He frames his photograph: the anguished mother, struggling to keep her baby above the water; the frightened boy, his eyes mirroring bewilderment and pain.

After Sawada wins the Pulitzer, he searches for the families, with only the picture to guide him. He finds them and gives each family half the prize money — and a copy of the photograph.

Sawada writes: "I return to the front tomorrow. I will be careful. I'm not ready to die yet. The best is yet to come." Four years later, Sawada volunteers to take his new bureau chief out to assess the war in Cambodia. The two men are found the next day, murdered.

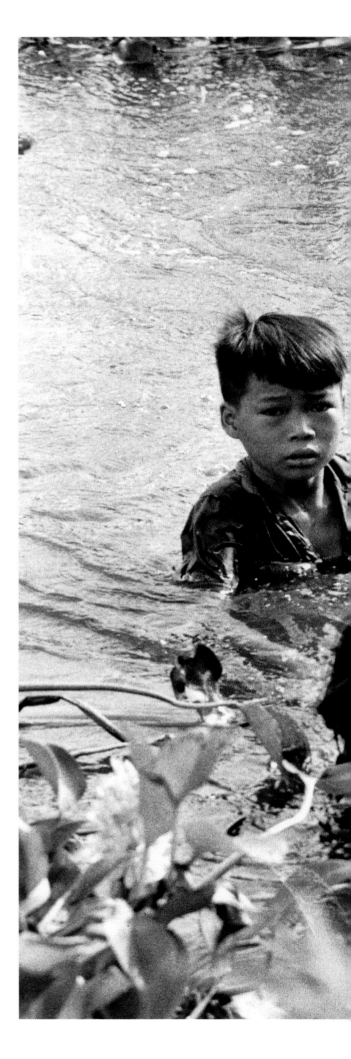

1966

VIETNAM—
FLEEING TO SAFETY
Kyoichi Sawada

September 6, 1965, Qui Nhon, South Vietnam

United Press International

Leica, 105 mm lens, Kodak Tri-X film

Courtesy of Corbis

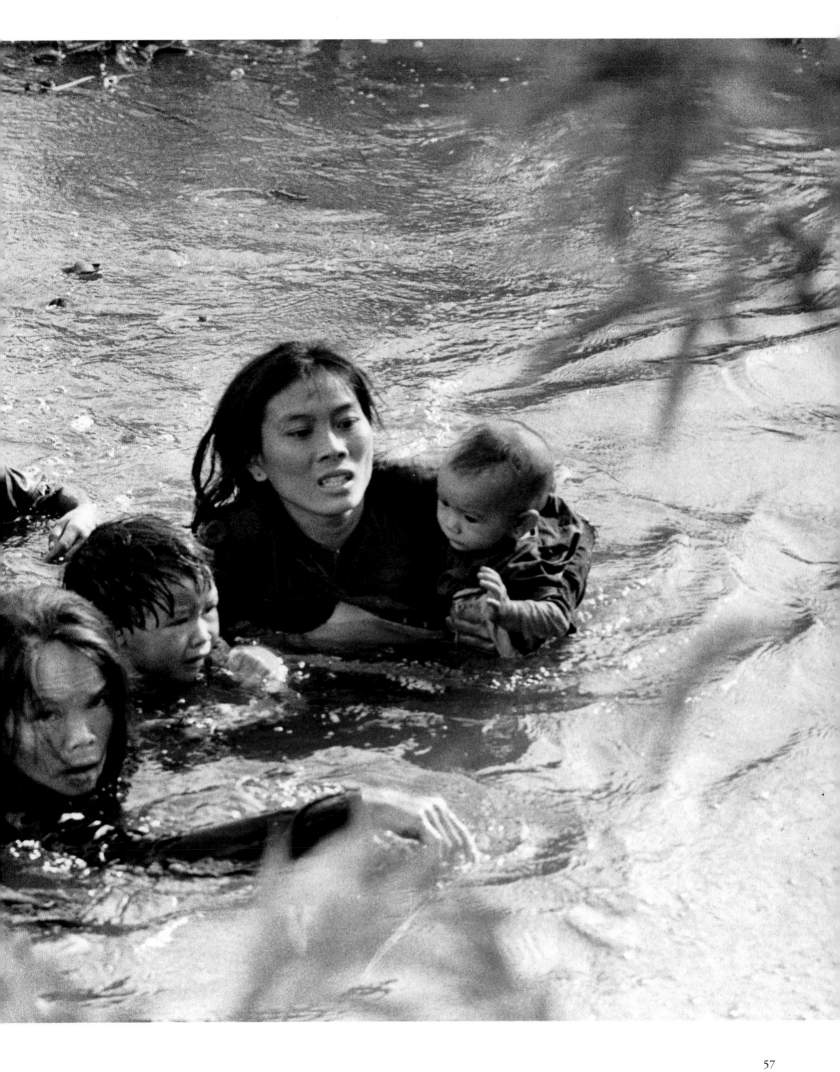

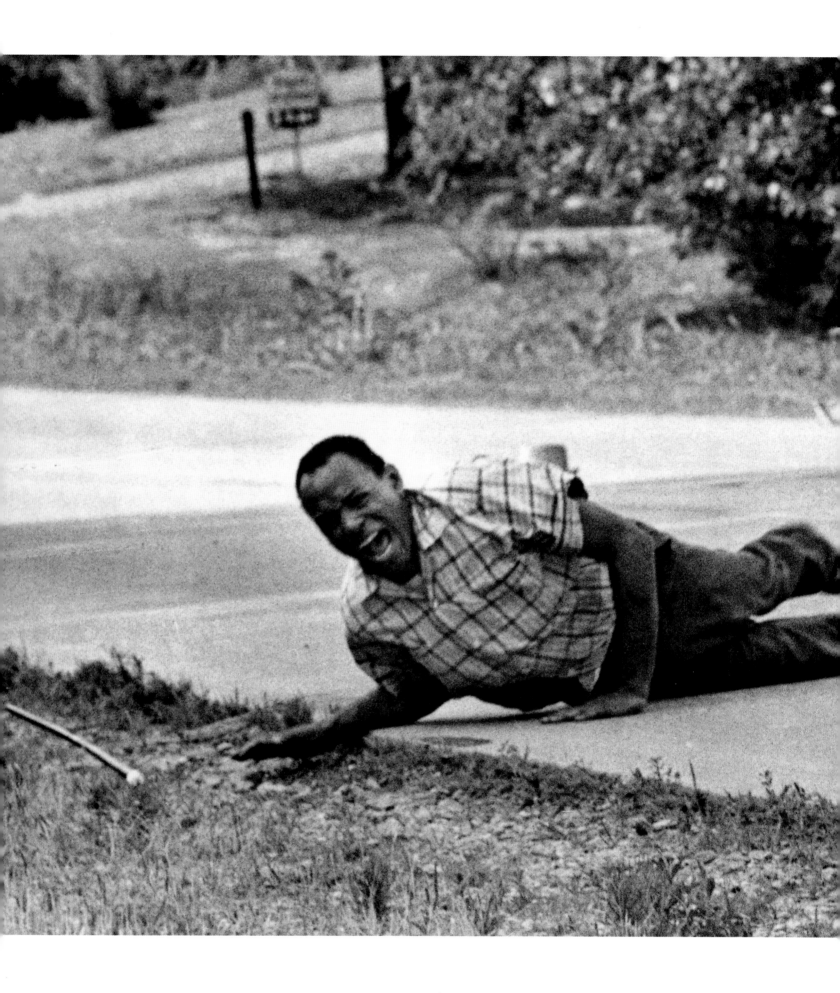

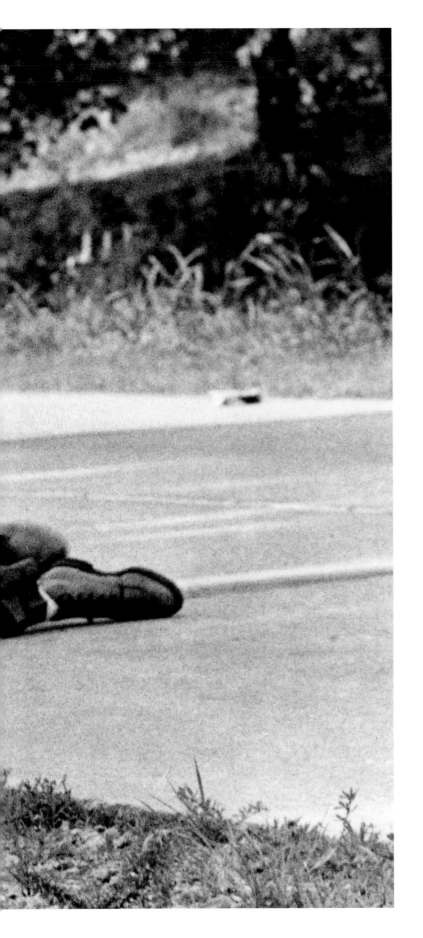

'James.
I just want James'

It has been four years since James Meredith became the first African-American to attend the University of Mississippi — with the intervention of the U.S. attorney general, U.S. marshals and the National Guard. Determined to prove that black Americans can pursue their civil rights without fear, Meredith decides to walk the length of Mississippi to encourage African-Americans to vote.

It is the second day of the walk — June 6, 1966, two years after three civil rights workers were killed in Mississippi. The state is deeply divided by racial hatred. Meredith is unarmed, accompanied by a handful of supporters, a few police officers and some journalists. One of them is Jack Thornell of The Associated Press. "The press wasn't really walking with him," says Thornell. "We were leapfrogging ahead in cars."

Thornell and two other photographers are parked by the side of the road as Meredith approaches. Suddenly, a voice calls out: "James. I just want James Meredith." A white man stands, leveling a 16-gauge shotgun.

Says Thornell, "I was sitting in the car when we heard the shot. By the time we got out, Meredith was going down. We were in the line of fire. We were trying to protect our heads. We weren't taking a lot of photographs." But as Meredith crawls painfully to the side of the road, Thornell manages to capture his outraged agony on film.

Galvanized by the shooting, black leaders Martin Luther King Jr. and Stokely Carmichael take up the cause. Meredith recovers and rejoins the march, which is now 18,000 strong. The term "black power" is born.

1967

JAMES MEREDITH SHOT
Jack R. Thornell

June 6, 1966, Hernando, Mississippi

The Associated Press

Nikon, 105 mm lens, Kodak Tri-X film

Courtesy of The Associated Press

'Oh my God,
I didn't know what to do'

July 17, 1967: Air conditioners hum all over Florida. In Jacksonville, they over-whelm the electrical system and knock out the power. *Jacksonville Journal* pho-tographer Rocco Morabito is on his way to photograph a railroad strike when he notices Jacksonville Electric Authority linemen high up on the poles. "I passed these men working and went on to my assignment," says Morabito. "I took eight pictures at the strike. I thought I'd go back and see if I could find another pic-ture."

But when Morabito gets back to the linemen, "I heard screaming. I looked up and I saw this man hanging down. Oh my God, I didn't know what to do." The linemen, Randall Champion, is dangling upside down in his safety belt—felled by 4,160 volts of electricity.

"I took a picture right quick," says Morabito. "J.D. Thompson (another line-man) was running toward the pole. I went to my car and called an ambulance. I got back to the pole and J.D. was breathing into Champion." Cradling the stricken lineman in his arms, Thompson rhythmically pushes air into Cham-pion's lungs. Below, Morabito makes pictures—and prays.

"I backed off, way off until I hit a house and I couldn't go any farther. I took another picture." It is a prize-winning photograph, but Morabito's real concern is the injured lineman. Thompson finally shouts down: "He's breathing." Cham-pion survives.

1968 Spot News
THE KISS OF LIFE
Rocco Morabito

July 17, 1967, Jacksonville, Florida

Jacksonville Journal

Rolleiflex ƒ/8 at 1/500 second, Carl Zeiss 75 mm lens, Kodak Tri-X film

Courtesy of Rocco Morabito

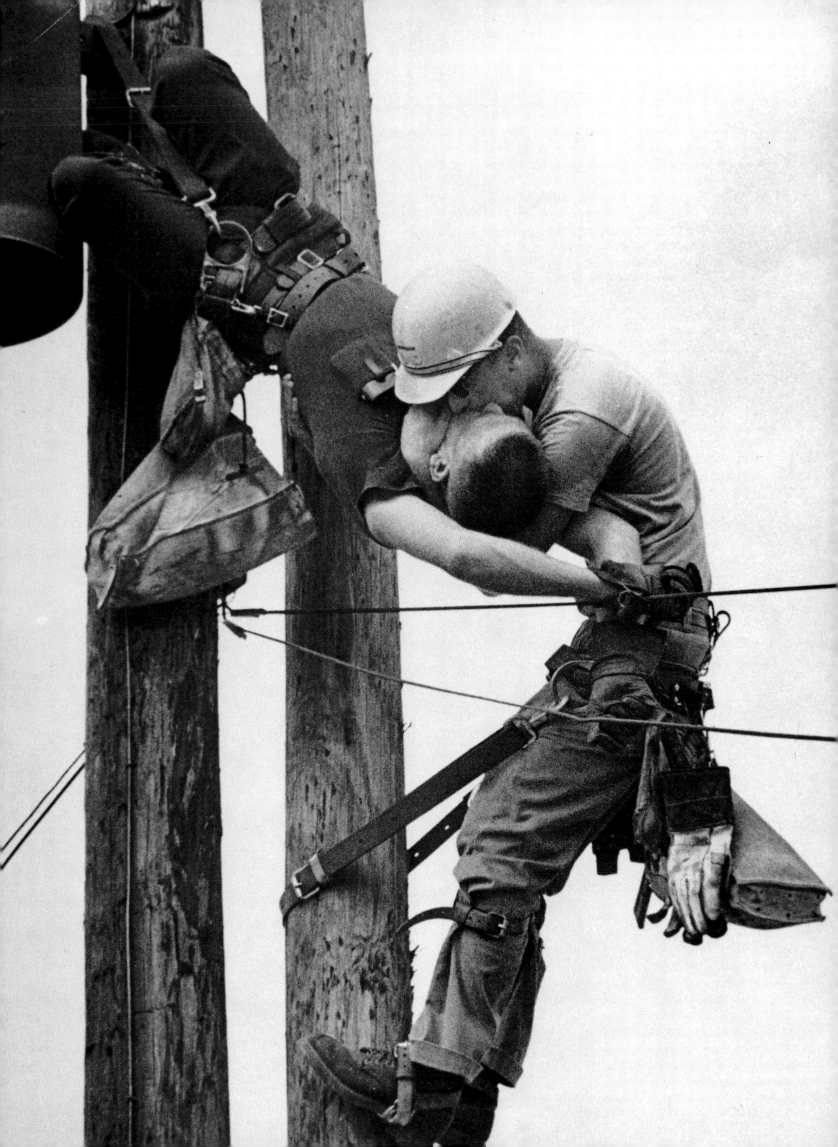

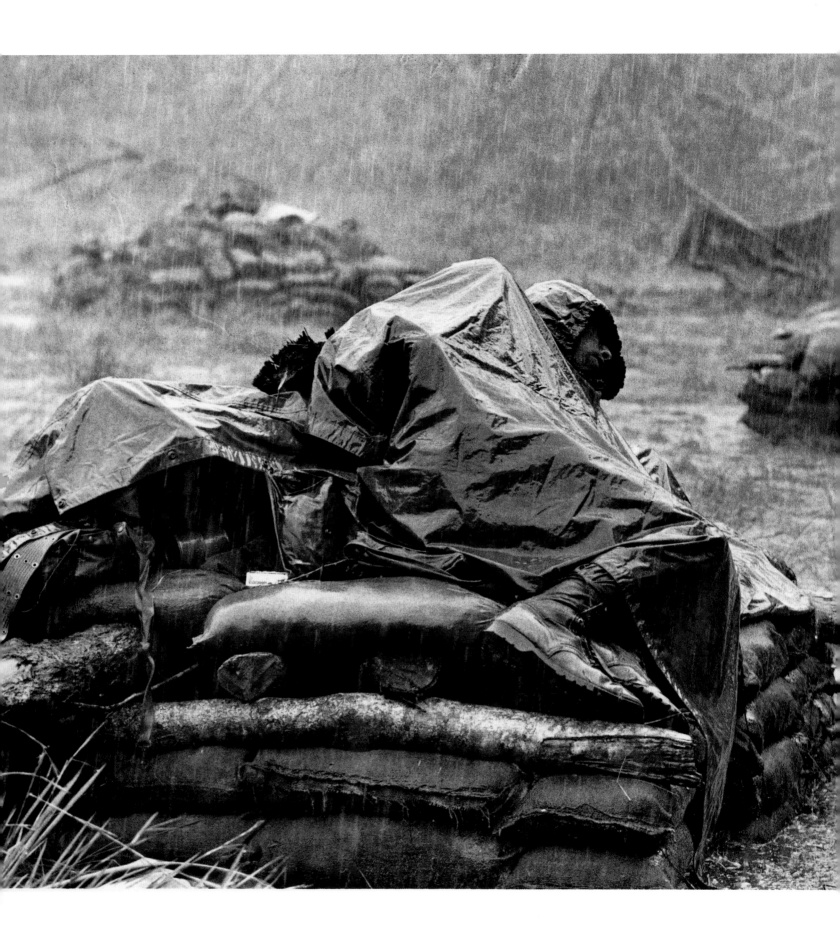

'A commotion...then all became silent'

Being a soldier in Vietnam meant trudging through unfamiliar countryside, knowing the next moment could mean obliteration by a booby trap or a mine. It meant numbing boredom, followed by terrifying struggle.

On June 17, 1967, Japanese photojournalist Toshio Sakai crouches with the men of B Company, about 40 miles northeast of Saigon. They are dug in behind sandbags and mud banks, surrounded by deep jungle. It is Sakai's first tour of Vietnam: "There was a commotion in the forest, then all became silent. Birds stopped chirping and insects quieted. My heart was beating fast. A tense atmosphere filled the air."

Suddenly, shells explode overhead. AK-47s crackle. It's a Viet Cong attack. The Americans return the fire. The jungle explodes with bullets. But in the midst of battle, the heavens open up. The downpour is so intense it forces both sides to stop shooting. Minutes pass, then hours. The soldiers hunker down.

Despite the miserable wet, Sakai remembers it as a moment of peace: "I saw a black soldier lying on the bunker and taking a nap. Behind him, I saw another white soldier holding an M-16 rifle, crouching and watching. The sleeping soldier must have dreamt of better times in his homeland. I quietly released the shutter."

1968 Feature

VIETNAM—
DREAMS OF BETTER
TIMES

Toshio Sakai

June 17, 1967, Phuoc Vinh,
South Vietnam

United Press International

Nikon F, 105 mm F2.8 lens, Kodak
Tri-X 400 ASA film

Courtesy of Corbis

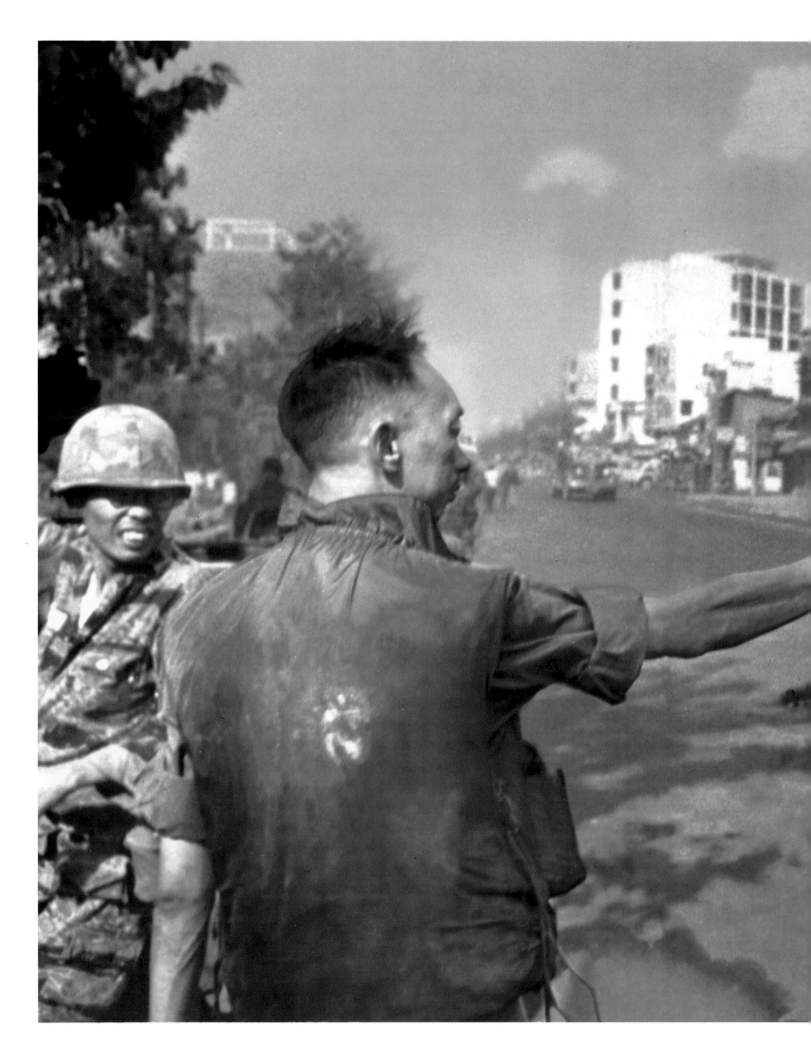

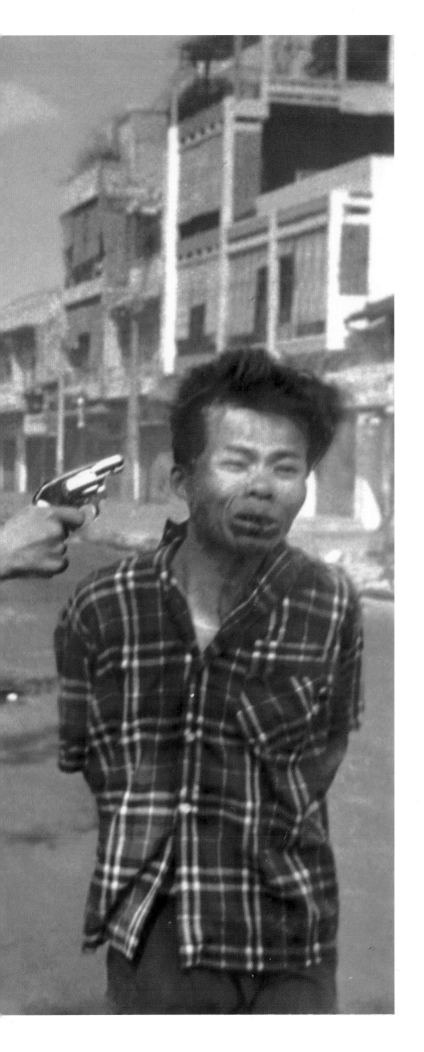

'Out of nowhere came this guy'

Jan. 30, 1968. North Vietnamese communists launch their massive Tet offensive, bringing the fighting right into the U.S. Embassy compound in Saigon. Thirty-six hours later, Associated Press photographer Eddie Adams, working with an NBC News crew, comes upon two South Vietnamese soldiers escorting a prisoner through the streets of Saigon.

"They walked him down to the street corner. We were taking pictures. He turned out to be a Viet Cong lieutenant. And out of nowhere came this guy who we didn't know. I was about five feet away and he pulled out his pistol."

The man with the pistol is Gen. Nguyen Ngoc Loan, chief of South Vietnam's national police. It all happens very fast: The general raises his pistol. Adams raises his camera. Loan presses his pistol against the prisoner's temple. He fires. Adams releases the shutter.

Loan "shot him in the head and walked away," Adams remembers. "And walked by us and said, 'They killed many of my men and many of our people.'" For Loan, the shooting is an act of justice: The Viet Cong lieutenant had just murdered a South Vietnamese colonel, his wife and their six children.

The American anti-war movement adopts the photograph as a symbol of the excesses of the war. But Adams feels his picture is misunderstood. "If you're this man, this general, and you just caught this guy after he killed some of your people.... How do you know you wouldn't have pulled that trigger yourself? You have to put yourself in that situation.... It's a war."

1969 Spot News
VIET CONG EXECUTION
Edward T. Adams

February 1, 1968, Saigon, South Vietnam

The Associated Press

Nikon, 35 mm lens, Kodak Tri-X film

Courtesy of The Associated Press

'I would have been off crying'

Moneta Sleet is there in 1955 when Martin Luther King Jr., organizes the Montgomery, Ala., bus boycott. He is there in 1964 when King wins the Nobel Peace Prize. He is there in 1965 when King leads the march from Selma to Montgomery. And he is there on April 9, 1968, when the nation mourns the great civil rights leader at the Ebenezer Baptist Church in Atlanta.

It has been just five days since a sniper's bullet killed the civil rights leader. Coretta Scott King has discovered that the pool of journalists covering her husband's funeral does not include a black photographer. She sends word: If Moneta Sleet is not allowed into the church, there will be no photographers.

Sleet takes a prime position, close to the family. "I looked over and saw Mrs. King consoling her daughter. I was photographing the child as she was fidgeting on her mama's lap. Professionally I was doing what I had been trained to do, and I was glad of that because I was very involved emotionally. If I hadn't been there working, I would have been off crying like everybody else."

1969 Feature
DEEP SORROW
Moneta Sleet, Jr.

April 9, 1968, Atlanta, Georgia

EBONY Magazine

Nikon, 35 mm lens, Kodak Tri-X film

Courtesy of Johnson Publishing Company, Inc.

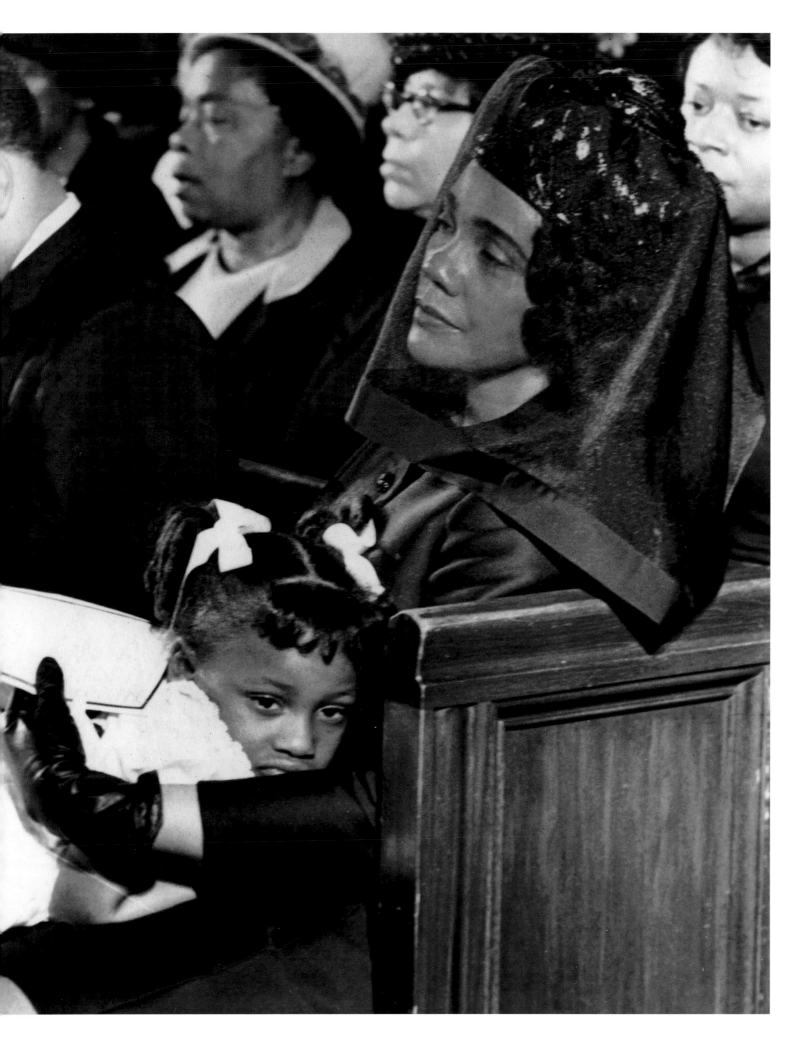

'One of the most positive women I've ever met'

Palm Beach, Fla.: glittering beaches, chic boutiques, celebrity sightings. As a photographer for *The Palm Beach Post*, Dallas Kinney has photographed much of the town's dazzling atmosphere. So he is stunned to discover "The Glades," an agricultural region just half an hour away, where migrant workers labor all day in the fields.

"It's called 'stoop labor.' I was an Iowa farm boy and I knew how much work these people were putting into it. I was unbelievably impressed." The workers follow the harvest down the East Coast each year, working winters in Florida. In 1969, determined to document their lives, Kinney and reporter Kent Pollack pitch the story to their editors — over lunch. "We drove them out into the middle of the migrant camp and gave them a bologna sandwich; we didn't have to say much after that."

Kinney photographs the workers in the fields and at home. "They opened their doors to me. I didn't desire to say 'pity the poor,' but rather to show the strength of people who, through great adversity, were dedicated beyond belief."

Emblematic of that strength is Lilie Mae, who has worked in the fields all her life. She lives in a small cubicle, no more than 8 feet square. No electricity, one small window, no running water. "Yet she was one of the most positive women I'd ever met," says Kinney. "Strong in her religion. A woman of great character and integrity and vision."

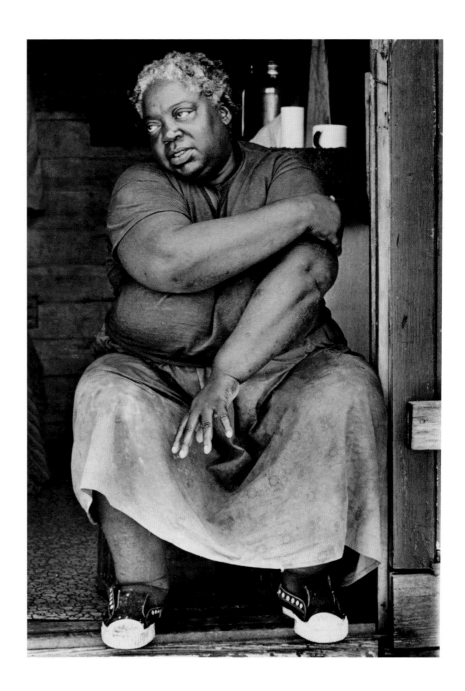

1970 Feature
MIGRATION TO MISERY
Dallas Kinney

1969, Palm Beach, Florida
The Palm Beach Post

Nikon & Leica, 35 mm and 85 mm lenses, Kodak Tri-X film

Courtesy of Dallas Kinney/*The Palm Beach Post*

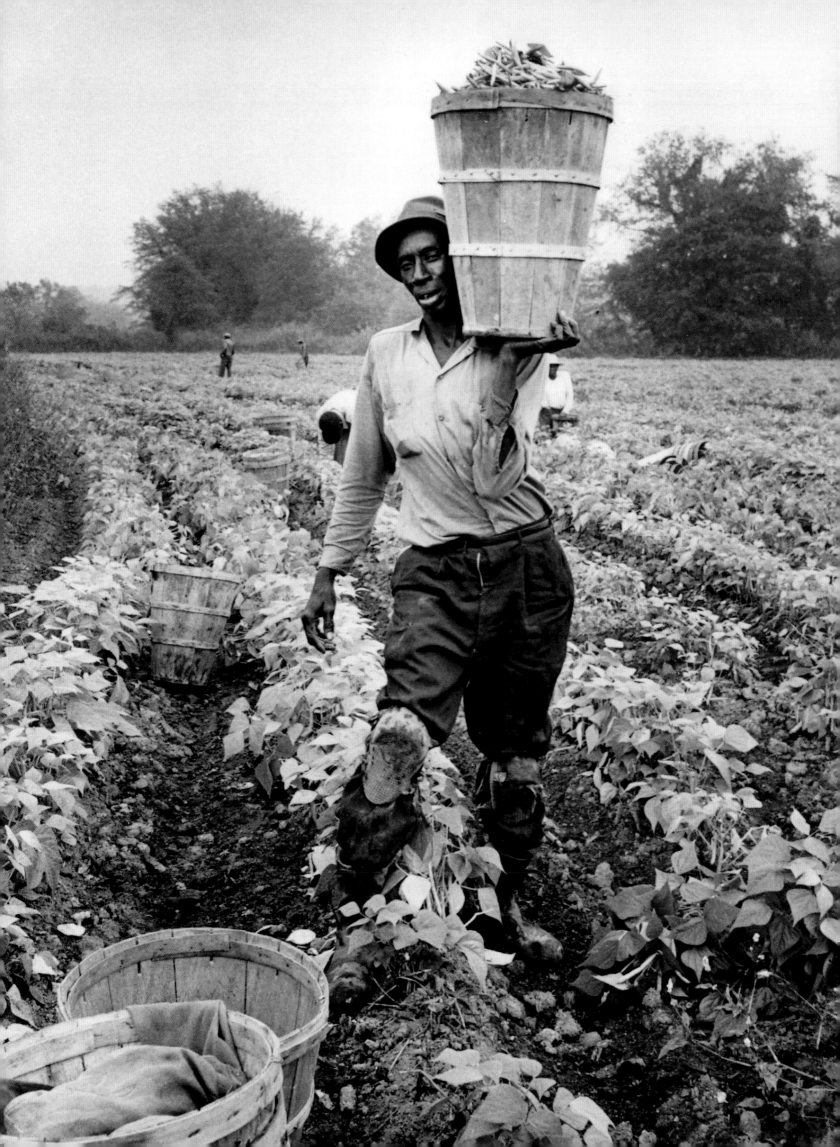

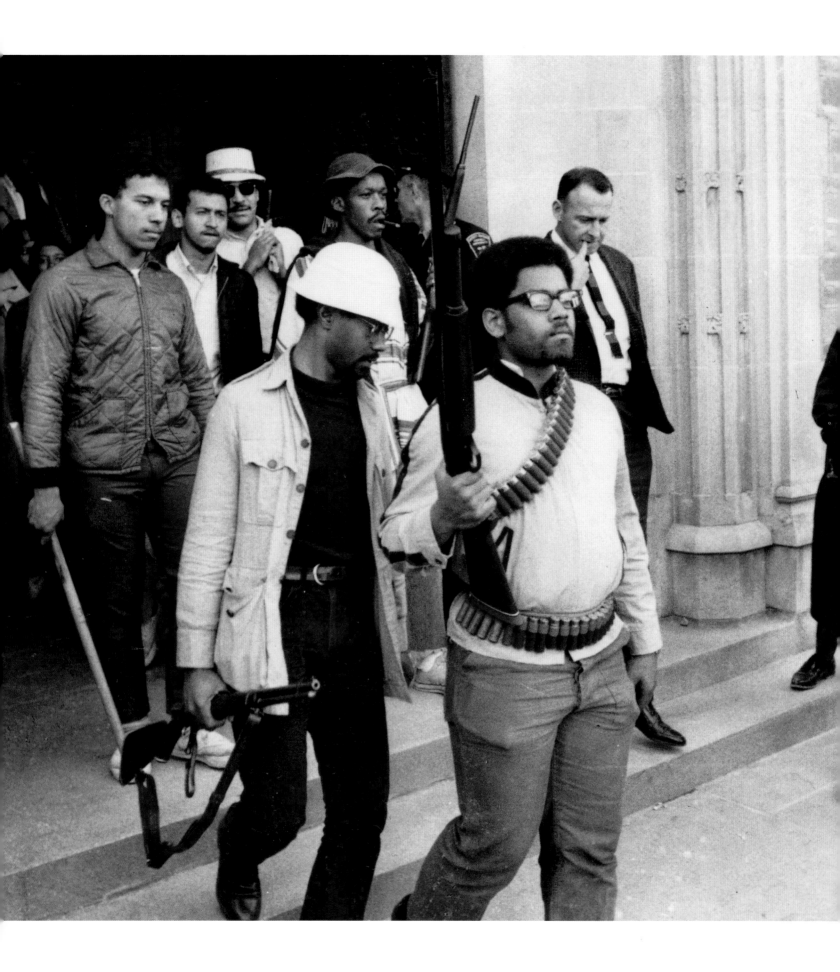

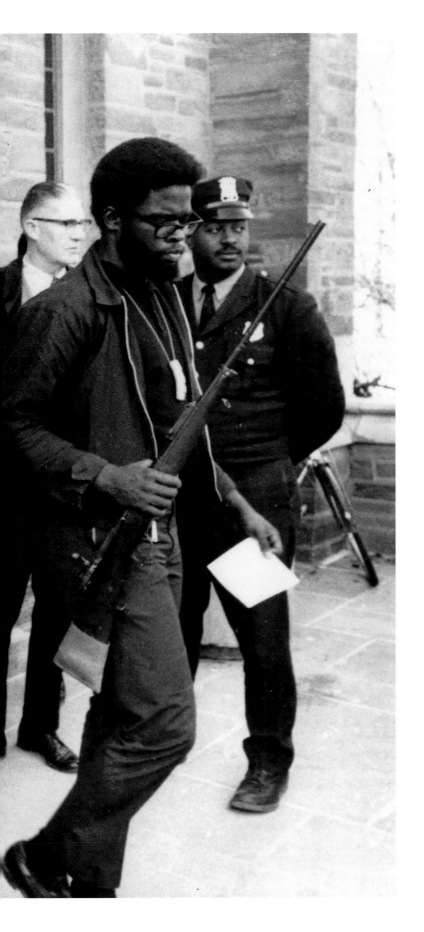

'The door opened and I felt a cold chill'

It's Parents' Weekend at Cornell University. Two thousand enthusiastic visitors crowd the campus. Thirty of them are fast asleep in Cornell's student union early on the morning of April 19, when they are roused by shouts of "Fire!" The flames are only rhetorical: A group of black students is seizing the building. Within minutes, the parents are outside and the militants are inside, refusing to leave.

Their demands are concrete: A separate college at Cornell run entirely by African-Americans. Amnesty for three black students threatened with suspension. A protest against the burning of a cross in front of the black women's dormitory.

In Albany, 250 miles away, Associated Press photographer Steven Starr hears the story. He arrives on campus in time to spot a student who appears briefly at a window, brandishing a rifle.

"I knew then that we were on top of a much bigger story," Starr remembers. But he does not have his camera ready. "I was sick that I had missed the one shot. I got out a long lens, trained it on the window and waited."

The pressure mounts. Finally, university president James Perkins decides he must give in to the militants' demands for amnesty. Thirty-four hours have passed. Starr is still there. "The door opened and I felt a cold chill. I made my pictures by instinct."

1970 Spot News

RACIAL PROTEST AT CORNELL UNIVERSITY
Steve Starr

April 20, 1969, Ithaca, New York
The Associated Press
Nikon F 28 mm F2.8 lens, Kodak Tri-X film
Courtesy of The Associated Press

'A girl…let out a God-awful scream'

Spring 1970. Student activists tear up campuses across America. Things are quiet at Ohio's Kent State University—until police break up a rowdy beer bash. Twenty-four hours later, 800 students demonstrate on the university commons. Someone throws a lighted railroad flare into the ROTC building. Firefighters arrive. Students hurl rocks and cut hoses. The building burns to the ground.

When photojournalism student John Filo shows up for classes on Monday morning, there are 500 National Guard troops on campus. Disappointed that he missed the weekend action, Filo grabs his camera and heads for a student demonstration scheduled on the commons.

The campus bell rings. The rally begins. Soon, National Guardsmen appear and order the demonstrators to disperse. Students shout "Pigs off campus!" They throw rocks. The Guardsmen form two lines and fire tear gas canisters into the crowd. The students throw more rocks. The Guardsmen retreat up a hill. At the top, the troopers suddenly kneel, aim and fire.

Filo thinks they are shooting blanks. Then he sees a bullet hit a metal sculpture and smack into a tree. Around him, students fall to the ground. A boy lies in a puddle of blood. "A girl came up and knelt over the body and let out a God-awful scream. That made me click the camera."

Thirteen students are injured. Four die. Eight troopers are eventually indicted in the killings. No one is ever convicted.

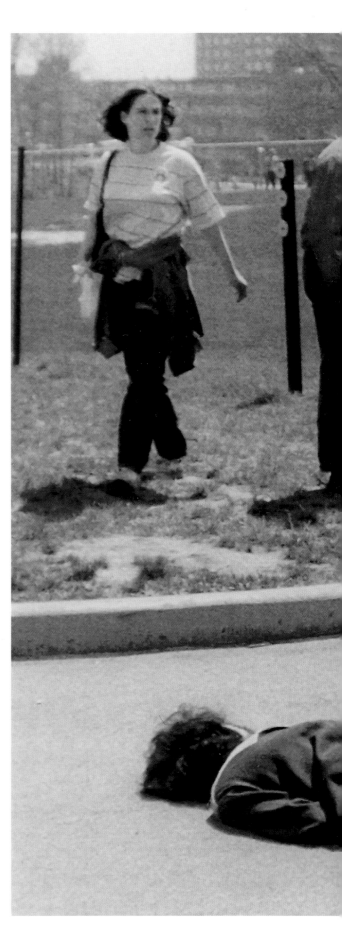

1971 Spot News
KENT STATE
MASSACRE
John Paul Filo

May 4, 1970, Kent State University, Ohio

Valley Daily News & Daily Dispatch

Nikkormat, Nikkor 43 mm–86 mm zoom lens, Kodak Tri-X film

Courtesy of John Paul Filo

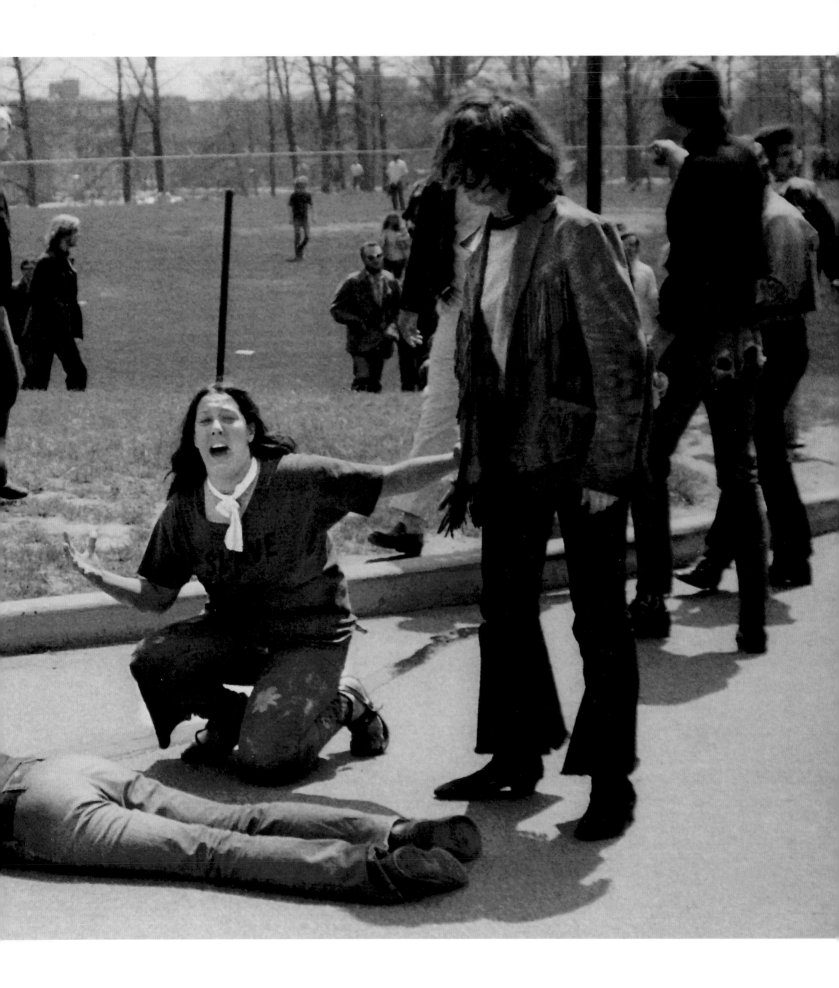

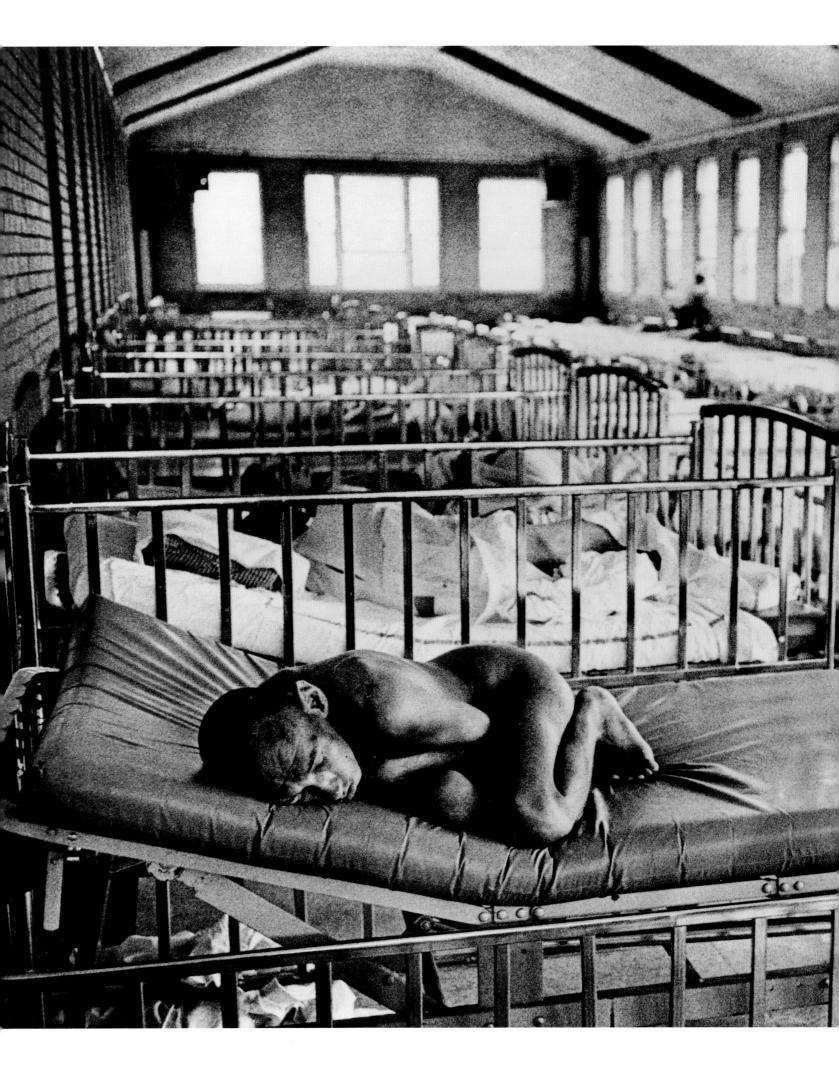

'Afterwards, the dreams and nightmares'

"It's a shock to your system; you can't even shoot pictures at first, you're just trying to breathe." In 1970, Jack Dykinga and two reporters from the *Chicago Sun-Times* spend four days inside the Lincoln and Dixon state schools for the retarded. Their purpose: to show what life is like in an institution where chronic under-funding has created horrific conditions for the patients. School officials cooperated. "They were very forthright," says Dykinga. "They were doing what they could, but they didn't have any money. They wanted to put pressure on the governor."

Dykinga finds wards packed with retarded children and adults, supervised by a tiny staff—at times just one aide for more than 100 patients. Some patients are sedated into a stupor. Others are tied to chairs. Many roam in loneliness and despair. "It's just overload, complete overload. You're never prepared. Because, for one thing, you're not accustomed to seeing young men running around naked with human feces all over themselves." Shooting photographs in such a situation, says Dykinga, "is instinctive. You're on cruise control. Afterwards, you have the dreams and nightmares. I can still smell how it smells."

Dykinga spots a man, naked, legs drawn up, arms crossed. "When I was photographing him what went on in my mind was how people are kind of pulled into themselves. They are hanging onto whatever they can."

1971 Feature
ILLINOIS STATE SCHOOLS FOR THE RETARDED
Jack Dykinga

July 26–29, 1970, Illinois

Chicago Sun-Times

Nikon, Nikkor 85 mm lens, Kodak Tri-X film

Courtesy of *Chicago Sun-Times*

'It's better to stay...
than to run away'

On March 25, 1971, East Pakistan declares itself the independent nation of Bangladesh. On Dec. 18, after a bloody war, Bangladesh is free.

Horst Faas and Michel Laurent cover the victory rally for The Associated Press. Faas spends the day in the streets of Dacca, photographing "massacres and bodies and uncovered mass graves." Then he heads for the racetrack, where he finds the leaders of the new nation exhorting an enthusiastic crowd. Suddenly, a group of guerrillas appears, leading prisoners. With burning cigarettes, they torture the prisoners for the crowd. One of the leaders comes down from the dais. "It was like a ballet," Faas says. "He took a bayonet from one of the soldiers and stabbed a prisoner. This was a signal for other soldiers to do this, but slowly."

The bayoneting continues. Faas and Laurent sweat and shake, trying to stay focused and take pictures. "These people didn't die; they were still moving about and crawling about. It went on for an endless time." Finally, "the crowd pressed forward and trampled over these bodies. Somebody said something; the crowd turned on us. I don't think I've ever gotten away so fast."

For Faas, the experience is horrible—and inevitable. "You feel bad about having to do that. But the purpose is to go there and get the picture. The conviction is that it's better to stay and take the photographs than to run away."

The photographers survive the wrath of the angry crowd. Four years later, Michel Laurent is killed while working in Vietnam—the last Western journalist to die during the war.

1972 Spot News
TORTURE IN DACCA
Horst Faas and
Michel Laurent

December 18, 1971, Dacca, Bangladesh
The Associated Press
Leica M2, 35 mm lens, Kodak film
Courtesy of The Associated Press

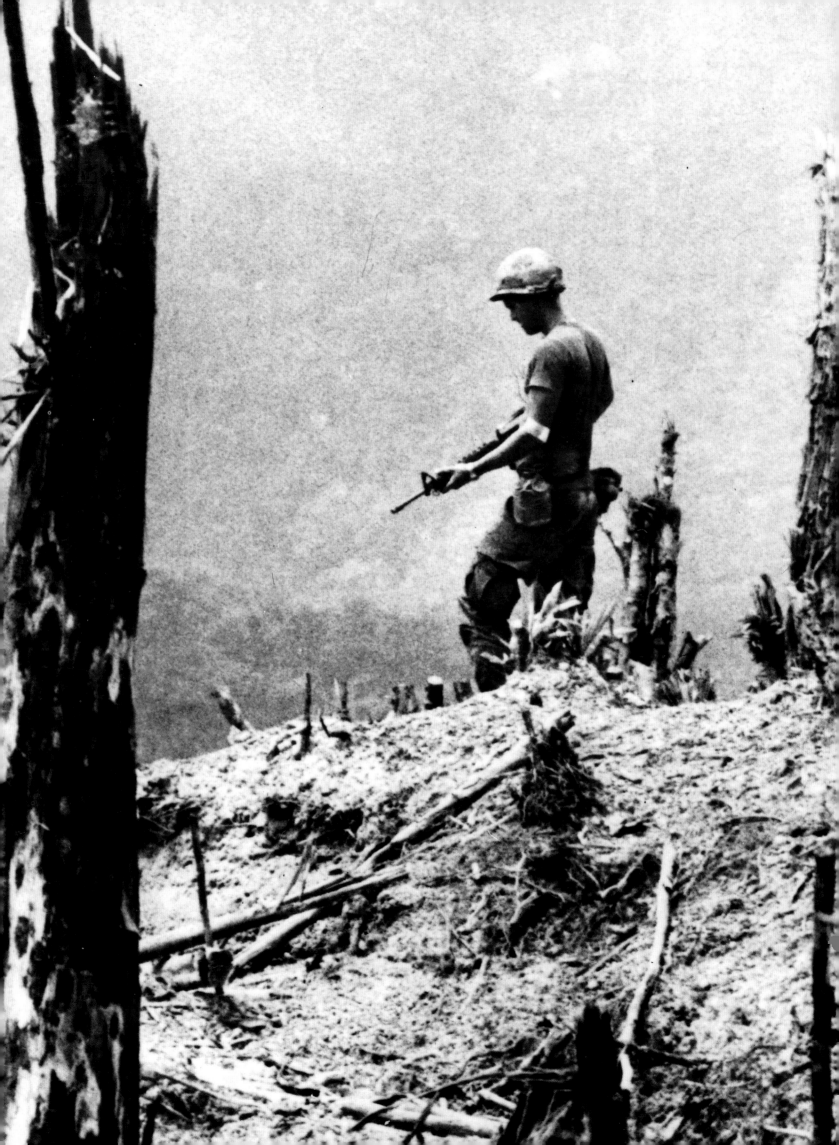

'The loneliness and desolation of war'

In 1971, photographer David Hume Kennerly wants to go to Vietnam. But United Press International resists sending a White House pool photographer into a war zone. Kennerly prevails, despite admonitions that "all the Vietnam pictures have been taken." They haven't been. In his two and a half years in Indochina, Kennerly photographs something beyond battles and bombings.

"I took a lot of pictures of bodies and people dying," he says. "But I think the feature side . . . those are some of the best." One photograph in particular captures the barren devastation of the war. "I was up in an area where there had been a lot of fighting and the fighting had subsided. I was on another hill and I saw that soldier walking. To me, that was more the war I saw, in terms of the day-to-day scene. It captured the loneliness and desolation of war."

Kennerly's Pulitzer portfolio shows the range of human experience: soldiers in Vietnam, a Cambodian child riding a water buffalo, refugees coming out of East Pakistan into India. "It was a year in pictures."

1972 Feature

VIETNAM—
LONE U.S. SOLDIER

David Hume Kennerly

April 27, 1971, A Shau Valley,
South Vietnam

United Press International

Nikon F, Nikkor 85 mm F1.8 lens,
Kodak Tri-X film

Courtesy of Corbis

'Too hot, please help me'

It falls from the sky, a thick, caustic gel, sticking to anything it touches — thatched roofs, bare skin — then burning, burning. Napalm: Everyone who is in Vietnam during the war sees it. For Nick Ut, a young Vietnamese photographer working for The Associated Press, the experience is life-altering.

Ut has lost his older brother to the war. He himself has been wounded three times. On June 8, 1972, he sets out to cover a battle raging near Trang Bang, 25 miles west of Saigon. "Really heavy fighting," he says. "I shot Vietnamese bombing all morning, the rockets and mortar." Determined to eliminate an entrenched Viet Cong unit, South Vietnamese planes dive low, dropping napalm. But one plane misses. Fire rains down on South Vietnamese soldiers and civilians. Women and children run screaming. A mother carries a badly burned child. "The one mother with the baby, she died right in my camera. I hear four or five children screaming, 'Please help! Please help!'"

As Ut furiously snaps photographs, a young girl runs toward him — arms outstretched, eyes clenched in pain, clothes burned off by napalm. "She said, 'Too hot, please help me.' I say 'yes,' and take her to the hospital."

The girl, Phan Thi Kim Phuc, survives. She grows up, gets married. Through the years, she and Ut stay in touch, brought together by a moment of tragedy.

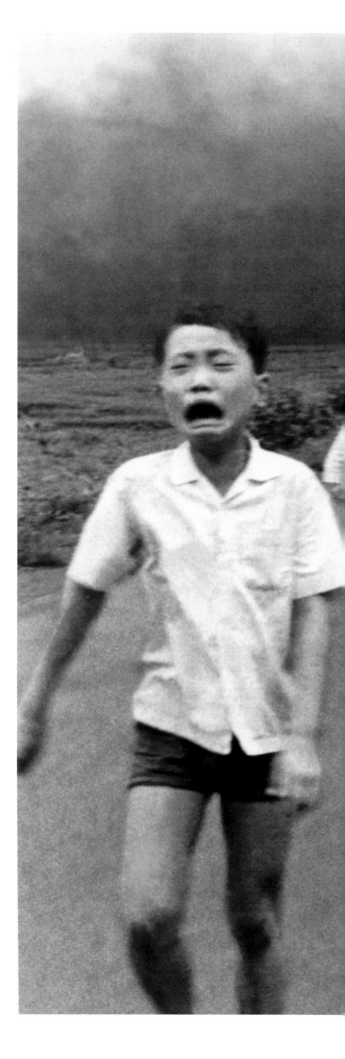

1973 Spot News

VIETNAM—
TERROR OF WAR

Huynh Cong Ut

June 8, 1972, Trang Bang, South Vietnam

The Associated Press

Leica M2, 50 mm lens, Kodak Tri-X 400 ASA film

Courtesy of The Associated Press

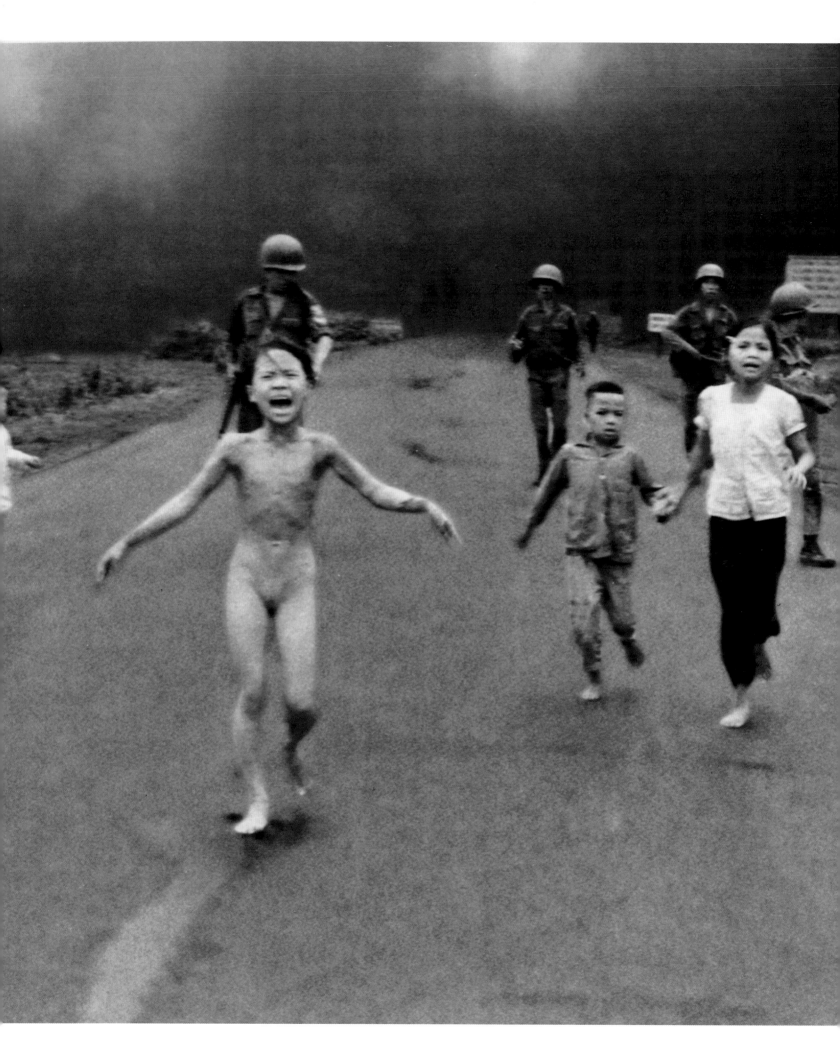

1973 Feature
MOMENT OF LIFE
Brian Lanker

January 27, 1972, Topeka, Kansas
Topeka Capital-Journal
Nikon, 24 mm lens, Kodak Tri-X film
Courtesy of Brian Lanker

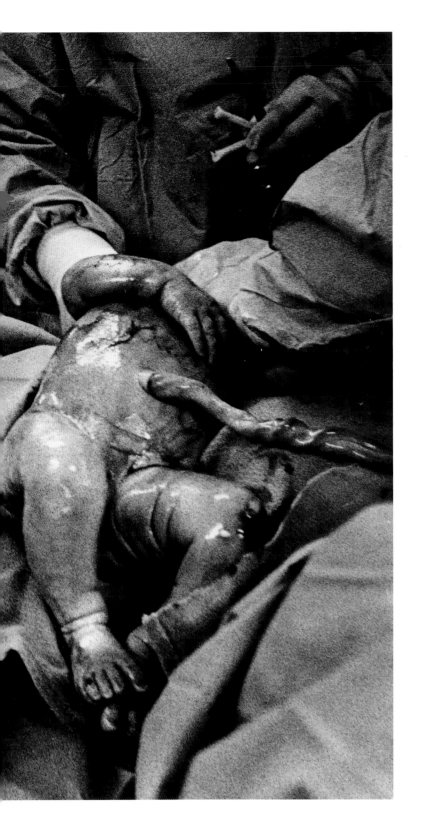

'Caught up with the moment and the emotion'

Brian Lanker is a young, unmarried photographer at the *Topeka* (Kan.) *Capital-Journal* when he decides to do a feature about the Lamaze method of childbirth. It takes him six months to find a couple willing to be photographed.

Jan. 27, 1972. Lanker is in the delivery room with Lynda and Jerry Coburn as they labor toward the birth of their first child. Lynda does her Lamaze breathing; Jerry lends support; Lanker takes photographs.

"During early labor," he says, "it was obvious to them that I was there. But later on, you have a bunch of doctors and nurses and I was able to blend in. When you're delivering a child, the mother could care less who else is in the room."

As the labor intensifies, Lanker becomes completely involved in what is going on. "It was almost a sixth sense. I was so taken and moved by the whole experience. You're so caught up with the moment and the emotion — fortunately, your professionalism and artistry take over and allow you to do the work while you're experiencing this incredible moment."

Finally, the baby — Jacki Lynn Coburn — makes her appearance. Lanker's camera captures the moment: the baby, just born, taking her first breaths; the father's look; the mother's smile.

'What's going on?
Put the knife down'

On Nov. 23, 1973, freelance photographer Anthony Roberts is eating lunch in his van in a Hollywood parking lot. He hears screams and shouts. Racing to investigate, he finds a man crouched on the ground, holding a knife against a young woman's throat.

The young woman, Ellen Sheldon, was about to leave the parking lot when the attacker, Ed Fisher, jumped into her car with a knife. "She panicked, jumped out of the car and started screaming," says Roberts. "He jumped out after her and pushed her down on the ground."

Roberts runs over and says, " 'What's going on? Put the knife down.' He was a madman, saying to her 'I'm going to kill you.'" A security guard runs up and aims his gun at Fisher's head.

"I thought the police would show up any moment," says Roberts. Leaving the security guard covering Fisher, the photographer sprints back to his van and grabs his camera. "I figured I'd document it, take a few photographs." But the police do not arrive.

"He said, 'That's it,' and moved to stab her. That's when the security guard shot." Fisher falls to the ground, mortally wounded. Ellen Sheldon escapes with minor injuries.

1974 Spot News
HOLLYWOOD
FATALITY
Anthony K. Roberts

November 23, 1973,
Hollywood, California

The Associated Press

Nikon F, 105 mm lens, Kodak
film

Courtesy of The Associated Press

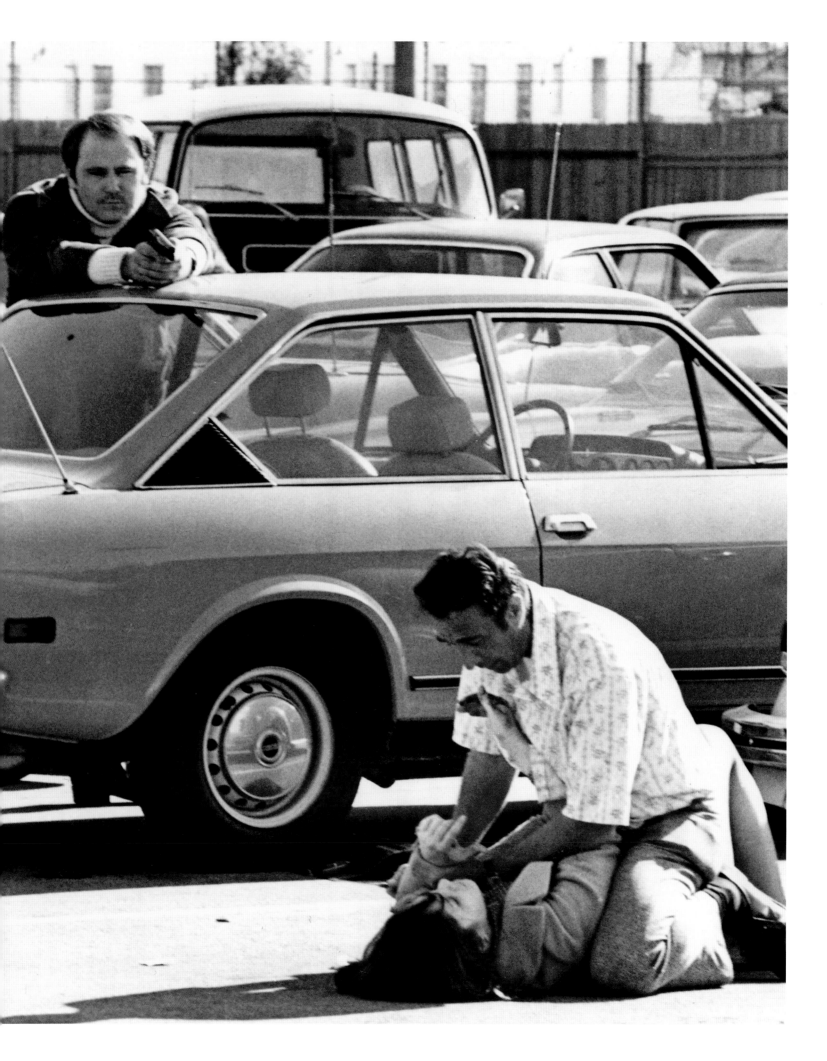

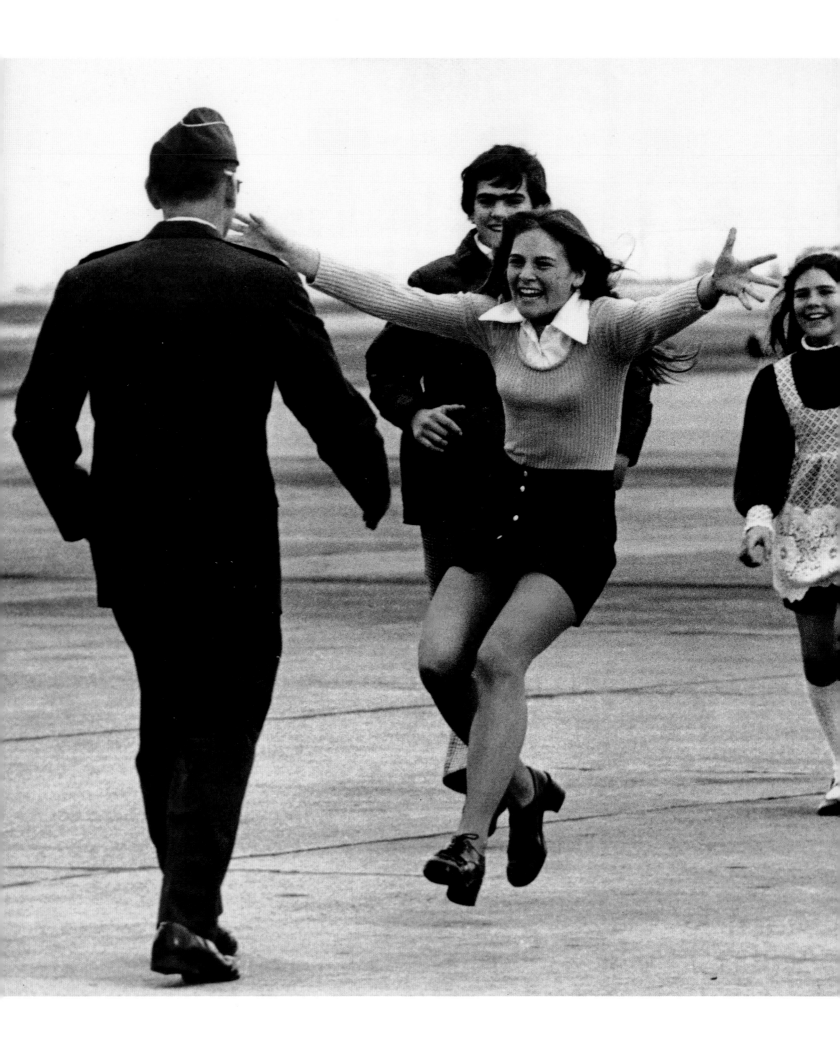

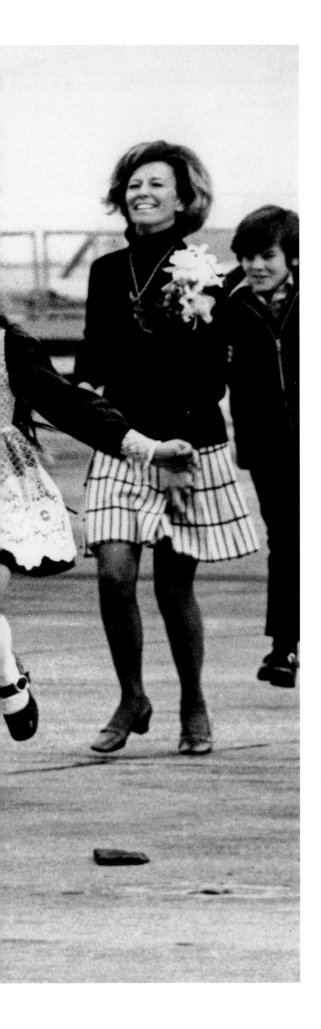

'Motion...that's what caught my eye'

"The day was overcast, no shadows. The light was beautiful." It's March 17, 1973, a perfect California day. Associated Press photographer Sal Veder waits on the tarmac at Travis Air Force Base. Around him, a crowd seethes with excitement: Families are about to be reunited with long-absent fathers, husbands, uncles and brothers—American prisoners of war just released from captivity in North Vietnam.

One of those POWs is Col. Robert L. Stirm of the U.S. Air Force. Stirm was shot down over Hanoi and badly wounded. His family has waited almost six years, not knowing whether they would see him again.

A giant C-141 taxis toward the crowd. The men disembark, alert and solemn in new dress uniforms. "To see them come home brought tears to a lot of people's eyes," says Veder. "Some of the photographers were pretty well shaken up, as I was, too."

Stirm is the last man off. Briefly, he addresses the crowd. "Thank you for this enthusiastic reception.... God bless you and God bless America."

As Stirm finishes speaking, Veder notices: "There was motion. The family had started to run toward him, and that's what caught my eye." Veder raises his camera, Stirm sees his children running toward him, Veder clicks the shutter: a burst of joy, captured in one frame. Stirm's son remembers: "It was just this overwhelming feeling. He finally made it back."

1974 Feature
BURST OF JOY
Slava Veder

March 17, 1973, Travis Air Force Base, California

The Associated Press

Nikon F2, 80 mm–200 mm zoom F4.5 lens, Kodak Tri-X film

Courtesy of The Associated Press

'Mr. Wilson, you are known to be tough'

"The great challenge is to communicate visually with impact what the story is about." In 1974, as a photographer for *The Washington Post*'s Sunday magazine, *Potomac,* Matthew Lewis tries to meet that challenge. He photographs the city's night life, its sporting events, its social scene, its people.

Coaxing some of the capital's busy citizens to sit for the camera is difficult. Richard Nixon's press secretary, Ron Ziegler, gives Lewis 20 seconds. The photographer fires off just five frames. Then there is John J. Wilson, attorney for former White House chief of staff H. R. (Bob) Haldeman, described by *Potomac* reporter George Lardner Jr. as "crusty, charming, contentious, impulsive and one of the best trial lawyers in town." The *Potomac* art director wants a double-page photo of Wilson. Lewis wonders, "How in the world am I going to make a double-page layout of a person sitting behind a desk?"

The noted trial lawyer solves the problem for him. "John Wilson walks into his office, says hello, and to my astonishment, he walks behind his desk, sits down and turns sideways with a clipped manuscript in hand and looks at me. There it was! My double-page layout! The most important element is missing — his demeanor. I said, 'Mr. Wilson, you are known to be tough.' Instantly, the look was there. One click and it was captured."

"They don't say

Mean John Wilson and his law partner at the cutting

By George Lardner Jr.

Nixon: "Was he lying down? Wilson? An old-timer?"
Haldeman: "Nothing like . . ." — White House Tapes

At 73 he moves slowly about the courtroom—an aging lion thoroughly at home in his den. He glares. He filibusters. He cites cases no one else can quite remember.

He is also, in no particular order, crusty, charming, contentious, impulsive, and one of the best trial lawyers in town. He has a reputation for being an SOB. He revels in it. If the Watergate coverup trial begins (an uncertain point at press time, given President Ford's pardon fever), John J. Wilson, the attorney for former White House chief of staff H. R. (Bob) Haldeman, can be counted on to be the most outspoken advocate in the room.

It is an old-fashioned style that some say could hurt the Watergate defendants, given the damaging evidence already confronting them on the White House tapes. But Wilson has made a career of roaring in the courtroom and surprising even his colleagues with the results.

George Lardner Jr is a staff writer with the national news desk of The Washington Post.

"Isn't it funn whipping boy." knowing his bus declared. "I saic way that I posse that I'm not sma

"He's like my Watergate defen are said about hi

John Johnsto overnight, excep Washington law minded affinity.

"He's very ope attorney Harry eral years ago Workers' pensio first. But he just over that rough, He tells you wha

1975 Feature
1970s WASHINGTON LIFESTYLE
Matthew Lewis

September 19, 1974, Washington, D.C.
The Washington Post
Nikon F, Nikon lens, Kodak Tri-X film
Courtesy of Matthew Lewis / *The Washington Post*

I'm not smart."

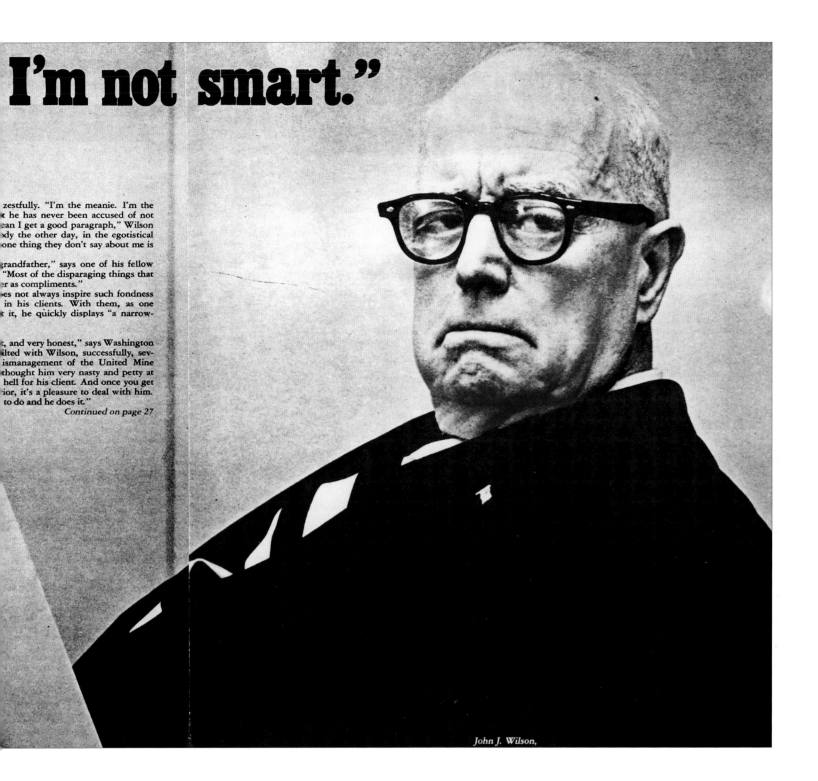

zestfully. "I'm the meanie. I'm the
⸱ he has never been accused of not
⸱ean I get a good paragraph," Wilson
⸱dy the other day, in the egotistical
⸱one thing they don't say about me is

⸱randfather," says one of his fellow
⸱ "Most of the disparaging things that
⸱r as compliments."
⸱es not always inspire such fondness
⸱ in his clients. With them, as one
⸱ it, he quickly displays "a narrow-

⸱, and very honest," says Washington
⸱lted with Wilson, successfully, sev-
⸱ismanagement of the United Mine
⸱thought him very nasty and petty at
⸱ hell for his client. And once you get
⸱ior, it's a pleasure to deal with him.
⸱ to do and he does it."

Continued on page 27

John J. Wilson,

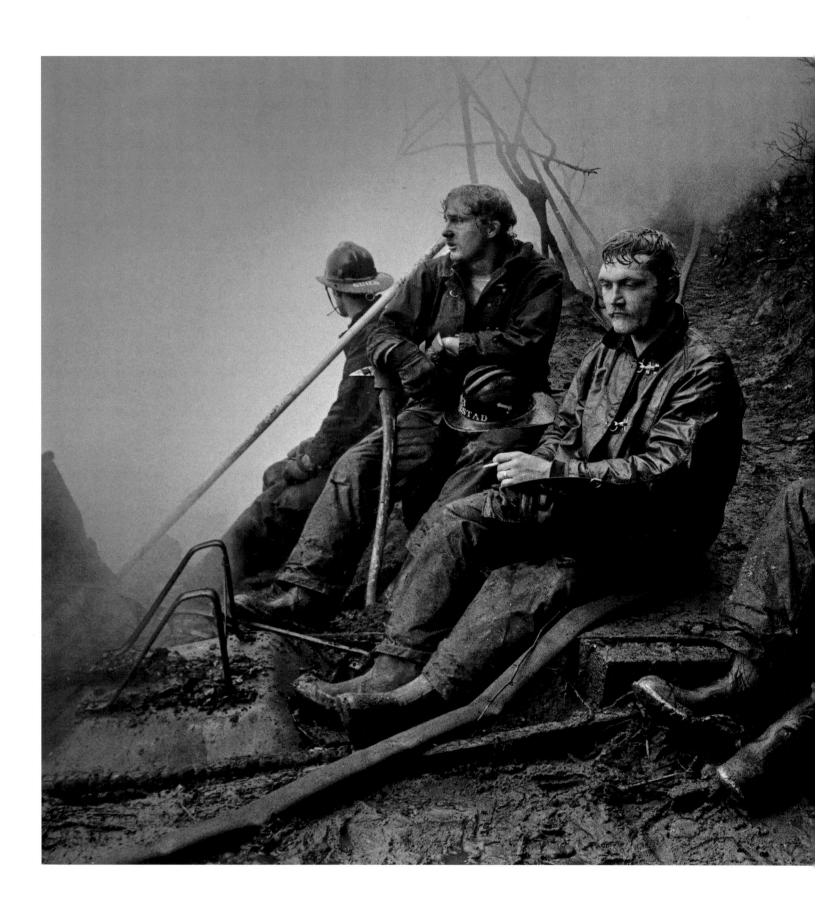

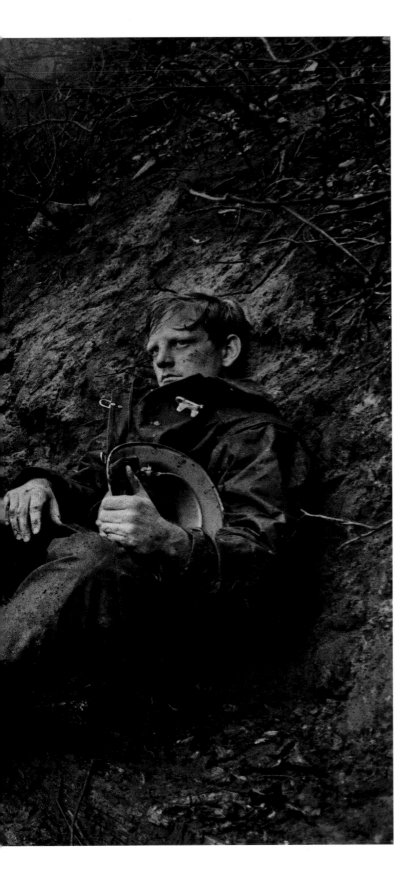

'When your mind and heart are there'

His grandfather was a firefighter, killed in the line of duty. As a young boy, he wanted to be a firefighter, too. So when Gerald Gay arrives at a Seattle fire early one morning, he is ready to follow the photographer's adage "the best pictures come when your mind and heart are there."

"I walked down this path. And there were four firemen sitting, taking a break. As I crouched and watched them, they just went back to what they were doing. All I really thought at the moment is, 'These are the firemen who fought the fire.'" The house has burned to the ground. But the firefighters are still on the job, clearing the debris.

"The background is wonderful. There's burned brush and smoke and an overturned wheelbarrow. And dejected people. I think if you're a good photographer, you're able to pull back and be nonthreatening and almost nonexistent. It's working with their energy and the lighting and somehow just trying to capture a moment. And just let people be themselves in front of you. There was one frame where the firemen turned. Each had a certain expression…which is what made the picture."

1975 Spot News
LULL IN THE BATTLE
Gerald H. Gay

October 11, 1974, Seattle, Washington
The Seattle Times
Nikon F, 28 mm lens, Kodak Tri-X film
Courtesy of Gerald H. Gay and
The Seattle Times

'Enough faith in their parents to get on the bus'

In July 1975, a federal court rules: Students in Louisville, Ky., must be bused to achieve racial integration — and an equal education for all. On Sept. 4, despite protests and riots, 90,000 students board 577 school buses and head off to new schools. Keith Williams is one of the photographers who cover the story for *The Courier-Journal*.

Remembers Williams: "There was apprehension on both sides — the students who were predominantly black being bused out to predominantly white counties, and people in predominantly white counties who didn't want to be bused into the city."

On Sept. 8, Williams boards a bus full of African-American students on their way home from their new school. "For the kids, here you are going to a neighborhood you've never gone to before. You've seen protesting and throwing rocks and you're going into that neighborhood where those protesters came from. They didn't know what was going to happen. Their parents were telling them this was for the best. They had enough faith in their parents to get on the bus."

School integration prevails. Eventually, the city and county school systems merge. Twenty-five years later, some of the finest academic programs in Louisville are available in once-maligned city schools. Students clamor to get in.

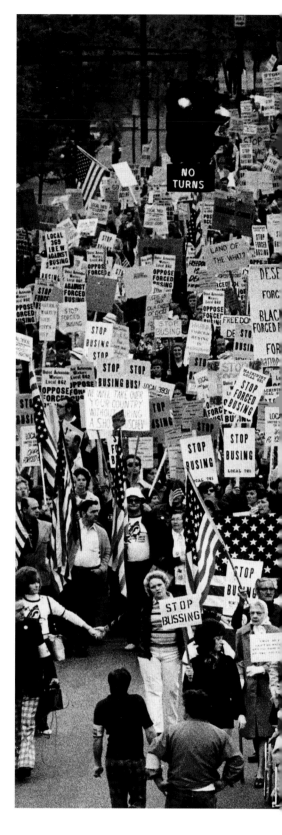

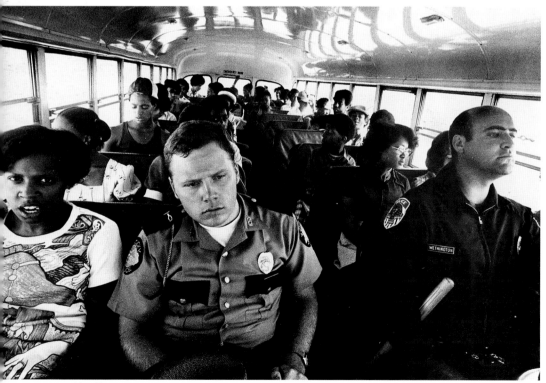

Keith Williams

1976 Feature
BUSING IN LOUISVILLE
The Courier-Journal & Louisville Times Photographic staff

September 8, 26, 1975, Louisville, Kentucky

The Courier-Journal

Nikon and Leica, Various lenses, Kodak Tri-X film

Courtesy of The Courier-Journal & Louisville Times Co.

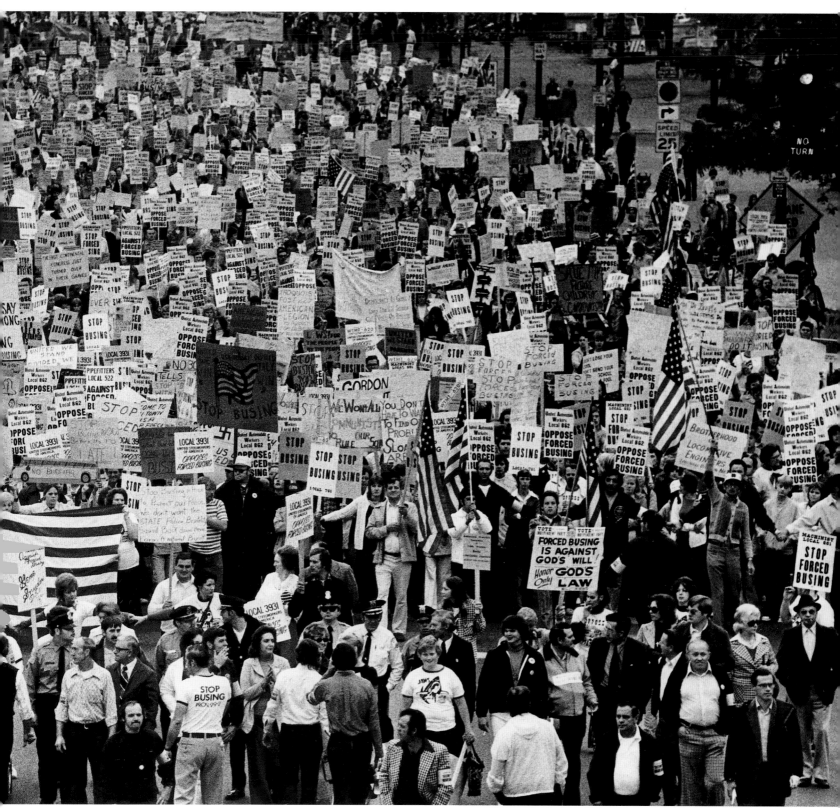

Rob Steinau

93

'I'm thinking, just keep shooting'

It's quitting time on a brutally hot day in July when *Boston Herald American* photographer Stanley Forman hears a report of a fire in Boston's Back Bay. He follows screaming fire trucks to a six-story apartment house in flames.

Forman remembers "a roaring, roaring inferno...heavy smoke. Heavy fire. It was like a firestorm."

Forman runs to the back of the building. "Then I spotted them. A woman, a child and they're standing there on the fire escape, 10 feet from the fire itself. And they're looking for help." As Forman watches, a firefighter climbs down from the roof. He pulls them away from the flames, shielding them with his heavy rubber coat. Seeking a better vantage point, Forman climbs onto a ladder truck.

"Everything was fine," says Forman. "I was just shooting a routine rescue. Switching lenses, switching cameras." A ladder rises slowly toward the fire escape. The firefighter reaches out to grab the ladder . . .

"All of a sudden, boom! It just crashes." As Forman watches, the fire escape rips away from the building. The woman is falling, the child is falling, metal is flying...

"Everything is falling and I'm thinking, 'Just keep shooting.' And I'm shooting and shooting. Then a bell went off in my head. I didn't want to see them hit." Forman turns away. When he turns back, he discovers the 19-year-old woman is dead. Her 3-year-old niece miraculously survives.

1976 Spot News
BOSTON FIRE
Stanley J. Forman

July 22, 1975, Boston, Massachusetts

Boston Herald American

Nikon ƒ/8 at 1/250 second, 135 mm lens, Kodak Tri-X film

Courtesy of Stanley J. Forman

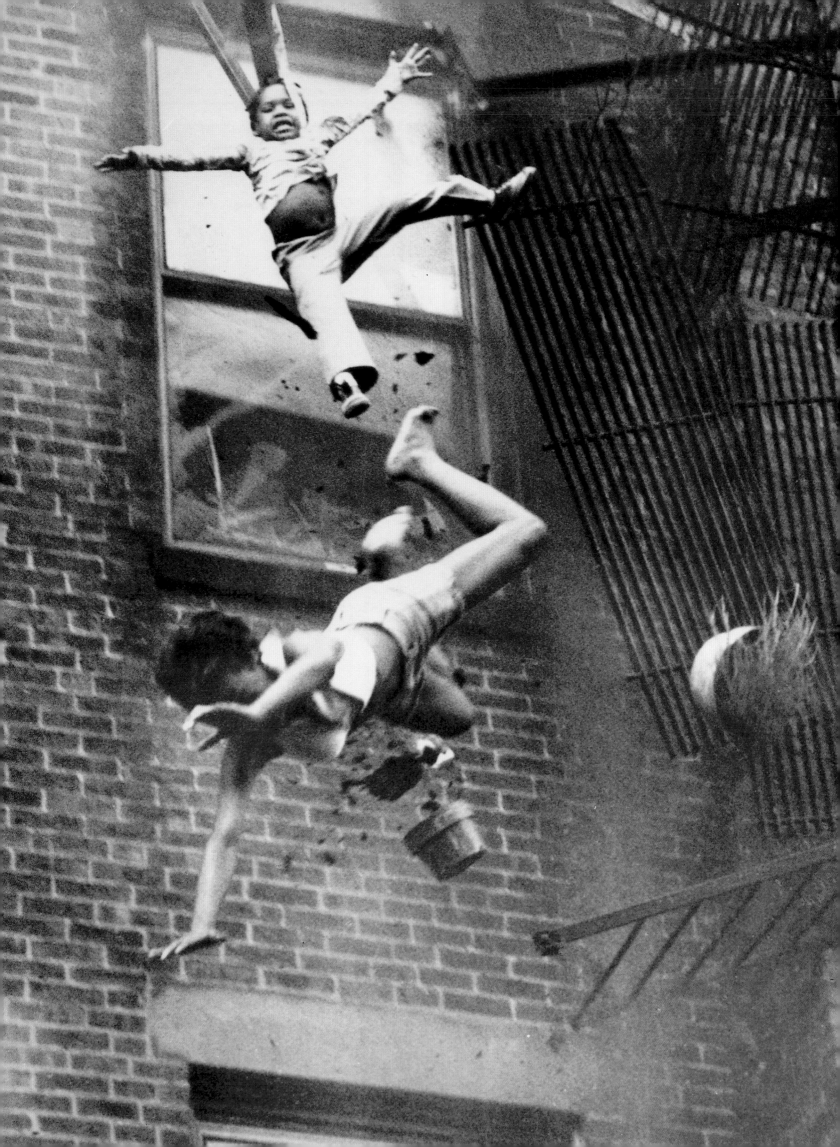

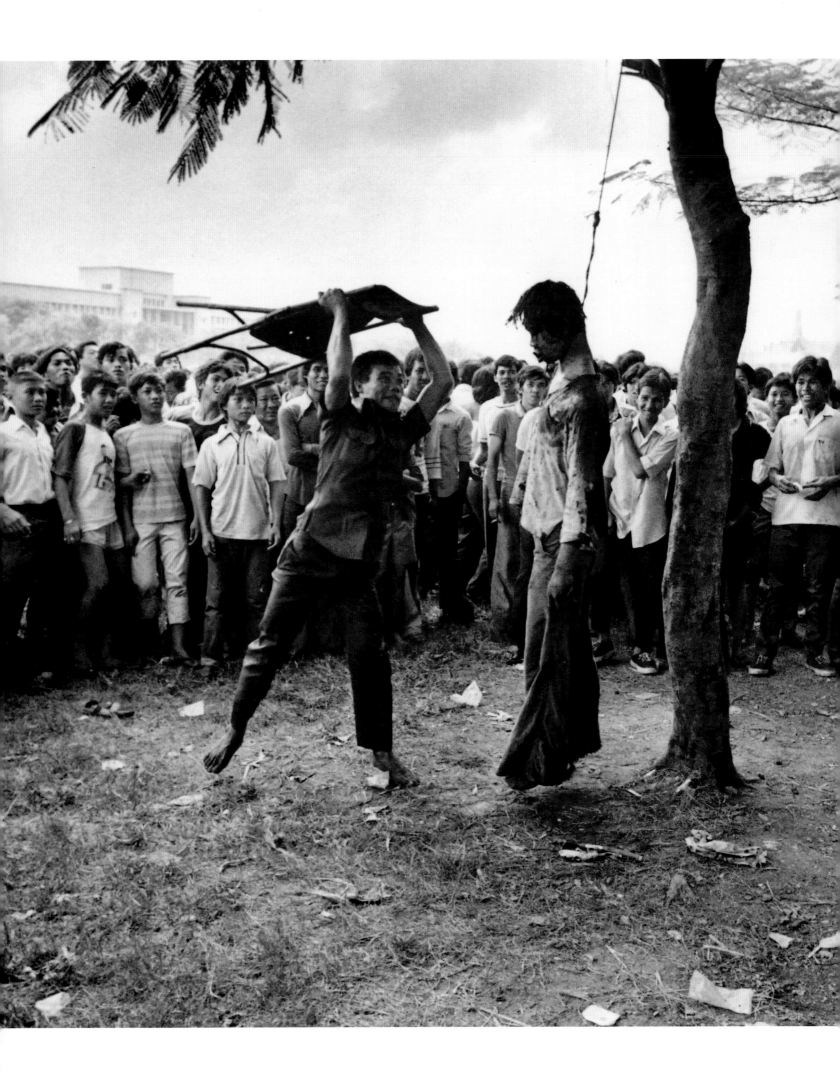

'No place to take cover'

October 1976: Thailand's third government in two years teeters on the brink, rocked by clashes between right-wing vocational students and left-wing university students. Late one night, two liberal students are lynched.

Associated Press photographer Neal Ulevich covered the Vietnam War for five years. But nothing he saw in the jungle prepared him for the morning of Oct. 6, when right-wing students attack left-wing students near the university. "When I got there, it was getting more and more violent. Paramilitary troops heavily armed with recoilless rifles showed up. The left-wing students were not armed and were not shooting back. They took refuge in the university buildings.

"Tremendous volleys of automatic weapons were fired across the soccer fields into the classrooms. There were bodies all over, glass breaking. There was no place to take cover. I was very scared."

Finally, the left-wing students surrender. Ulevich heads for the gates, anxious to get his pictures back to his office. "I saw some commotion in the trees. I walked down there and I saw a body hanging. He was certainly dead, but the crowd was so enraged that a man was hitting the body on the head with a folding chair. I stood there to see if anybody was looking at me. Nobody was. I took a few frames and walked away."

In the end, an irony: "When I won the Pulitzer, the Bangkok papers noted it on Page One. They were very proud that a photographer from Bangkok had won the Pulitzer. They didn't show the pictures."

1977 Spot News
BRUTALITY IN BANGKOK
Neal Ulevich

October 6, 1976, Bangkok, Thailand

The Associated Press

Nikkormat EL, 35 mm F2 lens, Kodak Tri-X film

Courtesy of The Associated Press

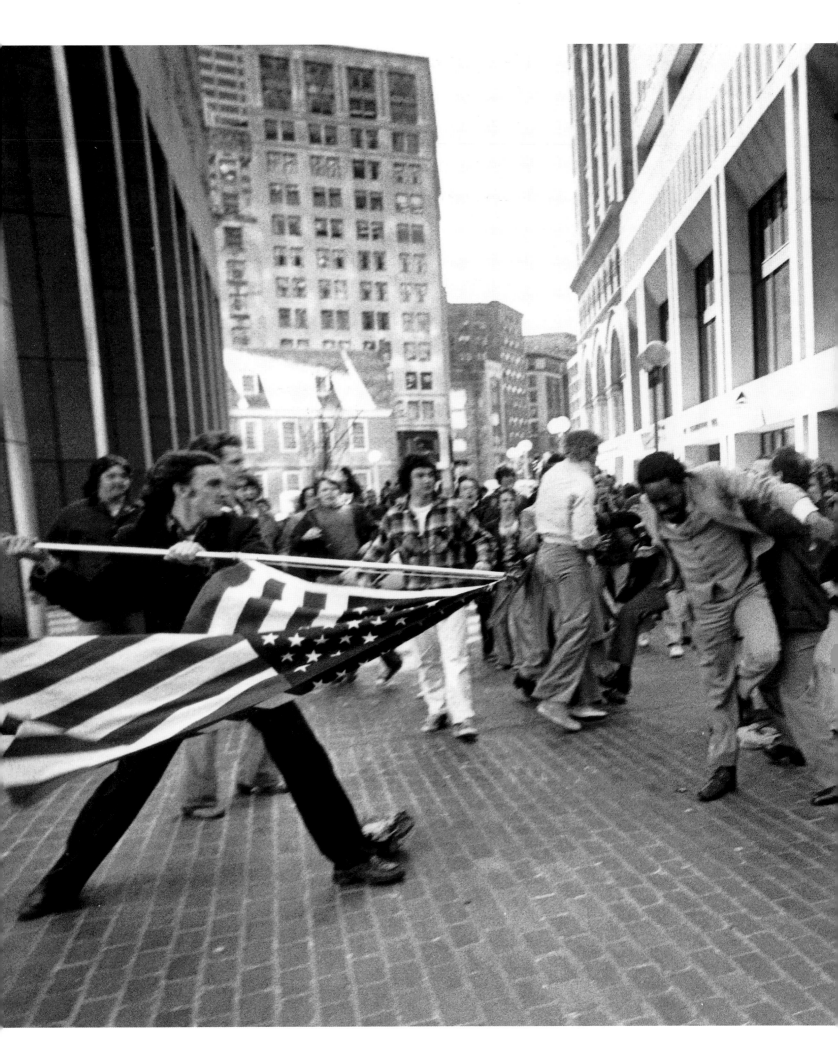

'He was being hit with the flagpole'

April 6, 1976. At Boston's City Hall, 200 white students demonstrate against plans to bus children to integrate the city's schools.

When *Boston Herald American* photographer Stanley Forman arrives to cover the rally, he finds that "everything appeared to be over. There had been a Pledge of Allegiance. Suddenly, I saw a group of youngsters. They were mixed racially. There was some pushing and shoving."

Forman spots Theodore Landsmark, executive director of the Contractor's Association of Boston, heading toward City Hall. Landsmark is black; the students are white. Suddenly, "everything started to happen in front of me." The white students attack Landsmark, punching and kicking him.

Through his viewfinder, Forman sees a student running with a flagpole dangling a large American flag. As others in the crowd hold Landsmark, the student strikes him repeatedly with the pole. "I was making pictures of Landsmark being hit, and I saw him going down and rolling over. He was being hit with the flagpole. I switched lenses to get him escaping from the crowd."

Police officers intervene, but not before Forman has recorded the moment that an American flag, symbol of liberty, is used as a weapon of racial hatred.

1977 Spot News

THE SOILING OF OLD GLORY

Stanley J. Forman

April 6, 1976, Boston, Massachusetts

Boston Herald American

Nikon, 20 mm lens, Kodak Tri-X film

Courtesy of Stanley J. Forman

'A supreme sacrifice for... freedom'

By the spring of 1976, the Vietnam War is over. But its effects are deeply embedded in the lives of millions. Robin Hood learned a trade in Vietnam — he went over as an Army information officer and came back as a photographer. Eddie Robinson served in Vietnam, too. But the war took something away from him: his legs.

The two veterans cross paths at the Armed Forces Day Parade in Chattanooga, Tenn., on May 15, 1976. Hood is walking along the sidelines, taking pictures for the *Chattanooga News-Free Press*. "I had just finished photographing a group of small Vietnamese children who had been relocated to Chattanooga as war refugees and were now watching the parade and waving small American flags."

Then Hood sees Robinson, in army fatigues, a rain poncho — and a wheelchair. "The thought occurred to me that here was a man who had made a supreme sacrifice for the freedom of those (Vietnamese) children." Hood releases the shutter. Robinson wistfully watches the parade and protects a child from the rain.

1977 Feature
MOMENT OF
REFLECTION
Robin Hood

May 15, 1976, Chattanooga, Tennessee

Chattanooga News-Free Press

Nikon FTN, 105 mm lens, Kodak Tri-X film

Courtesy of Robin Hood

'The place looked like an armed camp'

On Feb. 8, 1977, Anthony Kiritsis storms into Meridien Mortgage in Indianapolis. He wires a shotgun to Meridien president Richard Hall, marches Hall out of the building and commandeers a police car.

The story began months before when Meridien lent Kiritsis money to build a shopping center. The loan is due and Kiritsis cannot pay. He claims the money-lenders discouraged investors so that Meridien could foreclose on the property.

Now Kiritsis and Hall are holed up in the money-borrower's apartment. United Press International photographer John Blair is outside. "The place looked like an armed camp," Blair recalls. "State police, local police, sheriffs, every kind of law enforcement." Blair settles in with the rest of the UPI team and waits.

After three days of negotiation, Kiritsis finally agrees to release Hall. Blair is in the lobby, cameras ready. "Kiritsis walks him over still tied to the shotgun. He says 'I'm a national hero and don't you forget it.'" As Kiritsis rants to the crowd, the photographer gets his pictures. "I had a good position and phenomenal angles. I had three cameras and I used all three."

Kiritsis releases Hall. Blair's photograph is sent out with others over the wire. Months later, one picture wins the Pulitzer — but it is credited to another UPI photographer. "I had strong feelings it was my photograph," says Blair. A careful examination of the negatives determines that John Blair took the photograph that won the Pulitzer Prize.

1978 Spot News
MONEY-BORROWER'S REVENGE
John H. Blair

February 10, 1977, Indianapolis, Indiana

United Press International

Pentax Spotmatic, Takumar 20 mm lens, Kodak Tri-X film

Courtesy of John H. Blair

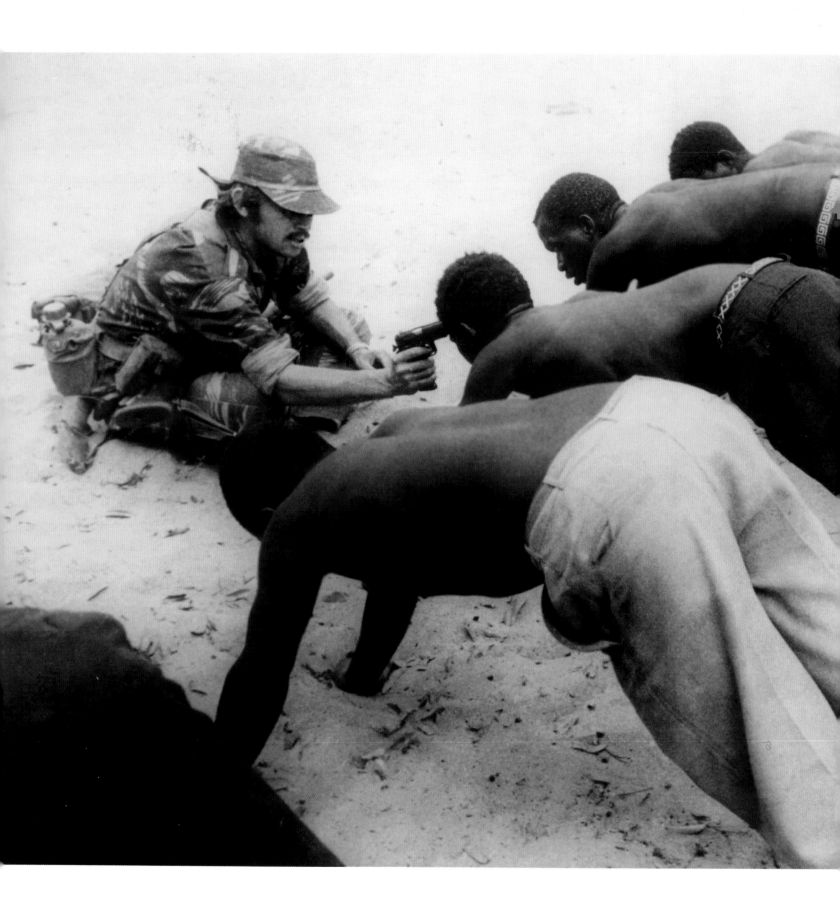

'All the feeling of...(a) massacre'

Ross Baughman wears a military uniform and carries a rifle. He rides the Rhodesian back country on horseback. But he is not a soldier. He is a photographer for The Associated Press.

It is 1977. The white Rhodesian government is under intense pressure from the country's disenfranchised black majority. Baughman travels with a rugged cavalry unit, Grey's Scouts. Their mission: to seek out anti-government guerrillas and destroy them.

The villagers will not give up the guerrillas. So the scouts resort to torture. "They force them to line up in push-up stance," Baughman remembers. "They're holding that position for 45 minutes in the sun, many of them starting to shake violently."

The soldiers warn that the first man who falls will be taken away. "Eventually, the first guy fell. They took him around the back of the building, knocked him out and fired a shot into the air. They continued bringing men to the back of the building. The poor guy on the end started crying and going crazy and he finally broke and started talking. As it turns out, what he was saying wasn't true, but the scouts were willing to use it as a lead."

Remembers Baughman: "It had all the feeling of an eventual massacre. I was afraid that I might see entire villages murdered."

The military confiscates most of Baughman's film. But he smuggles out three rolls. The pictures are published. The photographer is forced to leave Africa. Three years later, free elections are held in Rhodesia. Robert Mugabe becomes the first prime minister of the new, black majority-led country, Zimbabwe.

1978 Feature

ANTI-GUERRILLA OPERATIONS IN RHODESIA
J. Ross Baughman

September 17, 1977, Kikidoo, Rhodesia (Zimbabwe)

The Associated Press

Leica M4, 35 mm & Summicron F2 lenses, Ilford HP film

Courtesy of J. Ross Baughman

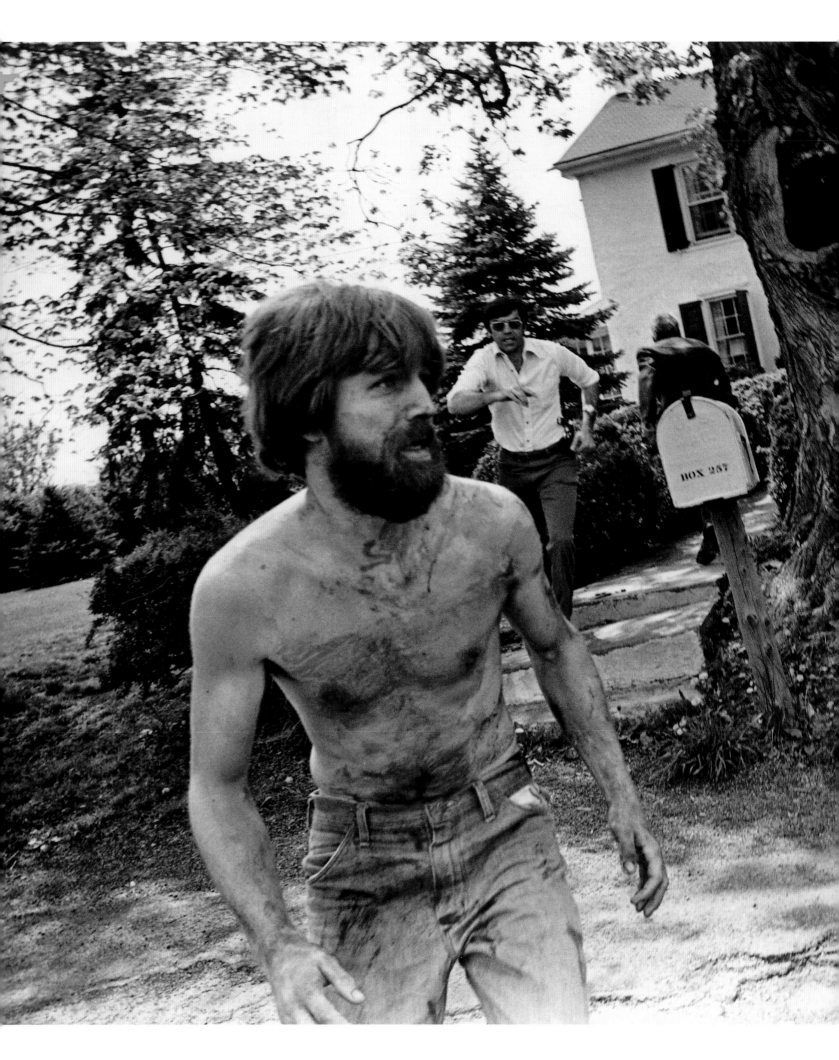

'He was wild, running toward me'

For Tom Kelly, Pottstown, Pa., is "a real nice place to live and work and have your kids grow up."

Kelly is doing just that, working as a photographer at *The* (Pottstown) *Mercury*, when a call comes over his police radio: An elderly woman is lying outside a house on Sanatoga Road, badly cut. Inside — a woman, a child, a man with a knife. The photographer races to the house. He finds it surrounded by emergency vehicles. Police officers crouch behind cars. A helicopter clatters overhead. Remembers Kelly: "Real quick you just knew it was a horrible, horrible situation."

Kelly learns that Richard Greist is holding his pregnant wife and young daughter hostage. Minutes, then hours, tick by. Finally, "the front door opened. What I saw gives me chills to this day." A little girl appears. Her face is slashed. She can barely see. "She was crying, 'Don't hurt my daddy, don't hurt my daddy.' I was just watching her. I couldn't take a picture." Suddenly, a police officer races up and gathers the little girl in his arms. Kelly's camera begins to click.

Police officers rush the house and seize Greist. But he breaks free. "He was wild, running toward me," the photographer remembers. "When he was four or five feet away, without looking up, without seeing him, I took the picture. You can see: It's crooked."

Kelly later learns that the little girl and her grandmother will recover. But Greist's pregnant wife, Janice, and the unborn child do not survive.

1979 Spot News
TRAGEDY ON
SANATOGA ROAD
Thomas J. Kelly III

May 10, 1978, Pottstown,
Pennsylvania

The (Pottstown) *Mercury*

Fujica ST-701, Takumar 28 mm
lens, Kodak Tri-X 400 film

Courtesy of Thomas J. Kelly III

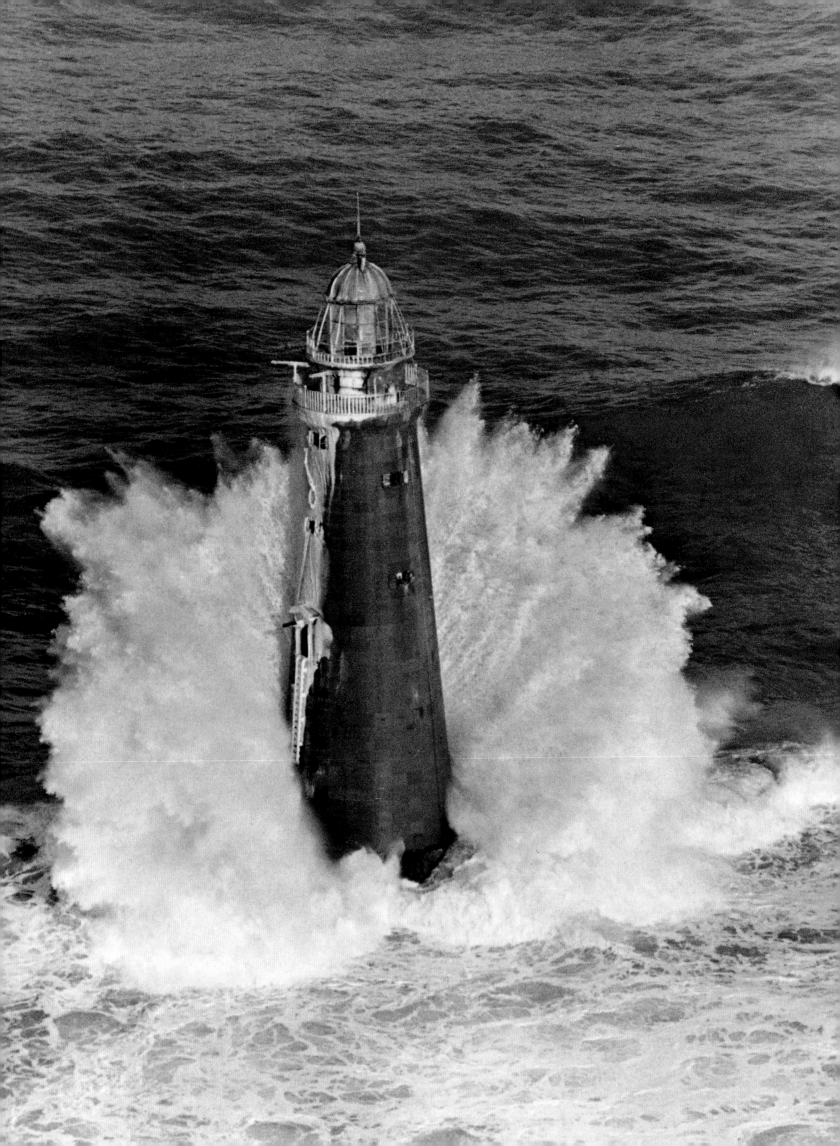

'We can't stay out here any longer'

The lighthouse is 114 feet high, which means that foam is spraying 100 feet into the air, propelled upward by a raging sea that sinks ships and floods towns up and down the coast.

It is Feb. 8, 1978. A blizzard has rammed New England, shutting down roads, businesses and schools. Snow buries everything. Nothing moves. Kevin Cole, chief photographer at The *Boston Herald American*, is stuck in Plymouth, Mass. "The snow was over the house. I've never seen anything like it." Determined to cover the storm, Cole heads for the Hyannis airport. "I found this place called Discover Flying School. The wind was blowing. The pilot said 'You're crazy, nobody's going up.'"

Before long, they are airborne. "It was this little, tiny plane. We took off. The whole coastline was gone, houses in the water, houses floating, waves crashing inside them. About two miles out, I saw Minot Light."

In the raging wind, they circle the lighthouse. The pilot tells Cole, "'We can't stay out here any longer.' Just as he started to turn, I saw a huge wave. That's when I got that shot, and that's the same time I threw up."

Other *Herald American* photographers fan out around the region, photographing the blizzard's destruction: Villages buried in freezing flood waters, commuters trapped in snow-covered cars. The newspaper publishes a special section, which chronicles the worst New England storm in 200 years—54 dead, 10,000 homeless and evacuated.

1979 Feature

BLIZZARD RAMS NEW ENGLAND

Boston Herald
Kevin Cole

February 6–8, 1978, Greater Boston area, Massachusetts

Boston Herald American

Nikon F, Nikon 80 mm–200 mm zoom lens, Kodak Tri-X 400 film

Courtesy of Kevin Cole, *Boston Herald*

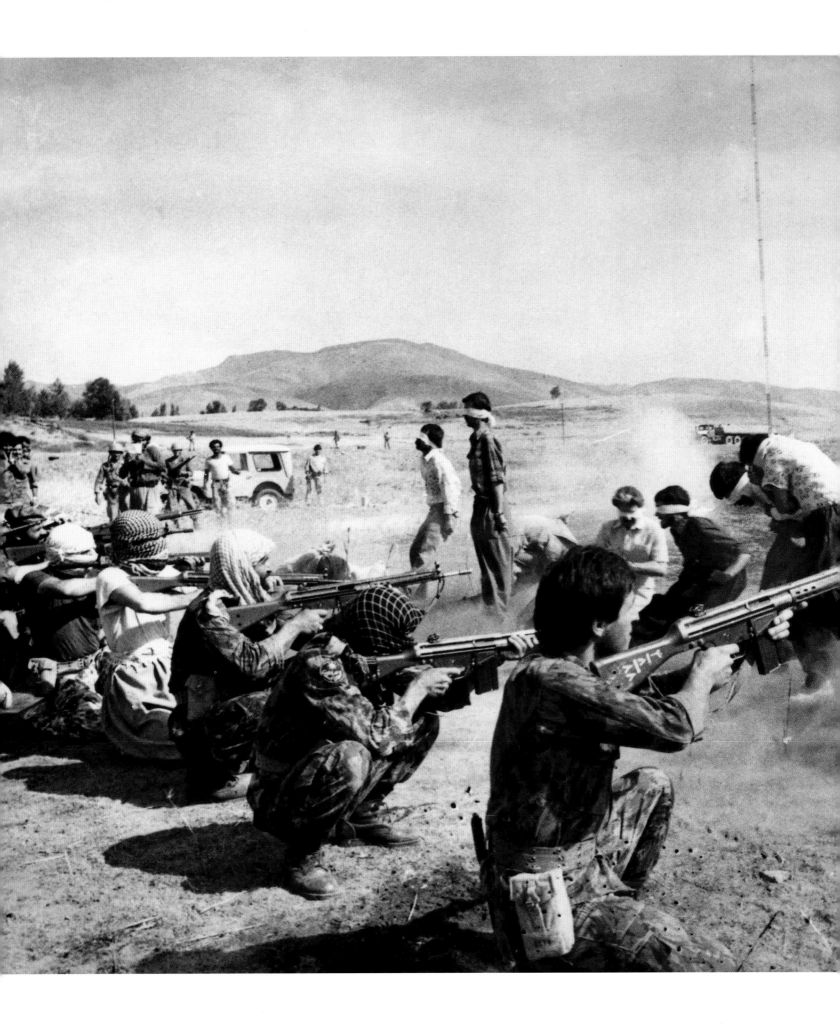

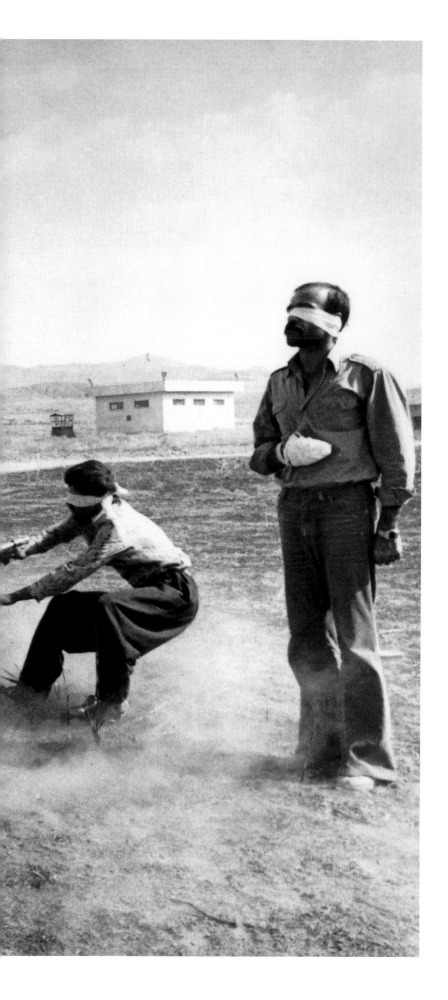

'The numbing transition from life to death'

Ayatollah Ruholla Khomeini's Islamic Revolution steamrolls over Iran, imposing his Shiite Muslim beliefs on the entire country and destroying "corrupt Western influences." The country's 4 million Sunni Muslim Kurds reject Khomeini's rule — and his religion — and demand independence. Khomeini sends in his Revolutionary Guards, who slaughter thousands of Kurds, dispensing "justice" in mock trials.

On Aug. 27, in Sanandaj, nine Kurdish rebels and two former police officers of the deposed shah of Iran are tried and sentenced to death. Their execution by firing squad is brutal and quick, documented in startling detail by a photographer from an Iranian newspaper. A United Press International staffer working in Iran at the time later tells the story: "I was tipped off about the picture some time in the afternoon, when the paper came out, and went over to their office." The staffer gets the photograph from the newspaper and transmits it to UPI's European office, which sends it out over the wire. The photographer is never identified. Neither is the UPI staffer.

"The photographer later related he was at risk of being shot himself, and smuggled the film in his trouser pocket. Those in the bureau often sat gazing at the picture, and contemplated the numbing transition from life to death that it depicts."

1980 Spot News

JUSTICE AND CLEANSING IN IRAN
Photographer unnamed

August 27, 1979, Sanandaj, Islamic Republic of Iran

United Press International

Camera/film data unavailable

Courtesy of Corbis

'Doing crazy stuff to get the cows moving'

Hundred-mile cattle drives, camaraderie by the campfire — it's not the romance of life on the range, but the promise of good pictures, that draws Skeeter Hagler out into Texas cattle country, where he sleeps in a bunkhouse and rises at dawn each morning.

A confirmed "city slicker," in 1979 Hagler is determined to document the life of the cowboy for the *Dallas Times Herald*. He isn't much good on a horse. So he follows the cowboys on foot or by pickup, photographing everything they do — eating, resting, driving cattle, roping steers. The cowboys, always reserved, aren't sure how they feel about having him around.

One cowboy cuts the tail off of a rattlesnake and sneaks up behind Hagler, shaking the rattle. "It scared the **** out of me," Hagler laughs. "I jumped up and ran for a mile. The cowboys really got a kick out of it. They thought I was a good sport." Hagler's willingness to laugh at himself earns the cowboys' trust. "I got to know them out of sheer persistence. I wore them down."

Hagler eventually finds himself up in a helicopter with a pilot-cowboy. "We got up there and he started doing all this crazy stuff to get the cows moving, loops and dives. He's got sirens. He's got a red flag in his hand. He leans out the window, hollering, screaming, and waving the flag while he's got the sirens going. The guy flies using only one hand on the controls. It's really a sight."

1980 Feature
THE AMERICAN
COWBOY
Erwin "Skeeter" Hagler

Spring/Summer 1979, Texas
Panhandle

Dallas Times Herald

Nikon, 20 mm lens, Kodak Tri-X,
Kodachrome film

Courtesy of Erwin "Skeeter"
Hagler

'Wandering around without an escort'

There are 5,600 inmates in Michigan's Jackson State Prison. Most of them are armed. A flattened Coke can becomes a weapon. So does the steel the prisoners use to manufacture license plates.

Detroit Free Press photographer Taro Yamasaki roams the prison, armed only with a camera. "There was a lot of violence against the inmates *and* the guards so they were all interested in my doing a story," says Yamasaki. "The only way the inmates were going to talk to me was if the guards weren't around. The guards decided to let me be in there alone. The warden never knew I was wandering around without an escort."

What Yamasaki discovers is profoundly disturbing. "There was a free market in weapons and drugs. Employees and guards were bringing stuff in. When the inmates started trusting me more, they allowed me to photograph them with knives and drugs. I was very careful. I never photographed their faces. If they had some kind of jewelry, I said, 'Take it off.'

"There were very few guards — sometimes one guard with 1,500 inmates. They were not armed. They were afraid to enforce the rules. They would have a contract out on their heads. I photographed two guards who almost were killed.

"The inmates trusted me, but they also figured they could kill me. You never knew what was going to happen. There were so many crazy guys in there who had nothing to lose. I was constantly afraid."

After Yamasaki's photographs are published, voters defeat a proposal to increase prison funding. Inmates riot, seizing cellblocks, looting, setting fires. At Jackson State Prison, nothing changes.

1981 Feature

JACKSON STATE PRISON
Taro M. Yamasaki

10 days in October–November 1980, Jackson State Prison, Michigan

Detroit Free Press

Nikon F2, 35 mm lens, Kodacolor 400 film

Courtesy of Taro M. Yamasaki

'Things got wildly out of control'

April 12, 1980, Monrovia, Liberia: Master Sgt. Samuel Doe and his group of disaffected soldiers storm the presidential palace, murder the country's president and declare martial law. The coup is felt halfway around the world in Fort Worth, Texas, home to Southwestern Baptist Theological Seminary, whose students do missionary work in Liberia.

Larry Price, a photographer for the *Fort Worth Star-Telegram*, covers Doe's first international press conference in Monrovia. It is sparsely attended. As it ends, an official mentions matter-of-factly that executions are about to begin nearby.

When Price and his reporter arrive, they find soldiers erecting telephone poles on the beach. A bus pulls up. "They hauled all these people off," says Price. "They marched them up there, tied nine of them, one to each post. They started heckling them, harassing them, shouting...it dawned on me that this was going to happen. I started to take a lot of photographs."

Nine soldiers back off. The commanders give the order: aim, then fire.

"Once they did start firing, the exuberance was overwhelming. Things got wildly out of control. These people were dead, but the other soldiers started running up and shooting at them anyway. They were just jumping up and down. The crowd sort of crushed in; they wanted to get in and look."

1981 Spot News

LIBERIA— EXECUTIONERS CELEBRATE
Larry C. Price

April 22, 1980, Monrovia, Liberia

Fort Worth Star-Telegram

Nikon FM2, Nikkor 20 mm lens, Kodak Tri-X film

Courtesy of Larry C. Price

'Through my lens I saw him grimace'

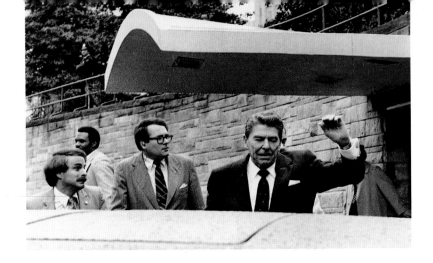

On March 30, 1981, Associated Press photographer Ron Edmonds waits for President Ronald Reagan outside the Washington Hilton Hotel. John Hinckley Jr. joins the crowd. Both men intend to shoot the president. One man holds a camera; the other, a gun.

Edmonds remembers standing near the presidential limousine as Reagan appears. "Some people across the street shouted at him; he started to wave. As he waved, I put my finger on the button. The shots rang out. Through my lens I saw him grimace."

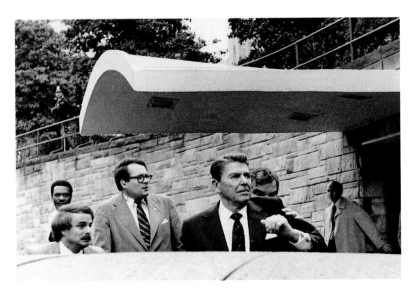

Believing that killing Reagan will somehow impress the actress Jodie Foster, Hinckley fires six shots from a .22-caliber pistol. "President Reagan was only in view a split second," says Edmonds "then Secret Service agents pushed him into the car. It wasn't until the car zoomed off that I saw Brady, McCarthy and Delehanty lying on the ground." White House press secretary Jim Brady, Secret Service agent Timothy McCarthy, Washington police officer Thomas Delehanty — and President Reagan — have all been seriously injured. None of the injuries are fatal.

Edmonds remembers: "When you're in those situations, it seems like an eternity because there is a lot going on. It was awful. Just awful. I have always believed in keeping my guard up. I always made sure I had the president in plain sight wherever I was at and I was ready with the camera. You have to anticipate. You never know what is going to happen until it does. Fortunately, I pushed all the right buttons."

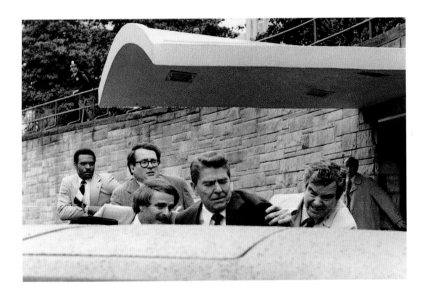

1982 Spot News
ASSASSINATION
ATTEMPT
Ron Edmonds

March 30, 1981, Washington, D.C.

The Associated Press

Nikon F3, 50 mm lens, Kodak Tri-X film

Courtesy of The Associated Press

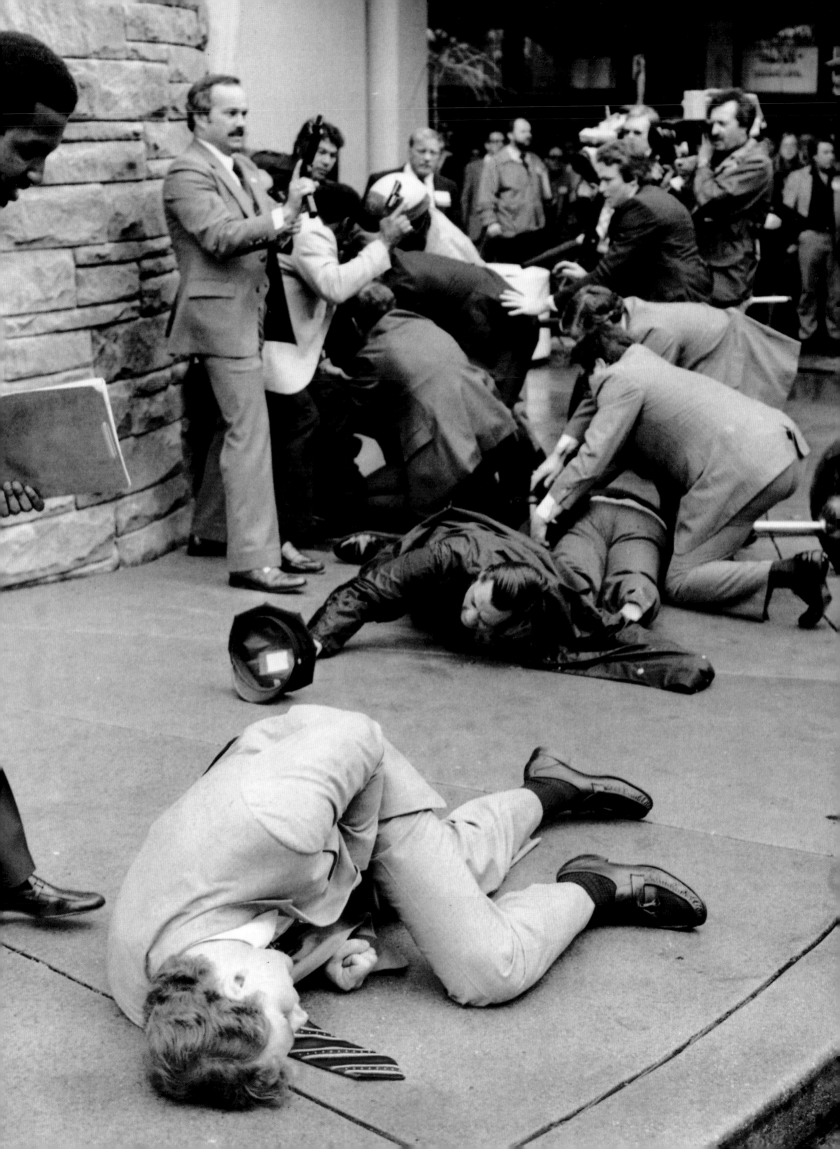

'I breathe the city, the city is everything'

For more than 30 years, John White has been photographing Chicago. "I live in the city, I breathe the city, the city is everything. There's the lakefront, there are the parks, I can see as good a sunrise in the city as anywhere in the world."

As a photographer for the *Chicago Sun-Times*, White covers his share of murders, political rallies, robberies and fires. But what he loves most are uplifting pictures: young dancers rehearsing at a new high school for the performing arts or children running joyfully through Cabrini Green, Chicago's most notorious housing project. "I don't really take pictures, I capture and share life. Moments come when pictures take themselves."

White's prize-winning portfolio reflects a year in the life of the city and his work. "The purpose was to share slices of life from all walks of life; to be the psalm of the life of people. The photographs were from news situations, but not hard news. To me there is a wholeness that these images, these moments, give life. Most people get a steady diet of the hard news, the pain. I like to think these give the benefit of the joy and peace that life has also."

1982 Feature

LIFE IN CHICAGO
John H. White

September 1981, Chicago, Illinois

Chicago Sun-Times

Nikon F3, 35 mm lens, Kodak Tri-X film

Courtesy of John H. White and *Chicago Sun-Times*

'A pile of people, not a pile of garbage'

In 1982, Israel invades Lebanon, determined to drive out the Palestinian Liberation Organization and help establish a government sympathetic to Israel. But on Sept. 14, 1982, Christian president-elect Bashir Gemayel is assassinated.

Associated Press photographer Bill Foley heads for the Palestinian refugee camp at Sabra, which is run by the Christian militia. "There were guys with guns at the gates —Christian militia men who said, 'Take a hike if you don't want to get your head blown off.' I went back again on Friday; the men were still there. There was something going on inside. There was shooting."

On Saturday, Foley returns again, to find the guards gone and the gates open. "It's always very noisy," says Foley, "kids, cows, animals." But that day "we were 50 yards into the camp and you could hear your heart beat; nothing was moving."

It's not long before Foley realizes why: The streets are piled with bodies. "You'd see it was a pile of people, not a pile of garbage. You'd see people having dinner, they had been shot at the table. Women with their hands tied behind their backs, throats cut."

For three days the Christian militia had sealed off the camp and massacred those inside, killing hundreds. "They blamed the Palestinians for killing Gemayel, even though it could have been the Syrians; it could have been the Israelis," says Foley. "They blamed the Palestinians; someone had to pay." One of Foley's photographs shows an angry Palestinian woman brandishing helmets she believes were worn by the killers.

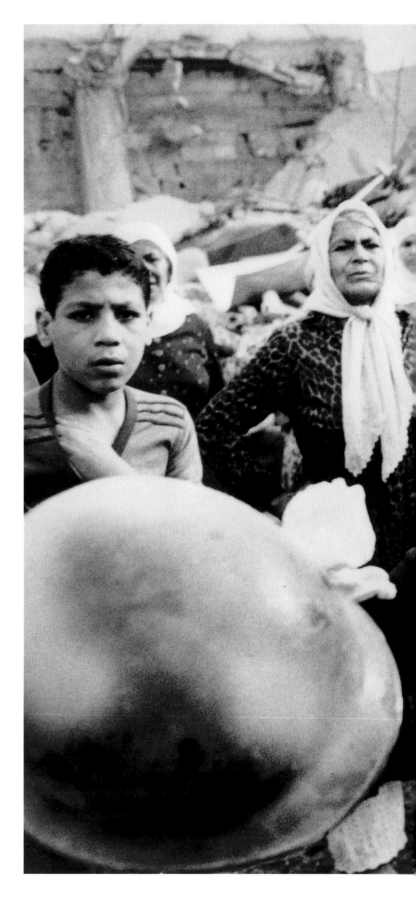

1983 Spot News
ANGRY SCENE
AT SABRA
Bill Foley

September 19, 1982, Sabra Camp in Beirut, Lebanon

The Associated Press

Nikon FM3, 24 mm lens, Kodak Tri-X film

Courtesy of The Associated Press

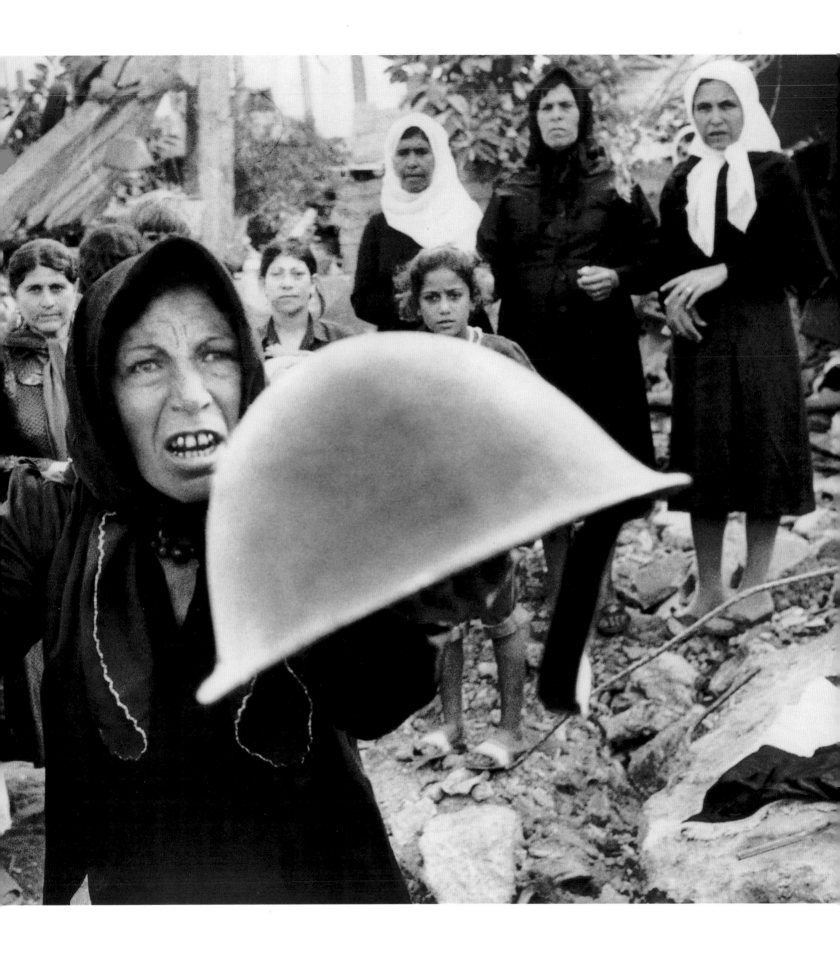

'Keep your focus, literally and figuratively'

El Salvador, March 1982. Civil war rips apart the country. Anti-government guerrillas mount a new offensive against the ruling military junta. Determined to disrupt the upcoming elections, the guerrillas sneak into election headquarters in San Salvador. The military gets wind and storms in after them. A huge gun battle erupts.

Dallas Times Herald photographer James Dickman is staying with other journalists at a hotel nearby. "We were awakened by the helicopters," he says. "We rushed over. The guerrillas had allowed themselves to be corralled into a narrow ghetto area with no real means of escape. The military started shooting guerrillas right in front of us. We were around the side of a building, staying low, trying to get pictures."

Preoccupied by the battle, government soldiers don't care what the journalists are seeing. "I photographed soldiers dragging away bodies. Nobody tried to stop us." Dickman's photograph of the battle's aftermath is just one in his series on El Salvador — vivid proof of the brutality of the war.

"One of the difficult parts is to keep your focus, literally and figuratively, on what you are there for. Hopefully you are human enough to be affected emotionally, but you realize that you are documenting it so people back home can see it and it will have an impact."

1983 Feature
EL SALVADOR: THE KILLING GROUND
James B. Dickman

March 28, 1982, San Salvador, El Salvador

Dallas Times Herald

Nikon FE2, 20 mm lens, Ektachrome film

Courtesy of James B. Dickman

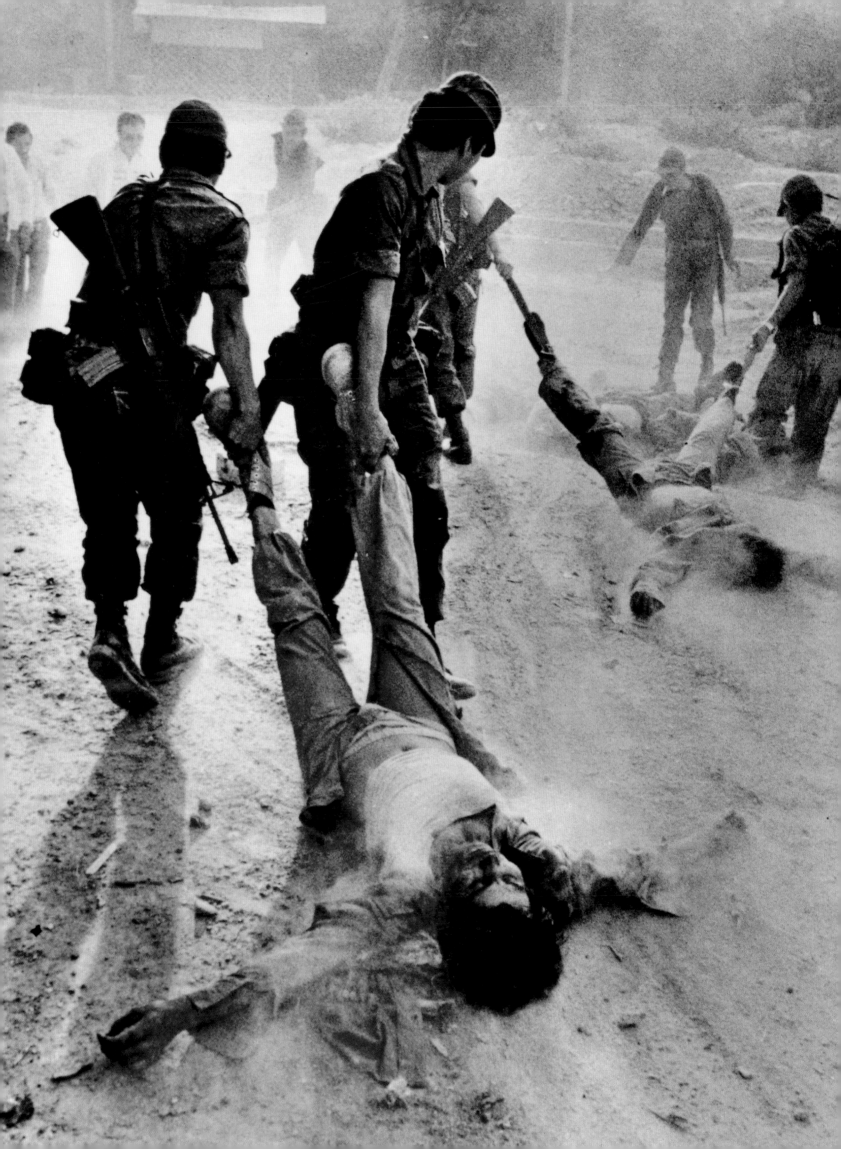

'Even in wartime, life goes on'

Lebanon 1983. Turmoil bloodies the countryside. An international force struggles, with little success, to keep the peace. On Oct. 23, a truck bomber drives into the U.S. Marine barracks in Beirut; 241 U.S. servicemen lose their lives.

When *Boston Globe* photographer Stan Grossfeld arrives to cover the story, the self-described "scared kid from the Bronx" finds himself running through ruined streets, shells exploding around him. He covers shellings in Beirut and firefights in Tripoli. But his real passion is the children.

"When I first went to Beirut, I didn't know the difference between incoming and outgoing," says Grossfeld. "But the kids know—and they get used to it because they're the most adaptable people on the planet. I always focus on the children because they are the most important thing. They have absolutely no voice. They are pawns amidst the politicians."

Grossfeld photographs children all over Lebanon—playing games, toting guns, running for cover. In a makeshift morgue in Tripoli he sees "this little girl lying in the heat. She had on a pink dress. I was sure it had been her birthday party, her fourth birthday. That image haunts me to this day."

Grossfeld's photographs contrast the innocence of children with the brutality of war: In Beirut, children ride a Ferris wheel while U.S. warships patrol just offshore. "It was just an ordinary carnival," Grossfeld remembers. "Even in wartime, life goes on."

1984 Spot News
WAR IN LEBANON
Stan Grossfeld

1983, Beirut, Lebanon

The Boston Globe

Nikon, 300 mm lens, KodakTri-X film

Courtesy of Stan Grossfeld / *The Boston Globe*

'It was a very intimate moment'

You can't make out his whole name. But you know a lot about him from the inscription on his tombstone: World War II, Korea, Vietnam. A dedicated soldier who served in three of the century's most brutal wars. His widow sits, hugging his tombstone; her husband has been dead less than a year.

Anthony Suau is at the cemetery, trying to take a Memorial Day photograph for *The Denver Post*'s front page. "I was just walking around. And I saw this woman. It looked like she had been holding the tombstone and then she let go. So I positioned myself with a longer lens. And sure enough, within a few minutes, she embraced the tombstone again. I made about six frames. And I realized immediately that it was a very intimate moment."

Suau puts down his camera and waits outside. When the woman leaves the cemetery, he approaches her. "I said, 'I just took your picture embracing this tombstone. And I want to make sure it's OK with you to publish it.' She was delighted.

"I got a lot of phone calls from people around the world saying, 'I've done that. I've hugged my husband's or father's tombstone. I can relate to that picture. I can really feel what that woman feels.'"

1984 Feature
MEMORIAL DAY
Anthony Suau

May 31, 1983, Denver, Colorado

The Denver Post

Nikon F3, Telephoto lens, Transparency film

Courtesy of *The Denver Post*

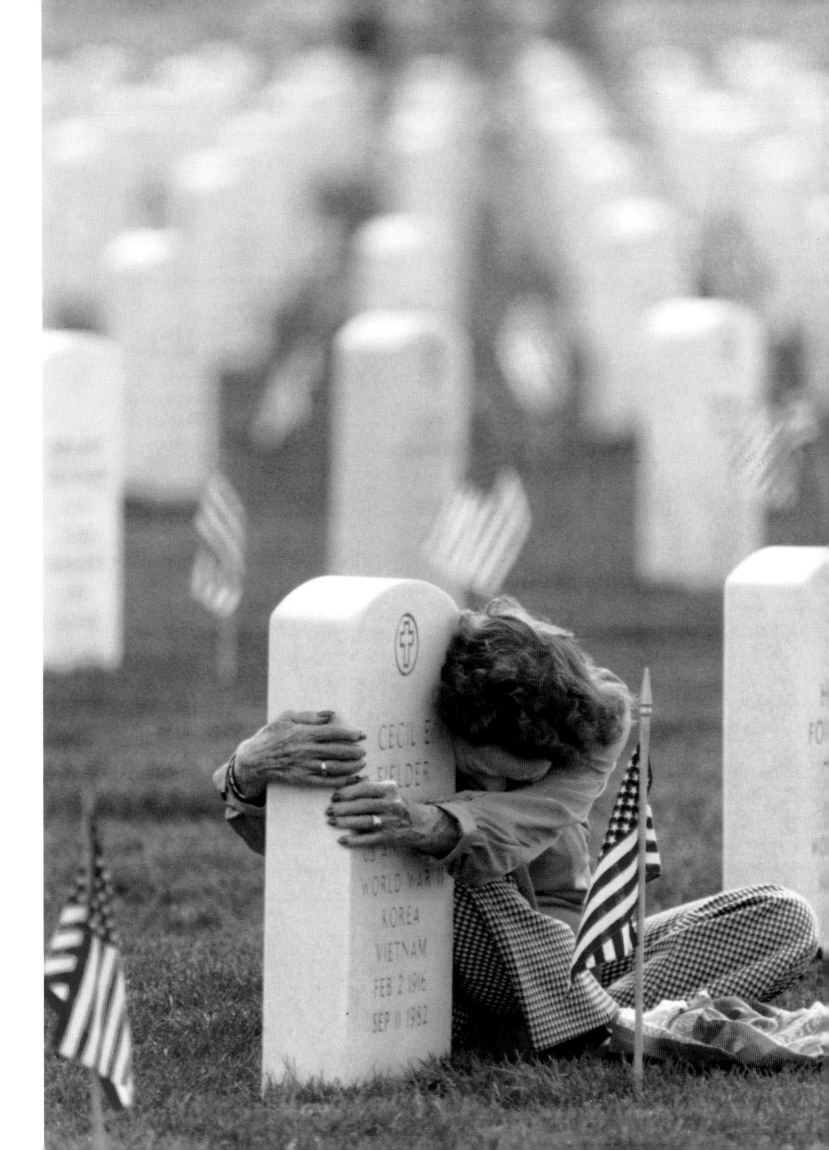

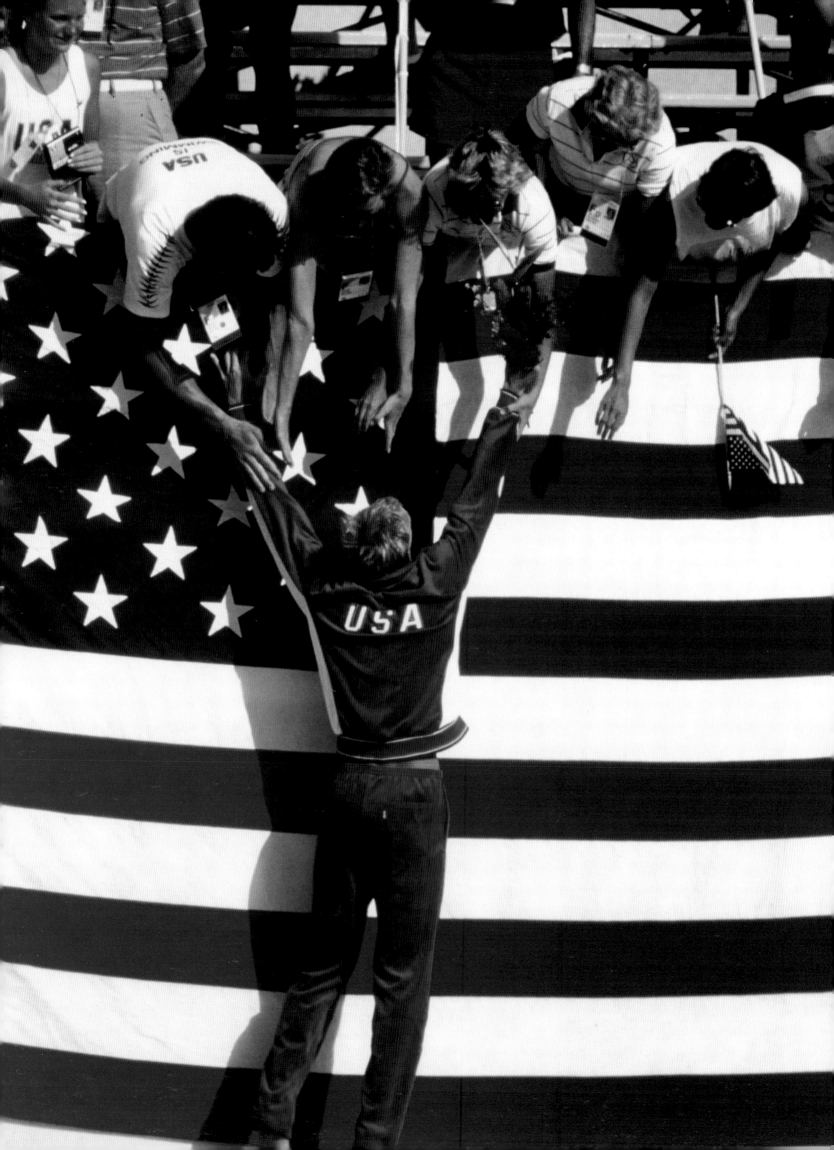

'We definitely did not play it safe'

At the 1984 Olympic Games in Los Angeles, athletes from China compete for the first time since 1952. Women from around the globe run their first Olympic marathons. And three photographers from *The Orange County Register* — Rick Rickman, Hal Stoelzle and Brian Smith — try to outdo news organizations that have 10 times their resources.

"The L.A. *Times* had 40 credentials and we had three," Rickman remembers. "It was a daunting task. You realize you're so outnumbered and so outgunned...it takes over and it effects everything you do. You drive yourself."

Realizing they can't go head-to-head with their competitors, the *Register* photographers set a different goal. "We were looking to create a striking shot," says Smith. "We wanted someone to pick up the paper and see something they hadn't seen on TV the night before. We definitely did not play it safe. Any time I could get out of the box for still photographers, I did."

Each photographer shoots three or four events a day. On Aug. 12, one of Hal Stoelzle's assignments is men's freestyle swimming. "I had arrived at about 5:30 a.m. to secure a spot and the finals didn't begin until late afternoon. The still photo positions...were located under the spectators' bleachers. The heat under the bleachers was oppressive, hotter than 100 degrees. But when Rowdy Gaines was greeted by his teammates in front of the American flag after winning a gold medal in the men's 100-meter freestyle race, I knew the wait had been worth it."

1985 Spot News

OLYMPICS IN
LOS ANGELES

*The Orange County
Register staff*

August 12, 1984, Los Angeles,
California

The Orange County Register

Nikon F3, 600 mm lens, Fuji color
100 film

Courtesy of *The Orange County
Register*

'A whole fresh round of killings'

In 1984, civil war roils El Salvador and Angola. American money and influence support the ruling government in El Salvador, the rebel army in Angola. The two conflicts have something else in common: Larry Price of *The Philadelphia Inquirer*.

Price remembers El Salvador as a dangerous story because "you never knew who the enemy was. You never knew what was waiting for you around the corner." Particularly menacing are the right-wing death squads, which murder more than 50,000 civilians in 13 years. "These death squads would target neighborhoods in El Salvador, summarily execute people, throw them into the back of a truck, drive them out and throw out their bodies."

The dead are often taken to El Playon (the beach), a field of volcanic lava outside of San Salvador. "I drove over late one afternoon. There had been a whole fresh round of killings. The remains of that person had been dumped a couple of days before. There were a lot of fairly fresh bones and skulls."

1985 Feature

WAR-TORN ANGOLA AND EL SALVADOR
Larry C. Price

July 1984 and November 1984, Angola and El Playon, El Salvador

The Philadelphia Inquirer

Nikon F3, 20 mm F3.5, 24 mm F2.8 lenses, Kodachrome 64 film

Courtesy of Larry C. Price

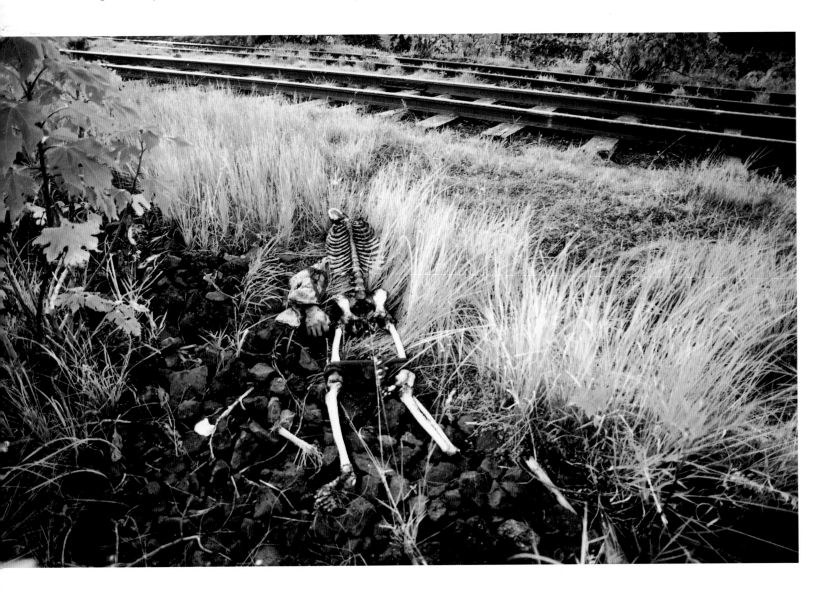

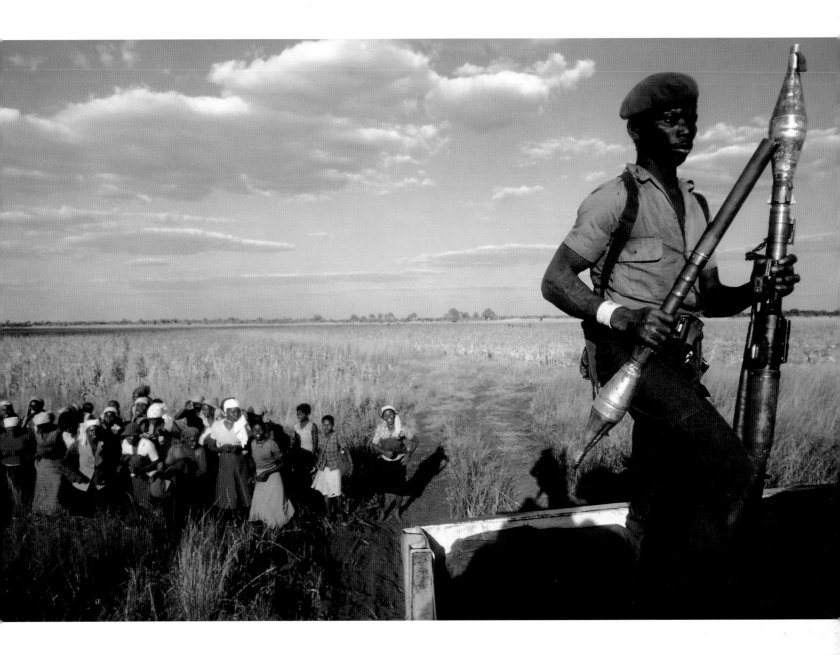

By 1984, Angola has been embroiled in internal warfare for almost 25 years. Journalists have a difficult time getting into the country. But Larry Price meets a nurse with Doctors Without Borders who introduces him to UNITA, the rebel group led by Jonas Savimbi. Wanting publicity, UNITA smuggles Price into Angola. He soon finds himself rolling through countryside that is "as far as you can get from anywhere on the planet."

As he travels, Price photographs the rebels. "This guy is carrying an anti-tank weapon, standing on the back of a truck. It was a vast savanna—we came from off in the distance. We passed these women and they started doing a ceremonial dance, a greeting dance. We'd roll into town and there would be a big celebration that would last all night."

'The sounds of kids dying of starvation'

"We snuck in on a food convoy. The convoy would travel at night and during the day they'd cover it up because Ethiopian MiGs would blow it up if they saw it."

It is 1984 when Stan Grossfeld and *Boston Globe* reporter Colin Nickerson discover the harsh reality of famine and politics in Ethiopia. The country's drought is in its fourth year. The crop has failed. The livestock are dead. Hundreds of thousands of people abandon their farms and villages and set out, looking for food.

There is little to be found. Some 130,000 tons of food from the United States have been held up by the Ethiopian government, which is determined to starve the rebel-held countryside into submission. Starve the people do — half a million Ethiopians, many of them children so hungry their bodies literally consume themselves. "I'll never forget the sounds of kids dying of starvation. They sound like cats wailing." For Grossfeld, the experience is overwhelming: "You try to be a technician and look through the viewfinder; sometimes the viewfinder fills up with tears."

At a feeding station in the Tigray Province, Grossfeld photographs a child licking a flour sack. "I remember that kid," says Grossfeld. "He might have survived. He was smart enough to lick the sack." But for others, there is no hope. Grossfeld photographs this starving mother and child waiting in line for food in Wad Sharafin Camp. Hours later, the child is dead.

1985 Feature
ETHIOPIAN FAMINE
Stan Grossfeld

1984, Wad Sharafin Camp, Ethiopia

The Boston Globe

Leica, Leica 85 mm lens, Kodak Tri - X film

Courtesy of Stan Grossfeld / *The Boston Globe*

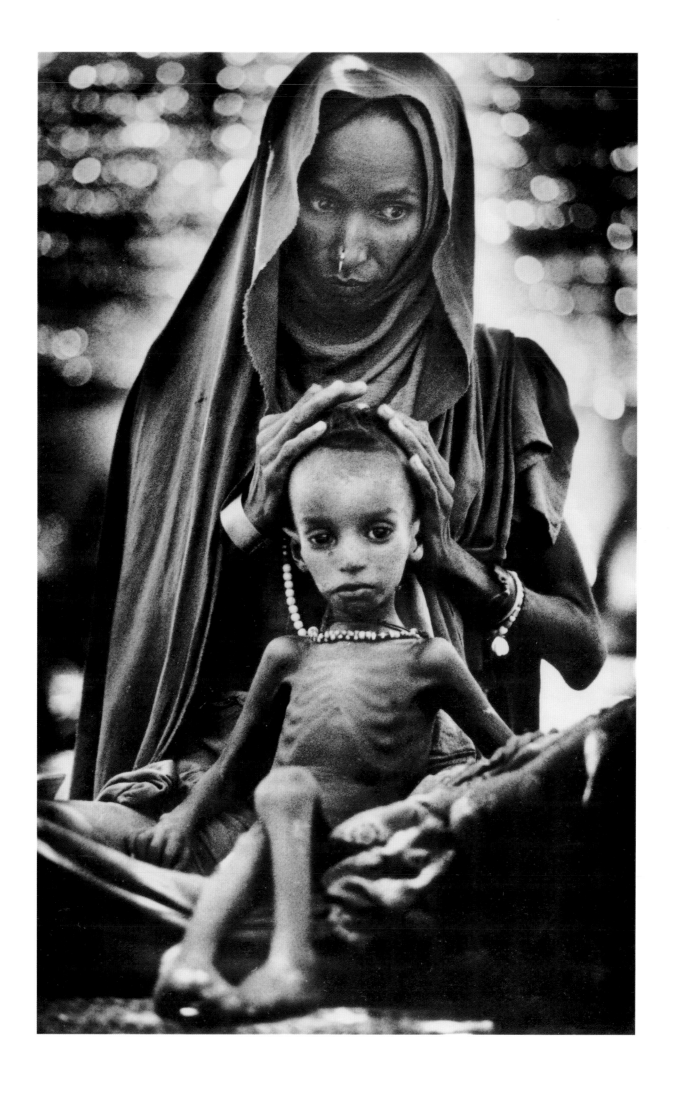

'Yo soy Americano loco'

They spend long hours in dusty fields under the hot sun, picking tomatoes and melons, cucumbers and okra. They make less than minimum wage and live in minimal conditions, sometimes without water or electricity. Yet between 500,000 and 1.5 million Mexicans cross the border to the United States each year, lured by steady work and U.S. dollars. Many go home at the end of the season; many stay behind.

For decades, the United States government encouraged this seasonal migration. That support ended in 1964. But the workers keep on coming. Now illegal, they cross the border under cover of darkness, dodging barbed wire, rattlesnakes and the Border Patrol.

In 1984, Stan Grossfeld finds himself on the banks of the Rio Grande watching a group of Mexican workers, chin deep in water, heading from Matamoros, Mexico, to Brownsville, Texas. "They were coming to work in the United States in the okra fields. I just plunged into the river, camera over my head, shouting out in my seventh-grade Spanish, 'Yo soy Americano loco.' (I'm a crazy American.) After that, they weren't afraid of me.

"I had been out with the Border Patrol, looking for illegal aliens. The patrol guys wouldn't go down to the river. After the Mexicans got across, then Border Patrol guys chased them. The Mexicans got away."

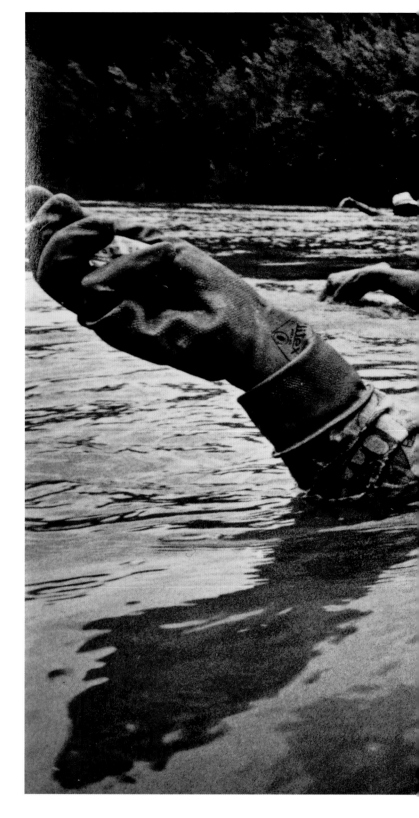

1985 Feature
MEXICANS CROSS
RIO GRANDE
Stan Grossfeld

1984, Matamoros, Mexico,
Brownsville, Texas

The Boston Globe

Nikon, Nikon 22 mm lens,
Kodak Tri X film

Courtesy of Stan Grossfeld /
The Boston Globe

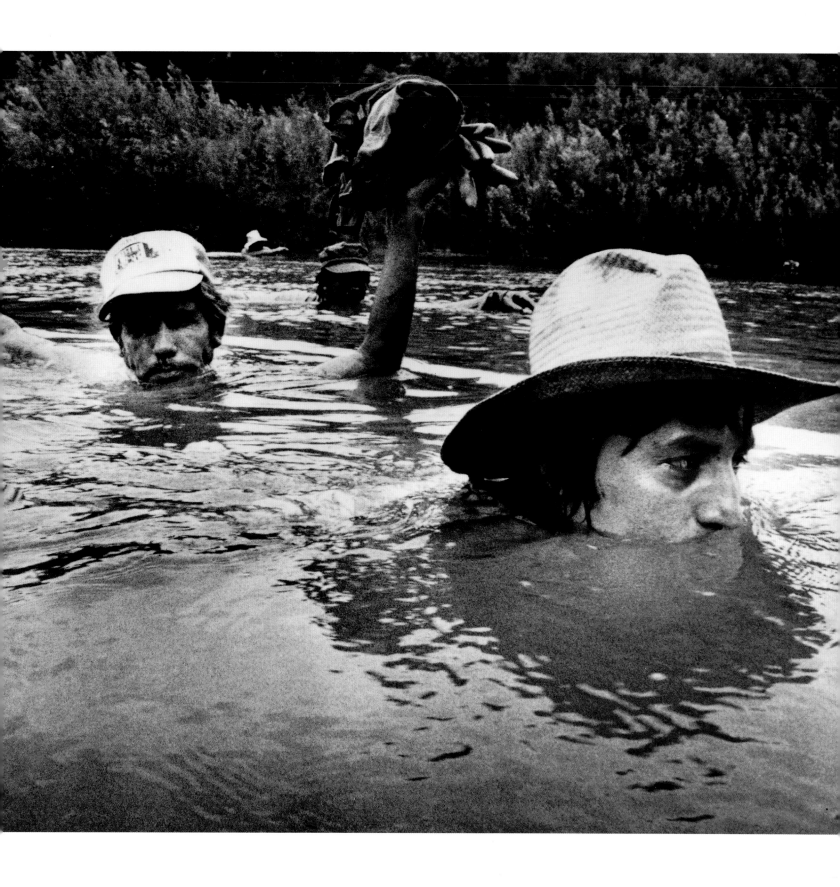

'They saw themselves as the last free men'

"I like any kind of food. Whatever's there, I buy it. Hot dog one day, the next Chinese food, roast beef sandwich." — Walter, Philadelphia, homeless

In the winter of 1985, *Philadelphia Inquirer* photographer Tom Gralish steps out of his life and into the lives of the city's street people. "I didn't know much about these guys. So I decided to show what their day is like. I wanted it to be straight-forward 'doc photography.' Go out and see what you can find."

Gralish walks the streets with his camera. "I hooked up with one little group. It was like a community — enough vendors to be nice to them, enough steam grates, a liquor store nearby, a hospital, lots of commuters to panhandle — everything they needed."

Some men live on fire escapes; others in alleys. Walter lives on a sidewalk heating grate. "Walter is one of the guys who is hard to reach because he talks to himself and rants to people on the street. Everyone knows him; people who live and work in the neighborhood give him change. He was one of those guys who was hot and cold to me."

Eventually, Walter allows Gralish to photograph him. "People like it when you pay attention to them. These guys had disdain for society and the rules; that's why they objected to the shelters. They saw themselves as the last free men."

1986 Feature
PHILADELPHIA'S
HOMELESS
Tom Gralish

January–February 1985,
Philadelphia, Pennsylvania

The Philadelphia Inquirer

Nikon F3, 180 mm lens, Kodak
Tri-X Pan film

Courtesy of *The Philadelphia Inquirer*

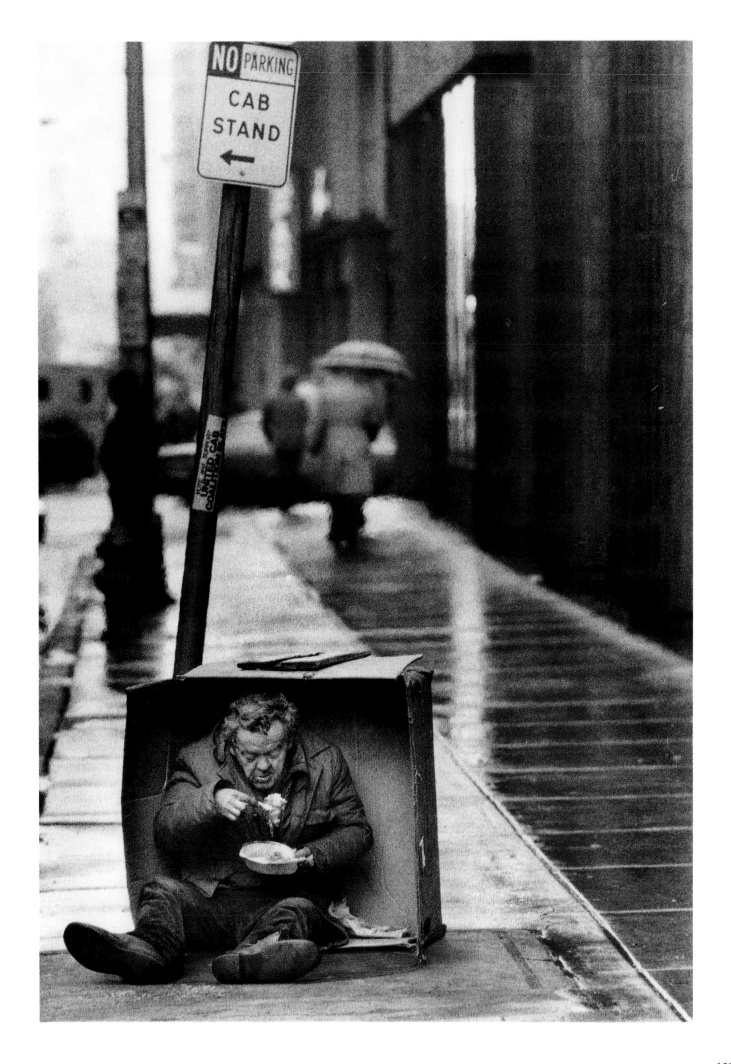

'They couldn't get her out'

On Nov. 13, 1985, the volcano Nevado del Ruiz explodes. A lethal wave of mud, ash and water crashes down the slopes of the Andes, killing at least 25,000 people. Thirty-six hours later, *Miami Herald* photographers Michel duCille and Carol Guzy arrive in devastated Armero, Colombia. "It looked like a tornado came through and wiped everything flat," says duCille. "There were bodies everywhere. It was the smell of death."

The town is a sea of debris and mud. "At certain points we would be trudging over bodies," says Guzy. In one of her most chilling photographs, an arm reaches out of the mud, the body trapped underneath. "It seemed frozen in time."

Guzy spots a moment of hope: Thirteen-year-old Omayra Sanchez, chin-deep in water but alive, surrounded by rescuers. Guzy only has time for a few photographs before she must race her film out to meet her deadline. "I was angry because I had to leave. I thought that I was going to miss this great rescue, this great moment that would happen after I left."

But the rescuers can't pry Omayra from the debris. "By the time I got back, she was gone," says Guzy. "I couldn't believe it. I couldn't believe they had their hands on her and the helicopter was there and they couldn't get her out."

"I went back six months later and I saw her mother. She had all the pictures from the newspapers. It was like a little shrine."

1986 Spot News

VOLCANIC MUDSLIDE IN COLOMBIA

Carol Guzy and Michel duCille

November 15, 1985, Armero, Colombia, South America

The Miami Herald

Nikon F3, Nikkor 24 mm & 180 mm lenses, Fuji film

Courtesy of Carol Guzy and Michel duCille

'Farmers put their guard up'

The families that farm Iowa's fertile soil deed their land, and the fruits of their hard labor, to their children and grandchildren.

But in the 1980s, declining crop prices and rising interest rates take their toll. Foreclosures increase. Small farms die. Farmers have nothing to pass on to the next generation. Determined to put a human face on the tragedy, Dave Peterson takes a leave of absence from his job at *The Des Moines Register* and heads out to tell the farmers' stories. It isn't easy.

"Farmers put their guard up," says Peterson. "It can take them a long time to warm up to the camera." Peterson begins spending time with Pat and Elmer Steffes, recording their desperate bid to save their farm and their crushing grief when, after the Small Business Administration denies help, that bid fails. "The symbol for the death of a farm during this period was the wooden white cross. The Steffes had planted a number of these on their land after their foreclosure.

"Once I started shooting, they seemed to forget about me and become lost in their thoughts. Elmer looked slumped and defeated as he propped his arm up on the hay bales. Pat slid in next to him, resting her head on Elmer's chest. She slipped her arms around him, needing to feel close. They were together in their grief but seemed lost and apart in their hopelessness."

1987 Feature

AMERICAN FARMERS'
SHATTERED DREAMS
David Peterson

May 1986, Des Moines and
Audubon, Iowa

The Des Moines Register

Canon F-1, Canon 17 mm F4 lens,
Kodak Tri-X film

Courtesy of David Peterson

'We knew the turf, we knew the people'

For more than two years, *San Francisco Examiner* photographer Kim Komenich and reporter Phil Bronstein travel to the Philippines, covering the corrupt and increasingly unstable regime of Ferdinand Marcos. "We knew the turf," says Komenich. "We knew the people."

News coverage helps force a Feb. 7, 1986, election. Marcos rigs the election and defeats opposition candidate Corazon Aquino. The military moves in to support Marcos; citizens take to Manila's streets in protest. "For the first time," says the photographer, "the people actually stood up against tanks and the tanks were turned back."

Within weeks, most of the armed forces shift their loyalty to Aquino. On Feb. 25, one regime ends and the other begins. Says Komenich: "It was a matter of photographing Mrs. Aquino taking the oath of the presidency, then jumping into a taxi. I'll never forget racing through those streets . . . there would be a roadblock with tires burning and the driver was driving up on the sidewalk to get past it." Komenich reaches the presidential palace in time to photograph Marcos giving his last public speech.

Later, in La Union province, Komenich photographs tribal groups exorcising Marcos' spirit from a four-story statue. "I always like to look for a picture within a picture. Anybody can stand up there and take a picture of what's presented. It's up to you to look for the irony and understand the power of photography to capture that irony."

1987 Spot News
FERDINAND
MARCOS TAKES
A FALL
Kim Komenich

March 1986, Luzon, Philippines

The San Francisco Examiner

Nikon F3, Nikkor 500 mm F8 lens, Kodak Tri-X film

Courtesy of Kim Komenich and *The San Francisco Examiner*

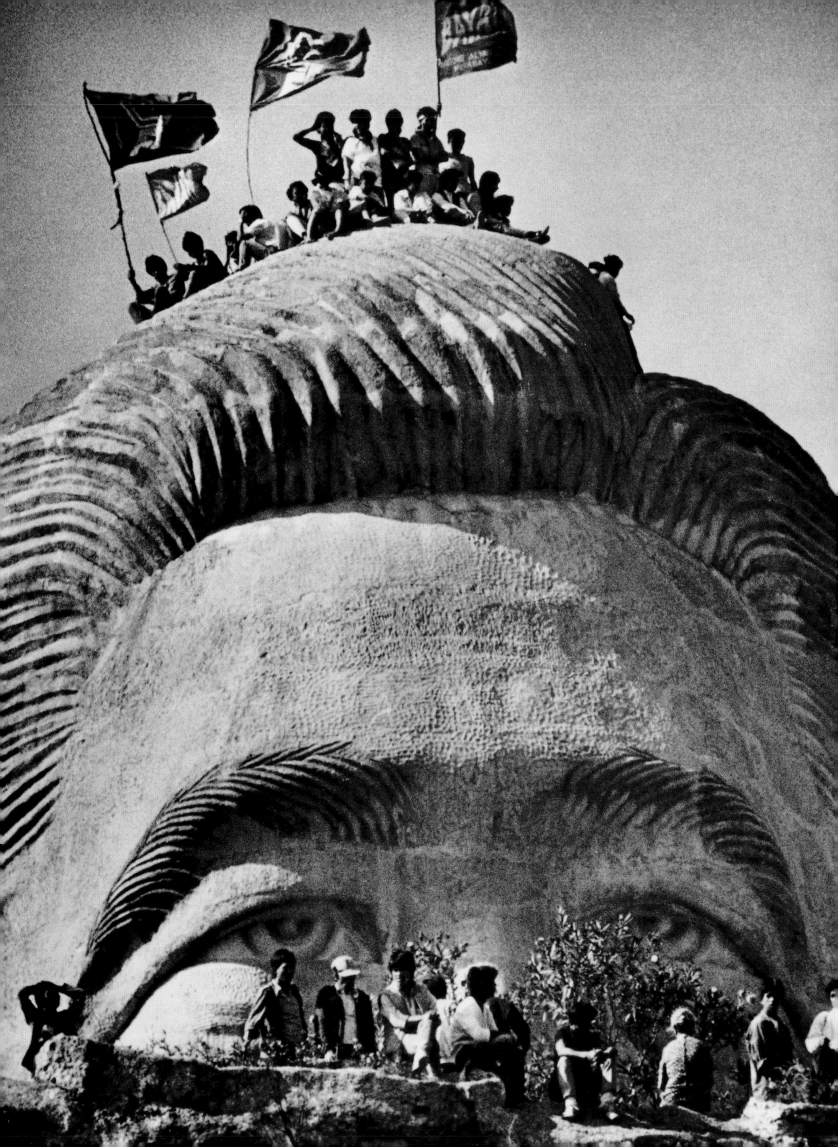

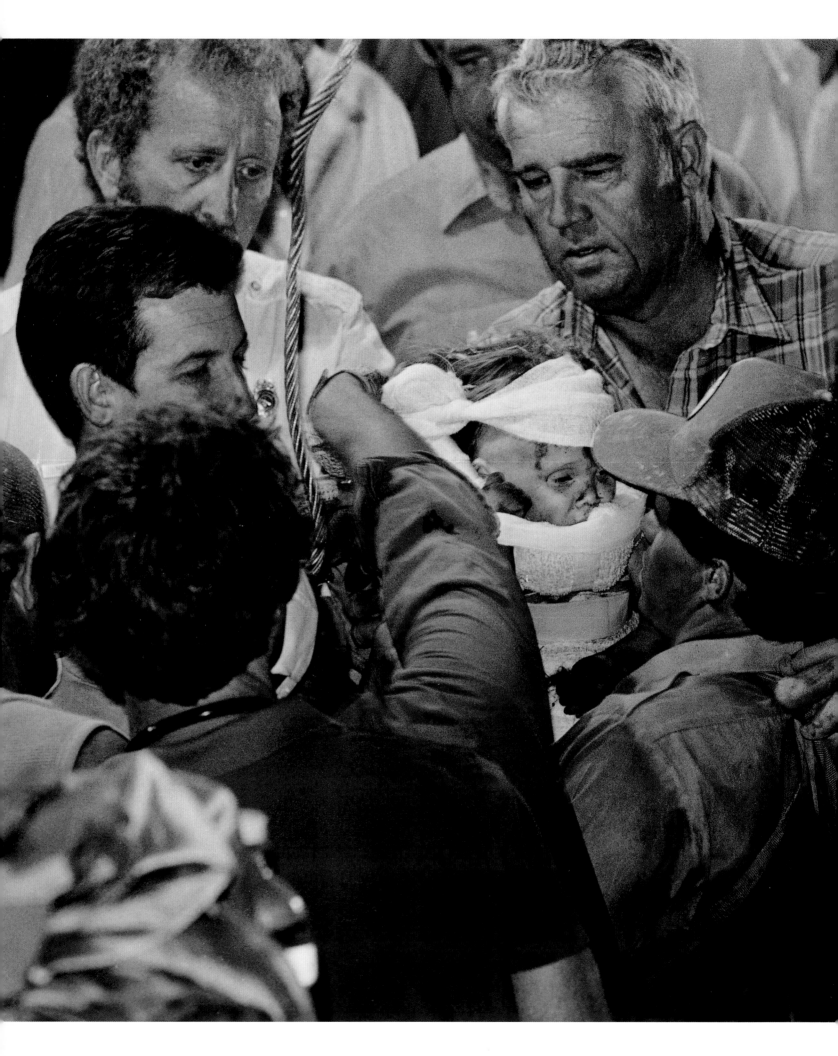

'Hardest thing I've ever had to do'

It is one of the media events of the decade. Eighteen-month old Jessica McClure toddles across her aunt's back yard in Midland, Texas, and falls 22 feet down a narrow well. Within minutes, rescue crews begin an intense effort to free her. Within hours, news teams from around the world jockey for position.

Squeezed in among the satellite trucks and media stars is Scott Shaw, photographer for the *Odessa American*. "The conditions were trying," says Shaw. "It was probably the hardest thing I've ever had to do."

Rescue workers decide to dig a shaft alongside the well, then tunnel across and pull Jessica out. With shovels, a backhoe and finally a drilling rig, they work furiously to reach the frightened little girl. The rescuers call out to Jessica. They even sing "Winnie the Pooh," her favorite song.

Hours turn into days. Nobody sleeps, including Shaw. "I visualized that if I went to sleep, I would wake up, and everybody would be gone." On Oct. 17, after 58 hours, the drillers break through. "As soon as (Jessica) came up, I knew it would be a brief period of time to get photos, so I just shot as quickly as I could. I was just so keyed in on making good photographs."

Despite the crush, Shaw gets his shot: baby Jessica, battered, bruised and very much alive; her rescuers, dirty, exhausted and enormously relieved.

1988 Spot News
BABY GIRL RESCUED FROM WELL
Scott Shaw

October 17, 1987, Midland, Texas

Odessa (Texas) *American*

Nikon F3, Nikkor 180 mm lens, Kodak Tri-X film

Courtesy of *Odessa* (Texas) *American*

'Step over this line and be human'

Officials call it Site 5, Project F 27-B. Residents call it The Graveyard. In 1986, it's a trash-littered public housing project that acts as a magnet for crack addicts, dealers—and Michel duCille, a *Miami Herald* photographer determined to show the real story of crack cocaine.

"Everyone had been painting it as a black inner-city problem. I set out to show that people in all walks of life were involved." In The Graveyard, duCille finds "black crack dealers who pretty much took over the apartment complex. They were kings there. White buyers would come in, prostitutes would come in, Hispanic buyers would come in."

For weeks at a time, duCille hangs out in The Graveyard, photographing lives fading to ruin. "You have to be there and they have to get to know you. They need to feel comfortable with you." A construction worker sucks cocaine fumes from a beer can. A woman turns tricks to support her habit. Four little girls roam their apartment, unsupervised, while their mother sleeps off her high from the night before. "Her baby would run around all day in one dirty diaper, without a bath. We brought her diapers and soap. There is a certain line of humanity that you have to draw and you say 'I have to step over this line and be human.'"

The publication of duCille's photographs moves people and stimulates change. The government sweeps in, cleaning up the complex and driving out the crackheads. "When I went through there a year or so ago, it had been painted pastel peach and white."

1988 Feature
THE GRAVEYARD
Michel duCille

1987, Miami, Florida
The Miami Herald
Nikon F2, 50 mm lens, Kodak Tri-X film
Courtesy of Michel duCille

'There was nothing
I could do'

Dec. 31, 1988. It's 6 a.m. and St. Louis furniture wholesaler Ron Olshwanger is finally on his way home. He has been up half the night, pursuing his hobby — photography — at a fire downtown. Olshwanger hears a call about another fire on his police radio. "I was freezing cold, I was full of smoke. I figured I wouldn't even go. Then I saw the smoke."

Minutes later, Olshwanger is watching an apartment building collapsing in flames. Firefighters rush in. There is screaming. Rescue workers stumble out, overwhelmed by smoke and heat. Says Olshwanger: "I pointed the camera toward the entrance. I saw Adam Long come running out. He had the baby in his arms and his helmet pushed back and he was giving her mouth to mouth." The photographer puts his finger on the shutter release.

"I've been at other fires where I didn't get the pictures because I was helping the victims," says Olshwanger. "But in this situation, there was nothing I could do." Olshwanger shoots as the firefighter runs toward the ambulance, where the girl's mother and sister wait to go to the hospital, badly burned.

Olshwanger's photographs make the front page of the *St. Louis Post-Dispatch*. The little girl does not survive. "It was her 2-year-old birthday. It was very sad. But she saved a lot of lives." Homeowners, schools and fire houses still display Olshwanger's photograph — a vivid reminder of the importance of smoke detectors and fire-prevention programs.

1989 Spot News
GIVING LIFE
Ron Olshwanger

December 31, 1988,
St. Louis, Missouri

St. Louis Post-Dispatch

Minolta X700, 28 mm–70 mm
zoom lens, Agvar Studio 35
400 ASA film

Courtesy of Ron Olshwanger

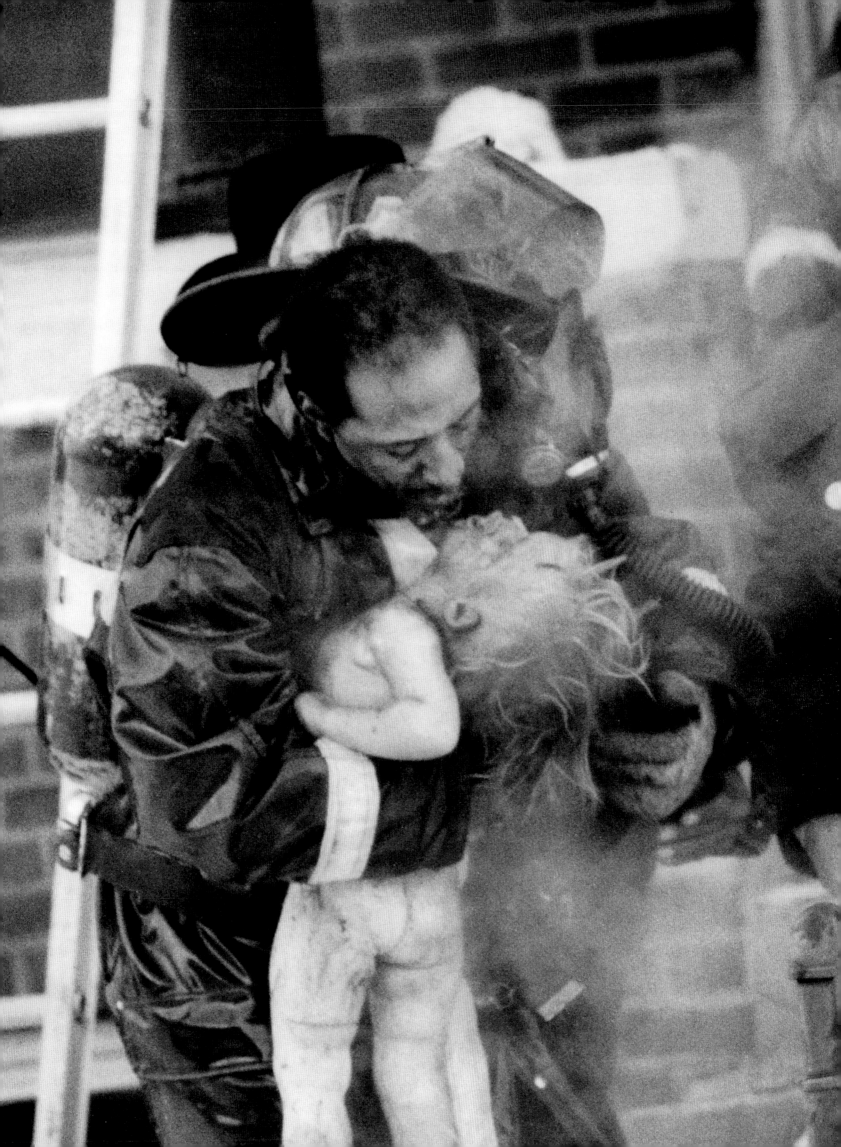

'The things that make the high school tick'

"I have been in their classrooms and lunch rooms and hangouts. I have cheered them on at games and cried with them at a funeral. I have played basketball with them in the gym and danced with them in the cafeteria.... I have seen them when they were bad and when they were good."

During the 1987–1988 school year, *Detroit Free Press* photographer Manny Crisostomo spends 40 weeks at Detroit's Southwestern High. The project begins with a letter to the school superintendent: "I'd like to photograph the things that make the high school tick. Classes, students, teachers, athletics, as well as the socioeconomic factors away from the classroom that have an impact on the students ... I hope to capture the special character of high school life."

The students at Southwestern High — black, white, Hispanic, Arab — come out of a community where resources are tight, unemployment is high and crime is an ever-present threat. Yet the photographer finds Southwestern "just like any other high school in America. You had problems with dating, with proms, with homecoming. Yet some kids would have to walk by three or four crack houses on their way to school."

Crisostomo mourns students lost to drugs, dropping out, teen pregnancy. Yet he finds cause to rejoice: "We talked, laughed and argued about the city and the world. I saw a lot of them mature and come to grips with impending adulthood."

1989 Feature

CLASS ACT AT
SOUTHWESTERN
HIGH

Manny Crisostomo

1987/1988, Detroit, Michigan

Detroit Free Press

Canon F1-11, 24 mm lens,
Kodak T MAX 400 ASA & 3200
ASA film

Courtesy of Manny Crisostomo

'People were almost silly with euphoria'

"I'm still reeling from the roller coaster of emotions of that year." The year is 1989, when *Detroit Free Press* photographer David Turnley sees democratic reform grind to a halt in China, then sweep across Eastern Europe and the Soviet Union.

Turnley is in Beijing in June when thousands demonstrate for democratic reform. "I found students in Tiananmen Square playing guitars and singing Beatles songs," he says. "I felt like I was going to experience what it was like to change the status quo." What he photographs instead is a massacre, as Chinese soldiers kill uncounted demonstrators near Tiananmen Square. Remembers the photographer: "To see the youth of that society having their dreams crushed was very disillusioning."

Despite events in China, the pro-democracy movement marches forward. Hungary opens its borders. Poland holds free elections. On Nov. 9, the Berlin Wall comes down. "I had gone to East Germany in early October and there was no sense that change was imminent," says Turnley. "It was absolutely shocking to me." Rushing to Berlin, Turnley photographs Germans attacking the wall with vengeful glee. "People were almost silly with euphoria. It was just such an unexpected, complete shift in the status quo."

Turnley follows the "democratic wave" to Czechoslovakia, where he photographs that "romantic revolution," and on to Romania, where Romanians who take to the streets are met by Nicolae Ceausescu's brutal security force. "It wasn't clear that the Romanians understood so much what they were aspiring toward as what they were aspiring against under Ceausescu." After a civil war that ends in Ceausescu's execution, Turnley photographs Romanians celebrating change, not knowing what the future will bring.

1990 Feature
FREEDOM UPRISING
David C. Turnley

1989, Romania, Germany and China

Detroit Free Press

Nikon F4, 28 mm, 85 mm, 180 mm lenses, Kodak color negative film

Courtesy of Corbis

'I was mostly reacting… recording history'

The Loma Prieta quake hits the San Francisco Bay Area on Oct. 17, 1989, at 5:04 p.m. Buildings crumble. Highways buckle. Fires roar. Drivers heading across the Bay Bridge dodge chunks of falling roadway. In Oakland, a mile and a half section of the double-deck Nimitz freeway collapses, crushing dozens of people inside their cars.

It could have been worse. Many people already are home, ready to watch the third game of the World Series on television. Some 60,000 fans pack San Francisco's Candlestick Park to see the game live. One of them is Ron Riesterer, photo editor for *The Oakland Tribune*. "I was sitting in a field box. The whole box went left then went back to the right. I immediately turned around and took a picture of the crowd. People upstairs got really scared."

Tribune photographers fan out around the city. Michael Macor heads for the collapsed Nimitz freeway. "I walked up an on-ramp and crossed to the other side. I looked down the length of the freeway and saw medical personnel working on a victim. I moved in closer and lower to the ground to show the medical team as well as the destruction. I was mostly reacting… recording history as best I could."

1990 Spot News
DEADLY QUAKE
*Oakland Tribune
Photo staff*

October 17, 1989, San Francisco, California

The Oakland Tribune

Nikon FM2, Nikkor 24 mm lens, Kodak Tri-X film

Courtesy of *The Oakland Tribune*

Michael Macor

'This was about people, defenseless, helpless'

In 1990, 120,000 Romanian children live in orphanages. Many have been placed there by parents with few resources and little access to birth control under the reign of dictator Nicolae Ceausescu. Abandoned, often disabled, the children live in crowded, dirty buildings. Food is minimal. Toys don't exist. Adult contact is rare.

William Snyder travels to Romania to photograph the children for *The Dallas Morning News*. "It was horrible, absolutely horrible," he says. At each orphanage, scores of children clamor around Snyder, desperate for attention. "I was a human being, someone that you could touch and see. The kids were all over me. I had a son about 2 years old. I just kept projecting him in that situation. It was very difficult."

Staff members are overworked, underpaid and often poorly qualified. "A lot of the workers didn't care about the children. They did the bare minimum. They swaddled the infants so that they wouldn't roll around and create problems, therefore restricting motor growth and coordination." An exception is Mimi Rizescu, "one of the few workers who really cared about the children." One of Snyder's photographs shows Mimi at the Vulturesti Home For Irrecoverables, feeding a 15-year-old who can't feed himself.

"I had always been a run-and-gun photographer. Going to Romania changed everything for me. This wasn't about pictures, this was about people, defenseless, helpless people. It was no longer just pictures to be taken, it was stories to be told."

1991 Feature

FORGOTTEN
CHILDREN
William Snyder

May 1990, Vulturesti, Romania

The Dallas Morning News

Nikon F2 & FM2, 105 mm
lens, Kodak color negative film

Courtesy of William Snyder

'Who is he? What's he done?'

Soweto, South Africa: It's not yet dawn when Greg Marinovich and Associated Press reporter Tom Cohen stumble onto a gunfight between supporters of the African National Congress and the predominantly Zulu Inkatha Freedom Party. A train pulls into a nearby station; a Zulu man, Lindsaye Tshabalala, disembarks. "He could have been returning from a night shift or making an early start to visit friends," says Marinovich.

ANC youths seize Tshabalala. "They began to stone and stab him. I watched in shock as he fell to the ground." The assault intensifies; finally, "a man hauled out a massive, shiny Bowie knife and stabbed hard into the victim's chest. My heart was racing and I had difficulty taking deep enough breaths. I called out 'Who is he? What's he done?' A voice from the crowd replied, 'He's an Inkatha spy.'"

When Marinovich tries to argue, the attackers insist he stop taking pictures. Marinovich says, "I'll stop taking pictures when you stop killing him." The brutal attack continues. "For those crucial minutes, it was as if I lost my grasp of what was going on. The pictures I kept mechanically snapping off would later substitute for the events my memory could not recall."

The Zulu now lies motionless on the ground. Marinovich is momentarily drawn away by an attack on another man.

"Suddenly, I heard a hollow 'whoof' and women began to ululate in a celebration of victory. Dread filled me. The man I thought dead was running across the field below us, his body enveloped in flames. A bare-chested, barefoot man ran into view and swung a machete into the man's blazing skull as a frantic young boy fled from this vision of hell."

Marinovich makes it back to his car. "I pulled over and, closing my eyes, began to beat the steering wheel with my fists. I could finally scream."

1991 Spot News
HUMAN TORCH
Greg Marinovich

September 15, 1990,
Soweto, South Africa

The Associated Press

Nikkormat, Nikkor 300 mm
F5.6 lens, Fuji film

Courtesy of Greg Marinovich

'Something of historical significance'

On Aug. 18, 1991, hard-line Communist Party officials demand the resignation of Soviet president Mikhail Gorbachev. He refuses. They hold him prisoner at his summer dacha and declare his resignation due to "ill health."

Associated Press photographer Olga Shalygin is in Moscow, filling in for the bureau's vacationing photo editor. "I was nervous because I hadn't done that type of management before," she says. "Everyone said, 'Don't worry about it. It's really quiet in the summer.'"

On Aug. 19, Shalygin hears a rumble in the street. She grabs her camera and hurries out of AP's Moscow office. "Tanks were rolling down. I got an image of a woman, hysterical and crying, 'Boys, boys, why the tanks?'" Shalygin's "quiet summer" is over. She sends out her pictures and rounds up the staff.

Photojournalist Alexander Zemlianichenko is about to leave on vacation. Instead, he heads for Moscow's television station. "There were armed military guards manning it like a checkpoint. Not letting people through into the TV area. Then I came to the AP bureau and saw the tanks. I felt my heart pounding. Really beating. This was something important. Something of historical significance."

In the end, the hard-liners fail to win over the military and the KGB. Within three days, the coup falls apart. On Dec. 25, Mikhail Gorbachev resigns. By the end of the year, the Soviet Union collapses.

1992 Spot News
RUSSIAN COUP
The Associated Press staff

August 23, 1991, Moscow, Soviet Union

The Associated Press

Nikon 801, 20 mm lens, Fuji 400 film

Courtesy of The Associated Press

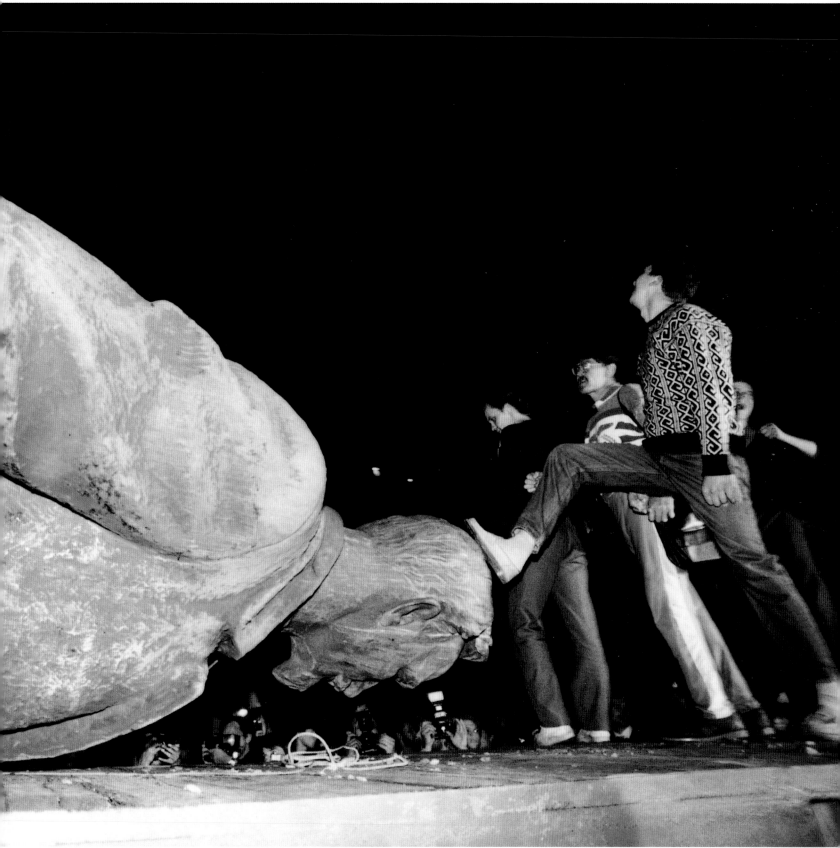

Alexander Zemlianichenko

163

'Interested in finding out who they are'

As John Kaplan photographs a 21-year-old murder suspect in Pittsburgh, he begins to wonder whether the young man's fate would have been different "if he had been from a better, safer part of town."

Kaplan decides to photograph a diverse group of 21-year-olds, "people who were cultural icons, people who we might fantasize being when we grow up and . . . people who had been left behind."

Model Tanya Mayeux "instantly hit." She goes from making minimum wage at Kmart to $7,000 a day as a high-fashion model after she is discovered by a talent scout in a shopping mall.

Heavy-metal singer Phil Anselmo was a creative and imaginative child, then a rebellious adolescent, "before finding a passion for knife-edged rock 'n' roll."

Detroit Lions rookie Mark Spindler sees a promising professional football career fizzle when a knee injury sidelines him after three games.

Brian, a male prostitute, hustles customers in San Francisco's streets and gay bars to support his drug habit.

No matter what their circumstances, says Kaplan, "people see it as a compliment that you're interested in finding out who they are." His work reflects the notion that "in America, we have a variety of choices, but those choices are limited by background, environment, individual talents and today's wide polarization of American society."

1992 Feature

AGE '21' IN AMERICA
John Kaplan

Period of months in 1991, Massachusetts, California and New York

Block Newspapers

Nikon F4, various lenses, Kodak Tri-X film

Courtesy of John Kaplan

'They broke into celebration'

In July 1992, 600 photojournalists arrive in Barcelona, Spain, to cover the summer Olympic Games. Some news organizations field dozens of photographers. *The Dallas Morning News* sends two: William Snyder and Ken Geiger.

For Geiger, photographing the Olympics is "one of the hardest things I've ever had to do. It's a marathon for a journalist." Snyder agrees: "Our goal was to be the lead photo on Page One every day. . . . I remember what it felt like to score a goal or win a race. That's what I was after, to capture what it felt like and bring it home to the people who look at our pictures."

Geiger's finds his first event, men's soccer, "kind of intimidating. . . . When I edited the film, I was real pleased. I thought 'Man I hope I can keep up this pace.'"

The photographers divvy up the events. Snyder gets basketball and diving. "We did what we wanted to do," he says. "We went out there with the idea that not only would we get the moments, but we would also try to shoot things differently."

Geiger covers track and field. He has just finished photographing the U.S. women's team winning the 4 x 100 relay when he notices the Nigerian women watching the scoreboard. "When it became official that they had third place (a Bronze medal), they broke into celebration. I had to change cameras to one with a shorter lens. Then I took the photo."

1993 Spot News
OLYMPICS IN BARCELONA
Ken Geiger and William Snyder

July 8, 1992, Barcelona, Spain

The Dallas Morning News

Canon EOS-1, Canon 600 mm F4.0 lens, Kodak Ektapress 400 film

Courtesy of Ken Geiger, William Snyder and *The Dallas Morning News*

Ken Geiger

'Difficult to find something different to shoot'

"It was just a typical campaign day where President Bill Clinton was kind of hopscotching around New Hampshire. He was real big on shaking everybody's hand. I'll bet he shook every hand in the state twice."

In 1992, Greg Gibson follows the Clinton presidential campaign for The Associated Press. Gibson and his colleagues shoot Clinton at press conferences, at debates, with his family, while he plays the saxophone. Everywhere they go, there are hordes of potential voters, campaign workers — and journalists. "There was so much press and so much interest in him. It was difficult to find something different to shoot."

One day, Gibson photographs a campaign stop at a shopping center. "I saw this little boy leaning on the counter and he had his head in his hands and I just knew Clinton was going to stop there. Sure enough he did, and he's talking to the boy and pretty soon Clinton has his chin in his hand just like the boy.

"I've always thought this was one of his greatest strengths, to connect with anyone he talks to, from a head of state to an average voter to a little child. He really had that connection with people. He made people feel important."

1993 Feature

SMALL TALK

The Associated Press staff

February 14, 1992, Salem, New Hampshire

The Associated Press

Nikon 8008, 24 mm lens, Kodak Ektapress 400 film

The Associated Press

Greg Gibson

'The mob parted long enough'

In the early 1990s, clan warfare ravages Somalia. Famine spreads. A United States-led multinational force restores supply lines, but its presence creates new tensions. In July 1993, four journalists are beaten to death by an angry mob. Most Western journalists flee. Paul Watson of *The Toronto Star* stays behind.

The press corps is down to just a few journalists, says Watson, when Somali gunmen shoot down an American helicopter in late September. "Witnesses said people dragged part of an American corpse away in a sack to put it on display," says the photographer. "The Pentagon flatly denied that American body parts were being paraded through the streets of Mogadishu."

On Oct. 3, a U.S. Army unit engages in a fierce fight with Somali warlord Mohammed Farah Aidid. In the aftermath, Watson hears that an American serviceman has been captured. Out on the street, he discovers a mob dragging the body of a U.S. soldier. "I approached with a bodyguard on either side. The mob parted long enough for me to shoot about seven frames. My bodyguard forced me back into the car because he had heard threats from the crowd."

Watson's first photographs show the filthy body of the dead soldier, clad only in underwear, partially exposing his genitalia. "I jumped out to get just a few frames more. They were all half-body pictures. I didn't want to give any editor an excuse not to use the picture."

Hundreds of newspapers publish the photograph. The public reacts with horror. In March 1994, the United States withdraws its entire military force from Somalia.

1994 Spot News

DEAD U.S. SOLDIER IN MOGADISHU
Paul Watson

October 3, 1993, Mogadishu, Somalia

The Toronto Star

Nikon 8008/801, Nikkor 35 mm–70 mm zoom lens, Fuji 400 film

Courtesy of *The Toronto Star*

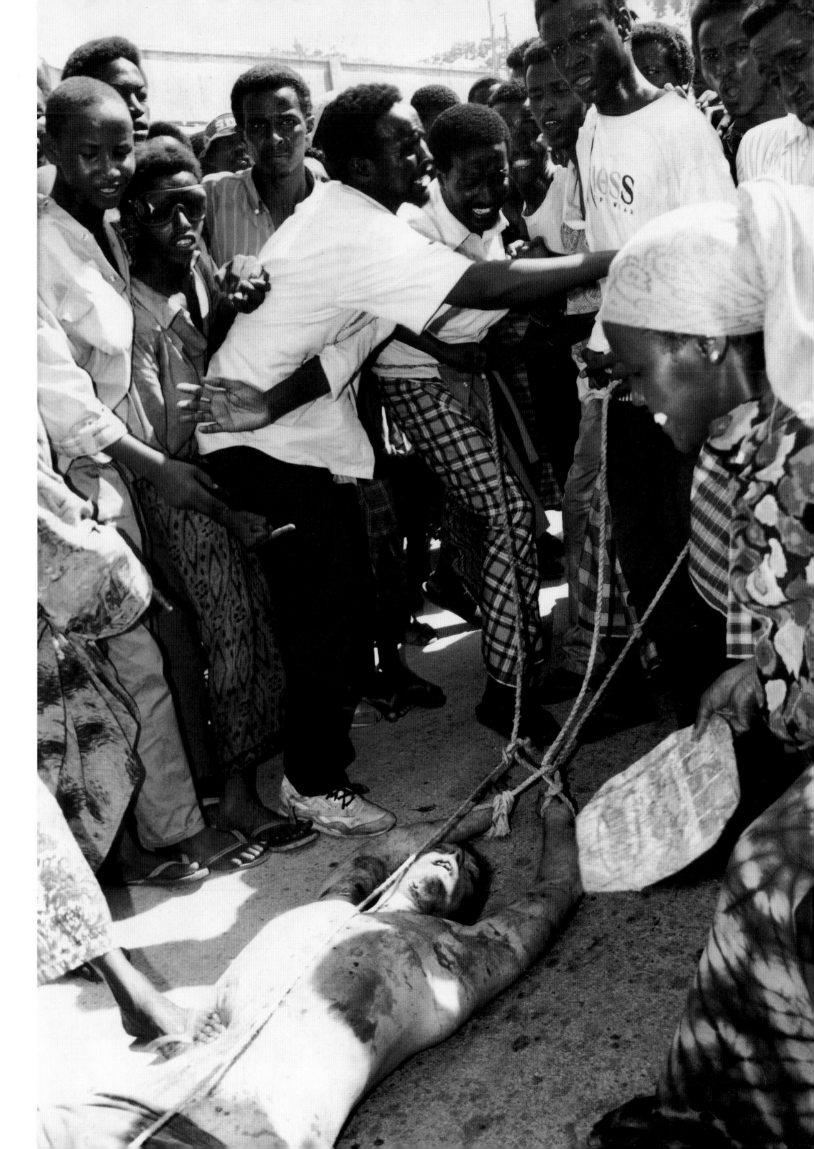

'I'm really, really sorry I didn't pick the child up'

By February 1993, South African photojournalist Kevin Carter has spent a decade photographing the political strife roiling his homeland. He describes lying in the middle of a gunfight, "wondering about which millisecond next I was going to die, about putting something on film they could use as my last picture."

Needing a change, Carter travels to the Sudan to cover the relentless East African famine. At a feeding station at Ayod, he finds people so weakened by hunger that they are dying at the rate of 20 an hour. As he photographs their hollow eyes and bloated bellies, Carter hears a soft whimpering in the bush. Investigating, he finds a tiny girl trying to make her way to the feeding center. Carter crouches, readying his camera. Suddenly, a vulture lands nearby. Carter waits. The vulture waits. Carter takes his photographs, then chases the bird away. Afterward, he sits under a tree and cries.

The photograph runs in newspapers worldwide. Carter receives outraged letters and angry midnight phone calls. Everyone wants to know: Why didn't he pick up the child?

Journalists in the Sudan had been told not to touch famine victims, because of the risk of transmitting disease. This is no comfort to Carter, who tells a friend, "I'm really, really sorry I didn't pick the child up." The controversy and other personal problems overwhelm him. On July 26, 1994, police find Kevin Carter dead, an apparent suicide. He is 33 years old.

1994 Feature
WAITING GAME FOR
SUDANESE CHILD
Kevin Carter

March 23, 1993, Ayod, Sudan

The New York Times

Nikon F3, Nikkor 180 mm F2.8 lens,
Fujichrome 100 film

Courtesy of Kevin Carter/Corbis/Sygma

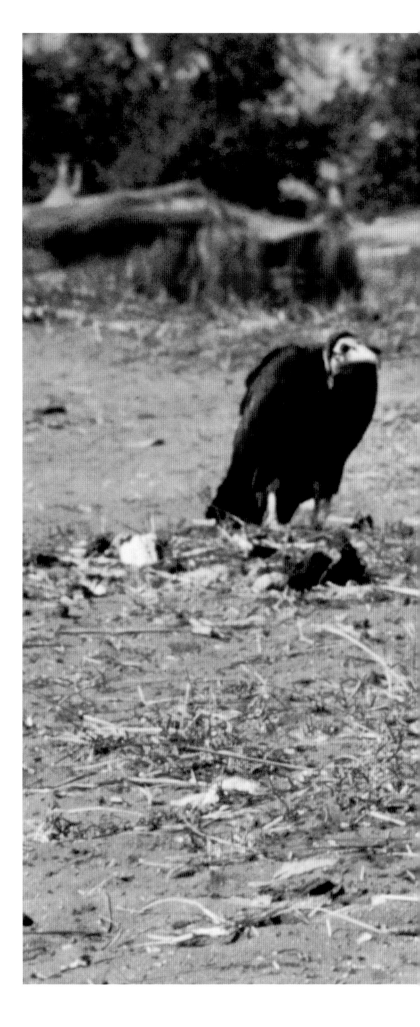

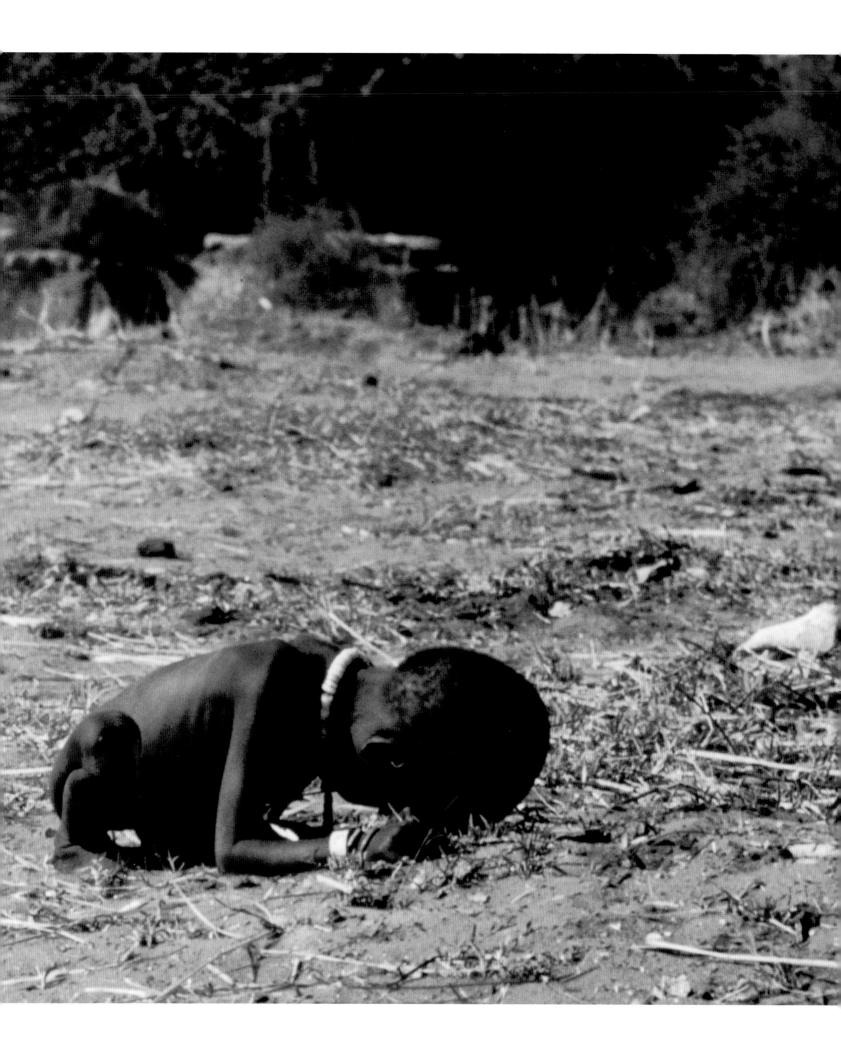

'They were trying to tear him apart'

"Some say I became obsessed, but I'd rather call it a mission." Carol Guzy has covered Haiti since the early 1980s, returning on her own when she cannot convince an editor to send her. "I felt like I had to make people see what was going on there," says Guzy. "The country is so small no one in the U.S. is aware of it."

On Dec. 16, 1990, Jean-Bertrand Aristide wins Haiti's first free presidential elections. Less than a year later, he is deposed and sent into exile. The United States imposes a trade embargo; thousands of Haitians flee. "I had gotten to the point that even I had lost all hope," says Guzy. "I thought nothing would get better. The military government was entrenched." In September 1994, U.S. troops land in Haiti to help return Aristide to power. "There were still a lot of problems," says Guzy. "But for the first time in a long time I saw hope and even jubilation in people's eyes."

In Port-au-Prince, Guzy photographs a "very joyous democracy march." Then someone throws a grenade into the crowd. "People were killed and wounded. There was shooting, nobody could figure out where it was coming from. I hit the ground with everybody else. I turned and saw the (U.S.) soldier. The guy on the ground with his arm raised up, the crowd thought he had thrown the grenade and they were trying to tear him apart. The U.S. troops were trying to protect him."

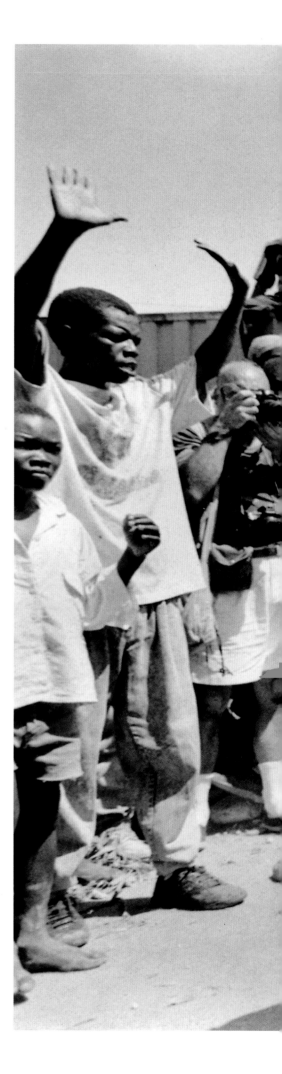

1995 Spot News
CRISIS IN HAITI
Carol Guzy

September 29, 1994,
Port-au-Prince, Haiti

The Washington Post

Nikon F3, 20 mm lens,
Fuji film

Courtesy of *The Washington Post*

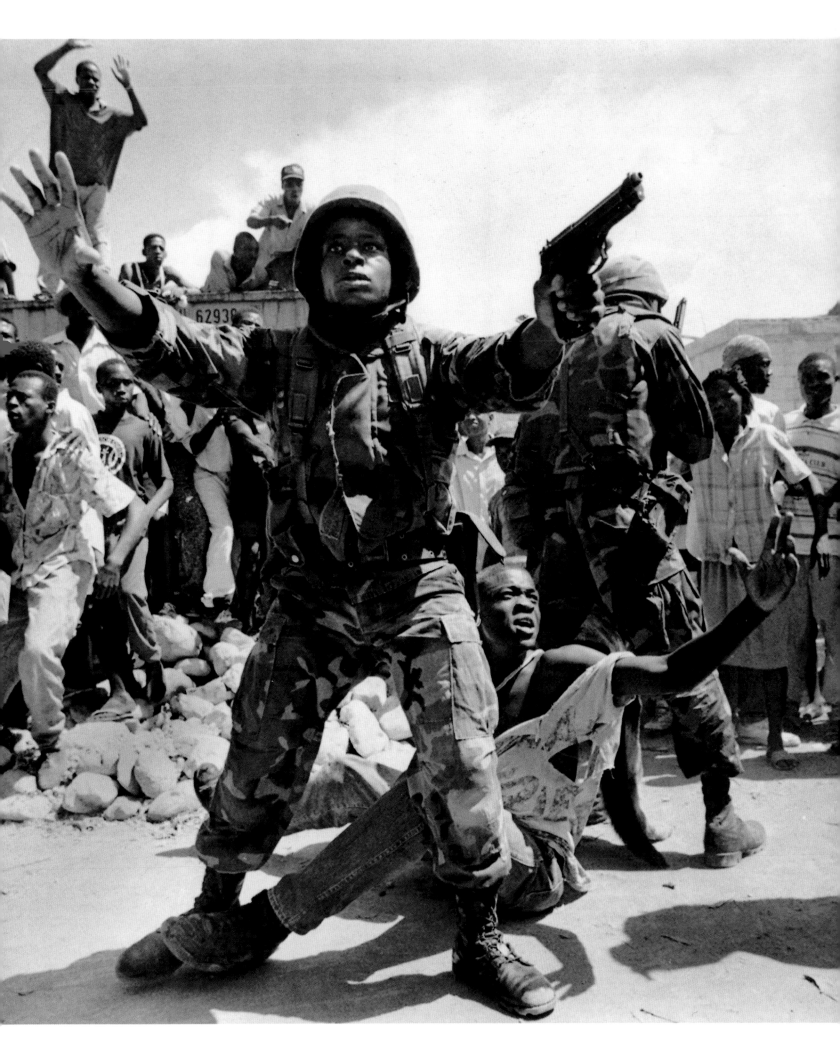

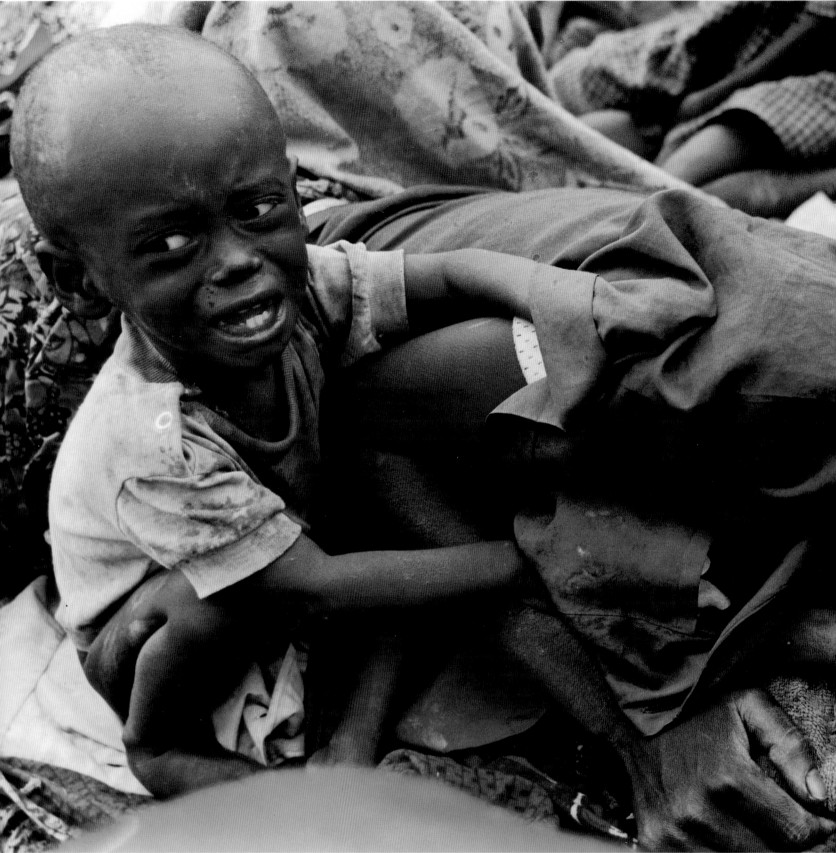

Javier Bauluz

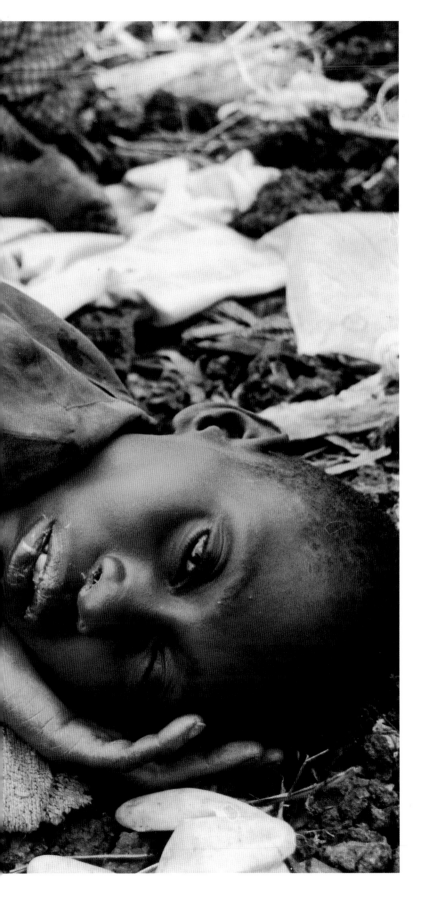

'A sea of scared, dirty and disheartened humanity'

Rwanda 1994. The centuries-old conflict between the Hutu and Tutsi tribes erupts in a wave of anarchy and genocide. Nearly 500,000 people are killed. Four photographers cover the devastating violence and its terrible aftermath for The Associated Press.

Karsten Thielker: "I don't want to send pictures of bones in dirty bloody clothes from the church massacre, of the rotting bodies in the middle of the street. I dread sending pictures of these hundreds of dead, lying together as if they were still afraid to die."

Javier Bauluz: "I saw a blanket by the edge of the road. One more dead.... Then I heard a cry.... I unfolded the blanket and found a child, maybe 7 years old. Fighting the repugnance of the smell and grime, I took him in my arms and walked some 100 yards to the hospital."

Jacqueline Arzt Larma: "As I was photographing, my eye would routinely linger in the frame to see if the person I was photographing was breathing."

Jean-Marc Bouju: "In a field of dead people, you just concentrate on taking pictures, trying to forget the smell.... The smell of rotting human flesh was absolutely everywhere.... The camps were a mess, swarms of Hutus and tens of thousands of kids. The lucky ones with their parents, the others just trying to survive.... It was a sea of scared, dirty and disheartened humanity."

Some do survive the killings — only to be struck down by cholera, which sweeps through the refugee camps, claiming hundreds of lives. At Munigi camp outside Goma, Zaire, a Hutu child cries for his sick mother.

1995 Feature

DESPAIR OF RWANDA

The Associated Press staff

July 27, 1994, Goma, Zaire

The Associated Press

Nikon 90, 28 mm–70 mm zoom lens, Fuji film

Courtesy of The Associated Press

'Mom, why can't you save me?'

"When you know something so brutal is going on, and women are singled out, you can't look away." In 1995, Stephanie Welsh is an intern on an English-language newspaper in Nairobi, Kenya, when she learns about ritual circumcision.

"I heard women at work whispering about it," says Welsh. "I learned about a Meru secretary who couldn't go home because her grandparents would have had her forcibly circumcised." After months of searching, Welsh locates 16-year-old Seita Lengila, whose family agrees to allow Welsh to photograph the ritual. "The family was somewhat honored that I wanted to be there because it's the most significant moment in her life. It's a celebration. Seita, since she had been to school, was afraid. She knew it was painful and it was dangerous. And that's something nobody else in the tribe ever talks about."

Each year, as many as 2 million African girls are circumcised—the clitoris and parts of the labia are cut away in hopes of keeping a girl pure for marriage. In Seita's village, the circumcision is done with a razor blade instead of a knife. "When they started cutting, Seita screamed, 'Why are you killing me?' and 'Oh, Mom, why can't you save me?'...I was shaking so terribly I could hardly focus.

"The ritual is very beautiful, if you take away the mutilation. It's the most important rite of passage in a girl's life, her initiation into the culture. But circumcision is a debilitating operation that takes away a woman's sexual pleasure and leads to enormous medical complications."

When it is all over, Seita staggers out to the bush. "She wanted to see what they had done to her in the light," says Welsh. "I stayed beside her for a long time."

1996 Feature
RITUAL OF OPPRESSION
Stephanie Welsh

April 1995, Samburu Village, Naibelibel, Kenya

Newhouse News Service

Nikon 8008/801, FM2, 28 mm, 85 mm lenses, Fuji 800, Kodak 100 and 400 films

Courtesy of Stephanie Welsh

'A loud boom, like a sonic boom'

On April 19, 1995, Charles Porter is working in the loan department at Liberty Bank in downtown Oklahoma City. Suddenly "there was just a huge, huge explosion...a loud boom, like a sonic boom. The whole building shook, the windows were bowing back and forth. We looked out the window and saw debris fluttering up in the air, this light-brown cloud rising up."

Thinking someone is demolishing a building downtown, Porter, an aspiring photojournalist, hurries to his car, grabs his camera and runs toward the explosion. "There is glass all over the street. I see people lying on the ground. A guy walks by without his shirt and blood is streaming from his head."

When Porter reaches the Alfred P. Murrah Federal Building, "it's like they shaved off the front of the building and then they took an ice cream scoop and scooped right down the center. You could see through the building."

Porter photographs a church with its stained-glass windows blown out, rescue workers aiding the wounded. Then "I see something run toward the left corner of my eye. I turn with my camera: It's a policeman carrying something. I snap the frame just as the policeman hands it to a fireman. The fireman turns, and he's holding this infant. He just holds it there for a couple of seconds. I take one shot."

The explosion injures more than 500 people. It kills 168, including the child in Porter's picture, Baylee Almon, just 1 year old.

1996 Spot News

OKLAHOMA CITY BOMBING
Charles Porter IV

April 19, 1995, Oklahoma City, Oklahoma

The Associated Press

Canon A2, 70 mm–210 mm zoom F2.8 lens, Kodak Gold 200 film

Courtesy of Charles Porter IV

'Share the prize with Yeltsin'

In 1996, Russian president Boris Yeltsin almost doesn't run for re-election. A powerful force in national politics for more than two decades, Yeltsin has led the new Russian republic for its first six exhausting years. But his popularity has bottomed out. The war with Chechnya is going badly. His economic reforms have failed to produce results. And he is recovering from two heart attacks he suffered the year before.

Somehow, Yeltsin finds the energy to pursue another term. He appoints his daughter, Tatyana Dyachenko, to a key role in his campaign. He talks leading Russian financiers into bankrolling the venture. Then he goes on the stump, promising voters he'll abandon unpopular austerity programs, increase government spending and end military conscription.

Yeltsin keeps his media profile high. He even dances on stage at rock concerts. That is where Associated Press photographer Alexander Zemlianichenko finds the Russian president on June 10 in Rostov. As Yeltsin bops to the beat, celebrating his lead in the polls, Zemlianichenko gets his shot. "I feel like I ought to share the prize with Yeltsin," says Zemlianichenko. "If he didn't dance, I wouldn't have gotten the photo."

The first election is so close a runoff is scheduled. On July 3, Yeltsin beats his chief challenger, Gennady Zyganov, and becomes Russian president for yet another term. Within a month, like politicians everywhere, he withdraws many of his campaign promises.

1997 Feature
YELTSIN ROCKS
IN ROSTOV
*Alexander
Zemlianichenko*

June 10, 1996, Rostov, Russia

The Associated Press

Nikon F90X, 300 mm F2.8 lens,
Fuji Color 800 film

Courtesy of The Associated Press

'That girl would live or she would drown'

After eight years as a photographer for *The Press Democrat* in Santa Rosa, Calif., Annie Wells knows what to expect from winter in Northern California: drenching rains, impassable roads, sweeping floods.

But nothing can prepare her for Feb. 4, 1996, when raging flood waters trap 15-year-old Marglyn Paseka at Matanzas Creek. "When I got here she was in the water alone," says Wells. "My heart is racing. It's an incredible scene. This girl is in peril of losing her life."

Rescue workers struggle to free the girl. Wells snaps pictures. "I got some tight pictures of her face. That's what I had to see. And I also shot some wide angle shots so you could see just how big this creek was."

Marglyn fights to keep her head above the water. At times she screams; at times she cries. A firefighter swims out to attach her to a line. The current sweeps him away. The minutes tick by: Marglyn is cold. She is slurring her words. She doesn't have much time. Torn by compassion, Wells keeps her lens on the water. "At that point, I knew that one of two things would happen: that girl would live or she would drown. I just had to wait until whatever was going to happen to her, happened."

The firefighter makes one last attempt. Annie Wells clicks the shutter. The exhausted firefighter, the lifesaving harness and the terrified girl appear in a poignant tableau. Within seconds, Marglyn is locked in the harness and pulled to the safety of the bank.

1997 Spot News
TEEN RESCUED FROM
FLOOD WATERS
Annie Wells

February 4, 1996, Santa Rosa, California

The Press Democrat

Nikon F4, 180 mm lens, Fuji color film

Courtesy of *The Press Democrat*,
Santa Rosa, California

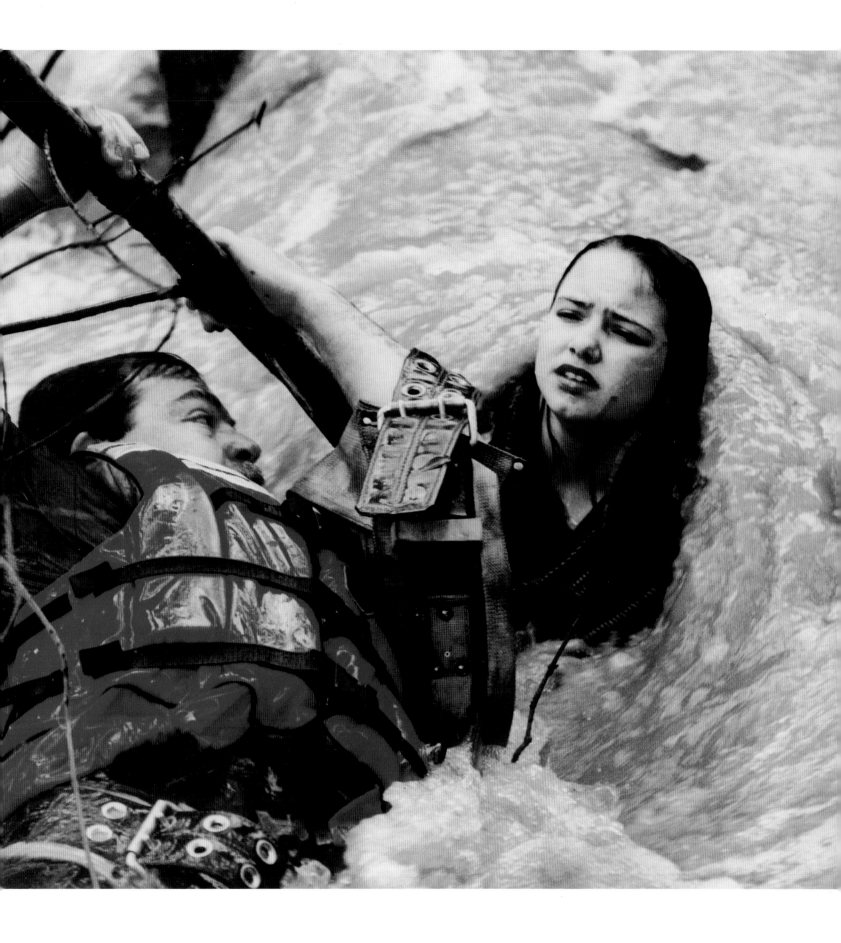

'She could feel when something was wrong'

She holds her sleepy daughter in her arms. But Theodora Triggs is not your average mother. She is a drug addict. Her daughter, Tamika, is 3 years old.

In the summer of 1997, Theodora and Tamika meet *Los Angeles Times* photographer Clarence Williams. "Tamika is the most beautiful little girl," says Williams. "I believe that she could feel when something was wrong, when her mom was high or she was nasty and needed a fix." Williams spends the summer photographing Tamika and Theodora for a story about the children of addicts. "They would wake up in the morning and I would be sitting on their front steps. I would stay there until they went to bed."

Williams' photographs reveal harsh ugliness — and occasional joys — for Tamika and other "orphans of addiction." Yet there are some photographs even Williams cannot take. When a child is biting an electrical cord, Williams puts down his camera and picks up the youngster.

Williams says Theodora is a "very bright woman" who "loves her daughter." Yet Theodora does not anticipate the photographs' drastic consequences. After the story runs, Theodora is arrested for child endangerment. "She had said that she would be together," says Williams. "That she'd be straight. But she wasn't." After her arrest, Theodora gets sober. Then she relapses. Tamika ends up in foster care.

"For me, part of it is to realize how important the story is," says Williams. "I'm a little more emotional now. My heart beats a little harder. It has raised the bar on what I do on a daily basis."

1998 Feature
ORPHANS OF
ADDICTION
Clarence J. Williams III

Summer 1997, Southern California

Los Angeles Times

Leica, 105 mm lens, Fuji color negative film

Courtesy of *Los Angeles Times*

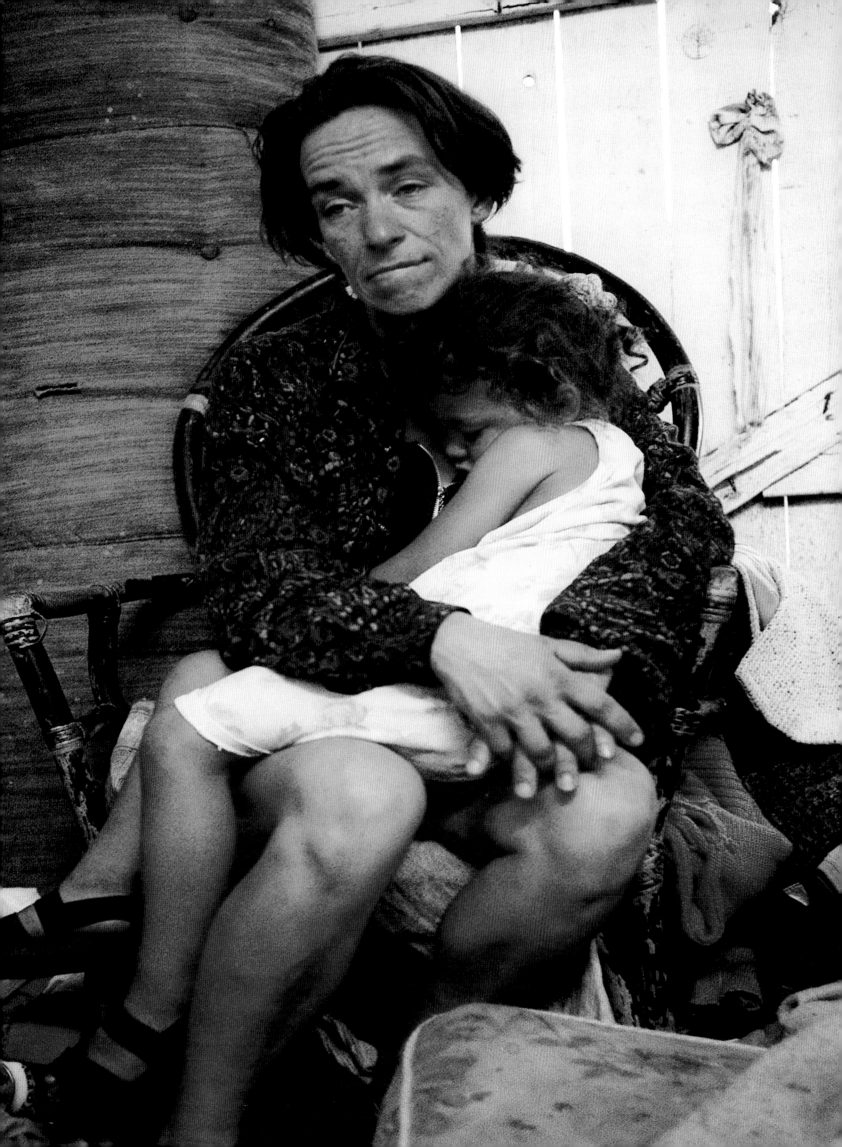

'People would flee together as a village'

The line of refugees reaches to the horizon, victims of the centuries-old warfare between Africa's Hutu and Tutsi tribes. Most are women and children. Many are hungry.

"The people would flee together as a village," says Martha Rial. "Many children were separated from their families." It is January 1997, and Rial is in Tanzania, photographing the refugees for the *Pittsburgh Post-Gazette*. The story has a personal angle for Rial: Her sister, Amy, is a nurse with the International Rescue Committee in Tanzania.

"I did photographs of her because of the Pittsburgh connection; I worked it into the whole scope of the project." Rial's pictures show her sister caring for malnourished children, refugees lining up for food, a Hutu woman who was raped and stabbed by Tutsi soldiers, a Tutsi woman who adopts an orphaned Hutu child.

Most of what she finds reeks of displacement and despair. "The stream (of refugees) you see here had been walking almost 24 hours. The previous evening they heard word that the Tanzanian government was going to force them to leave. They were trying to flee, to go deeper into the bush. They were forced back by the troops into Rwanda. The group is led by a handful of militia guys. Men who are the leaders in the communities. They may or may not be wanted for genocide."

1998 Spot News

TREK OF TEARS: AN
AFRICAN JOURNEY
Martha Rial

January 1997, Tanzania

Pittsburgh Post-Gazette

Nikon 90s, 80 mm–200 mm zoom
lens, Fuji color negative film

Courtesy of *Pittsburgh Post-Gazette*

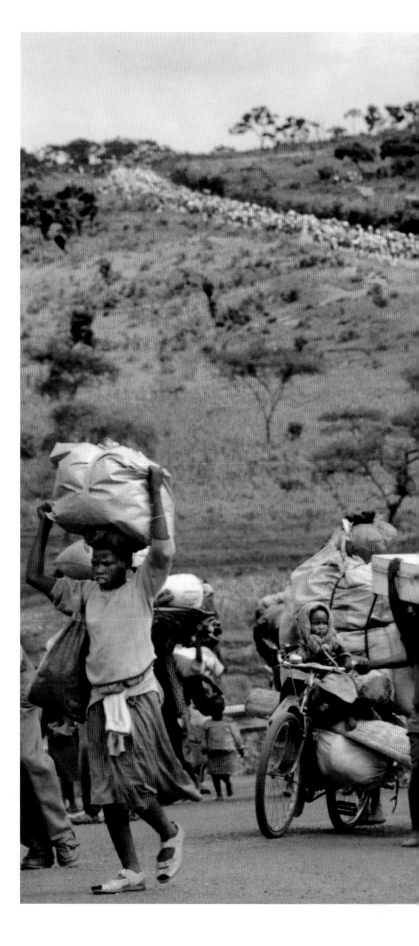

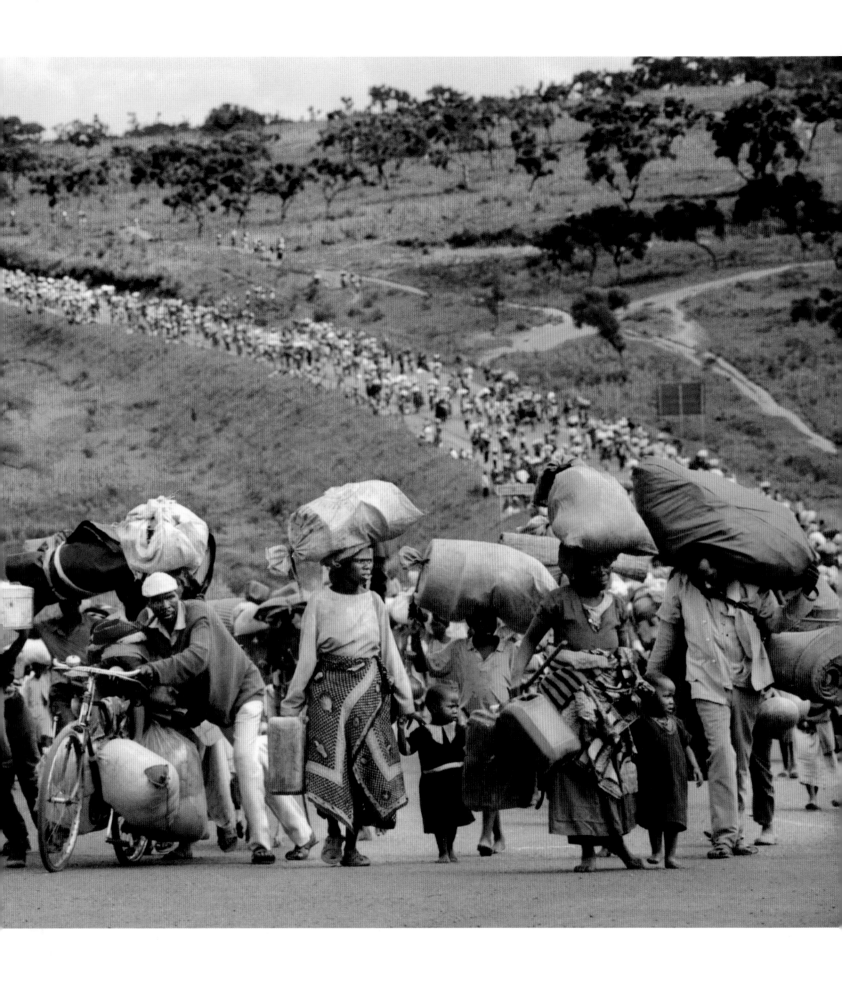

'Shaken by what I had seen'

On Aug. 7, 1998, a truck drives up to the U.S. Embassy in Nairobi, Kenya. Within minutes, a violent explosion shakes the ground. Windows shatter. Buildings collapse. Vehicles burst into flame. At almost the same moment, an explosion rocks the U.S. Embassy in Dar es Salaam, Tanzania. The two explosions kill 257 people; more than 5,000 are injured.

Associated Press photographers Khalil Senosi and Sayyid Azim are in the AP office in Nairobi when they feel the shockwave. They grab their cameras and run. Remembers Azim: "The scene was horrifying. Bodies were everywhere. I started taking pictures of people bleeding and running, dead bodies, destroyed buildings. Being a photojournalist for years, I kept myself cool. But when I got to the office I was shaken by what I had seen."

Meanwhile, AP photographer Jean-Marc Bouju rushes back from the Congo to Nairobi. "I went straight to the site," he says. "The scene was incredible — swarms of people digging to find survivors. The most memorable to me was the morgue, where dozens of mutilated bodies were piled up, with families trying to identify someone. As in any situation, you just concentrate on light, exposure...so it makes it easier to shield yourself a little from what you see." Bouju says he tries to keep in mind that "somehow, what I do is useful, showing what is happening."

Eight days later, Bouju attends the first of many burials. He photographs 5-year-old Shirley Wambui as she grieves for her aunt, a victim of the bombing.

1999 Spot News
NAIROBI EMBASSY BOMBINGS
The Associated Press staff

August 7 & August 15, 1998, Nairobi, Kenya

The Associated Press

Nikon B F E, BF2 E, 80 mm–200 mm zoom lens, Fuji 400 NPH film

Courtesy of The Associated Press

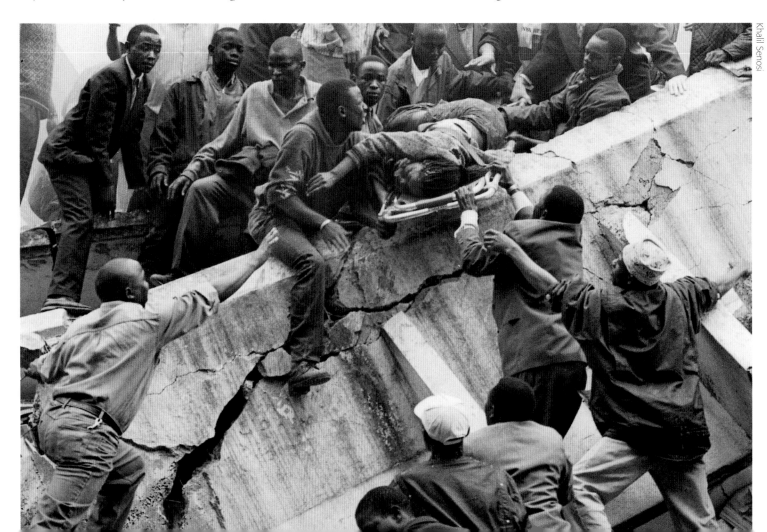

Khalil Senosi

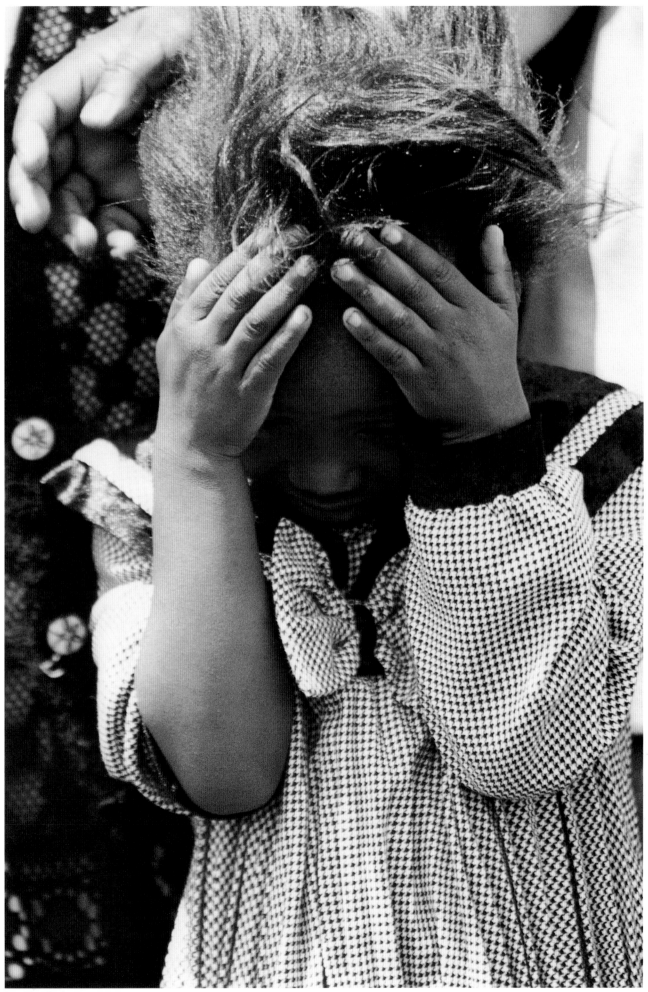

Jean-Marc Bouju

'Our lives were consumed'

Doug Mills calls it "a huge historical event. You had to keep perspective that every image that you took will be looked at again 10, 20 years down the road." In 1998, Mills is one of 15 Associated Press photographers covering the saga of President Bill Clinton and White House intern Monica Lewinsky. "Our pagers and cell phones never stopped going off," says Mills. "Our lives were consumed."

As the drama unfolds, AP photographers pursue each new player: Paula Jones, Linda Tripp, Betty Currie. Hoping to get the first fresh pictures of Monica Lewinsky, AP photographer Dan Loh helps stake out The Watergate Hotel and independent counsel Kenneth Starr's office. "No one knew who she was and what she looked like. It became a cat-and-mouse game." Loh is home in Philadelphia when he gets his shot. "Monica came right out the door of the John Wanamaker Building. I made the frames and that was it. Nice, even light, no sun shadows. After all these weeks of trying to see her...I felt like I'd completed the assignment."

Doug Mills is on Capitol Hill on Nov. 19 when Starr is sworn in before the House Judiciary Committee. "I was practically lying on the floor, shooting up. I had a preconceived idea of what I wanted. I didn't know it would come together, with the lights behind him, the eagle behind him. It was him being put in the spotlight."

On Dec. 19, Susan Walsh is at the White House when Clinton thanks the Democratic members of the House who voted against impeachment. "You see how Hillary is lining up...when he is speaking. You just know that somebody is going to block the picture. When that didn't happen, I knew I had a picture. It was incredibly satisfying."

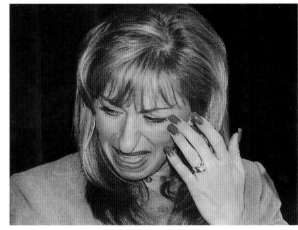
Ron Heflin

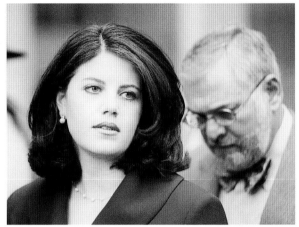
Dan Loh

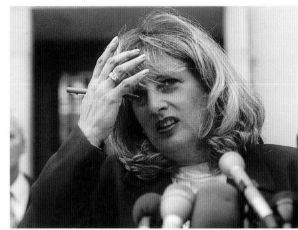
Khue Bui

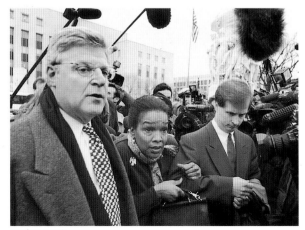
Stephan Saroia

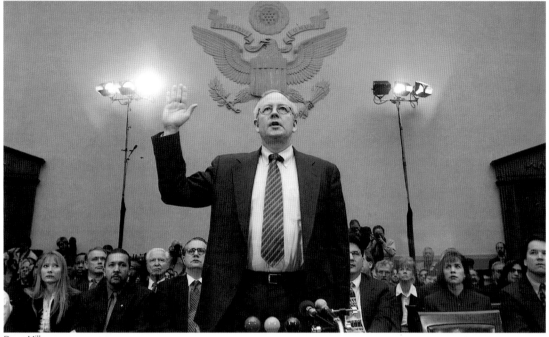

Doug Mills

1999 Feature

CLINTON
IMPEACHMENT
The Associated Press staff

January–December 1998, Washington,
D.C., Philadelphia, Pennsylvania, Dallas,
Texas

The Associated Press

Nikon F5, Kodak NC 2000 digital
cameras, various lenses, Fuji 200 ASA
film and digital imaging

Courtesy of The Associated Press

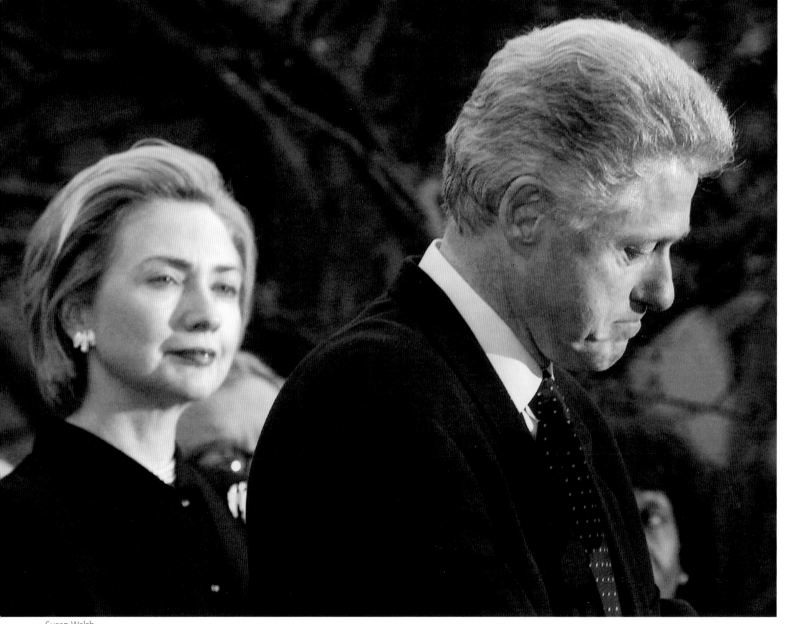

Susan Walsh

'It will never go away'

Littleton, Colo., is quiet. Little out of the ordinary happens here; not until April 20, 1999.

George Kochaniec Jr. knows something is happening the moment he walks into the *Rocky Mountain News* office. It's a shooting at Columbine High School and everyone, now including Kochaniec, is moving fast.

The photographer arrives at "a scene that was surreal . . . kids bleeding . . . TV reporters crying . . . scary. It will never go away." He stakes out a spot away from the chaos of ambulances, helicopters and anguished parents and sets up his long lens. He sees student Jessica Holliday screaming skyward, "asking why, why?" He sees anguished students embrace. "We didn't think it was real," one says, "until we saw blood."

Above the scene in a helicopter, *News* photographer Rudolpho Gonzalez photographs a wounded boy on the ground, not knowing he's dead. Days later, he takes a picture of a line of crosses atop a hill in nearby Clement Park, a magnet for the thousands who mourn. "I felt love, I felt pain," he says. "I was literally looking through tears."

The work of the 19-member *Rocky Mountain News* photo staff wins the Pulitzer Prize for documenting the story that changed Littleton forever: the day two Columbine High School students massacred 12 classmates and a teacher, turning their quiet town into the scene of the deadliest school shooting in American history.

2000 Spot News

COLUMBINE
Rocky Mountain News staff

April 20–30, 1999, Littleton, Colorado

Rocky Mountain News

Nikon F5, Fuji 400 ASA, 80-200mm lens
S-wave 2.8 on 100 ASA film

Courtesy of *Rocky Mountain News*

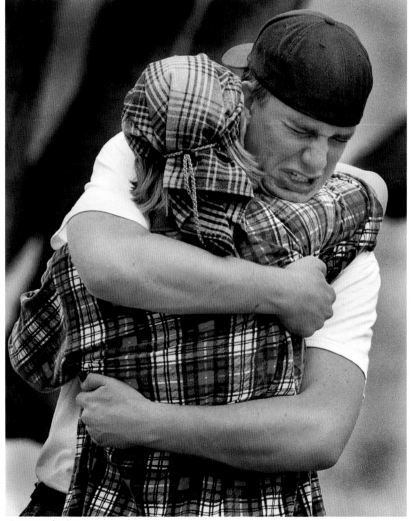

George Kochaniec, Jr.

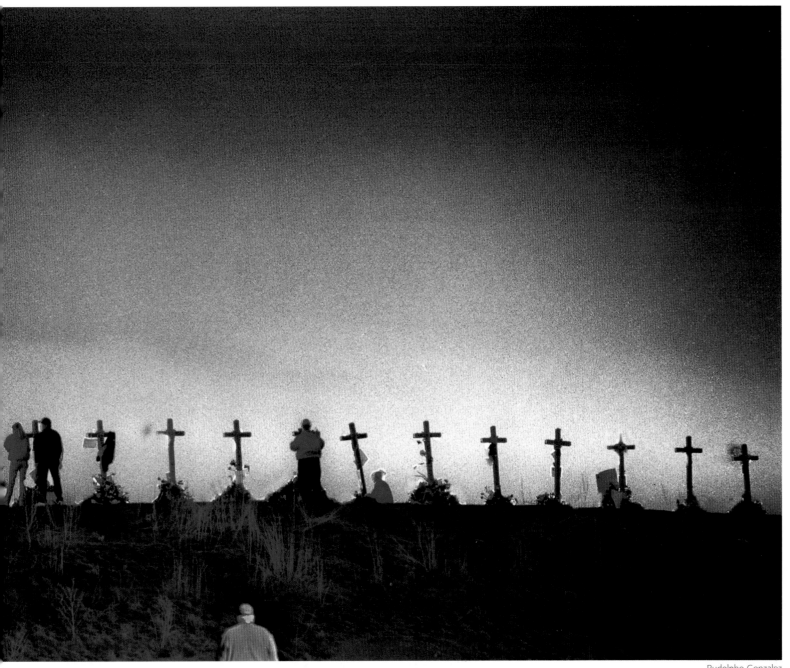

Rudolpho Gonzalez

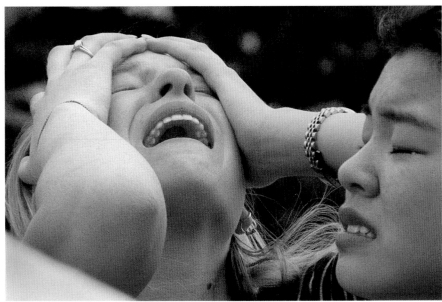

George Kochaniec, Jr.

'Why did they do this? Why?'

By the thousands, they come. Ragged, weary, fleeing the Serbs. A tidal wave of ethnic Albanians trying to cross from Kosovo into Macedonia and Albania. But there are no welcome signs.

Aid workers set up primitive tent camps. There is little food, water and few medical supplies. The refugees, mostly women, children and the elderly, wait in limbo.

Washington Post photographers Carol Guzy, Michael Williamson and Lucian Perkins spend two months in the camps. Interpreters help them understand the plight and despair. "No still picture," Guzy says, "could possibly convey their tears and pain or the hell from which they had come." Yet the photographers capture it as best they can.

Guzy crosses the border at Morina with refugees headed for a transit camp in Kukes, Albania. Stripped of their possessions, they wait to get in. On either side of the camp fence, members of the Shala family unite. They pass 2-year-old Akim Shala through the fence. Guzy's camera captures the baby sliding through the barbed wire into the hands of his loving grandparents.

Perkins and an estimated 70,000 refugees are near Macedonia in a no man's land called Blace. There is no shelter. Disease is spreading. Families try to get out. But border guards allow only a trickle of refugees to leave. Cameras swinging from his neck, Perkins hides behind a truck and slips past camp guards. He photographs sorrow and desperation.

Williamson is in Velika Krusa, Kosovo, covering the havoc wrought by Serbs. In a burned-out house, Qamil Duraku sits on a bucket, looks up and says, "You're here. You finally came." The man thinks the photographer is a war crimes investigator there to document the deaths of his cousins. In each hand he holds pieces of his relatives, body parts the Serbs had torched. He cries, "Why did they do this? Why?" Williamson tries to comfort Duraku. He can't. He takes his photograph.

2000 Feature

FLEEING KOSOVO

Carol Guzy, Michael Williamson and Lucian Perkins

April–June 1999; Kukes, Albania; Velika; Krusa, Kosovo; Blace, Albania

The Washington Post

Canon Cameras, Fuji Film

Canon EOS-1N on Fuji 800 ASA Color Press

Canon EOS with 80–200mm Lens on Fuji 200 ASA color negative

Courtesy of *The Washington Post*

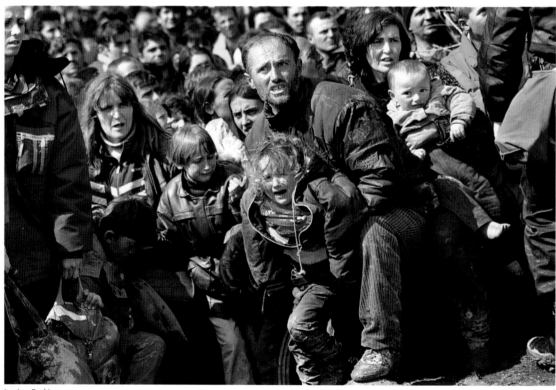

Lucian Perkins

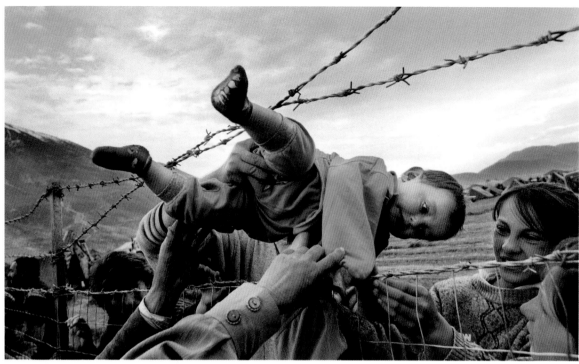

Carol Guzy

Michael Williamson

'What's happening? What's happening?'

It's dawn in Miami's Little Havana. Photographers and reporters doze on lawn chairs. Demonstrators mill about after an all-night vigil. Inside the house, a family lawyer negotiates by phone with U.S. Attorney General Janet Reno. On the sofa sleeps 6-year-old Elian Gonzalez.

Associated Press photographer Alan Diaz stands at the backyard fence. For five months from this spot, Diaz has covered the international custody war between the child's cousins in Miami and father in Cuba. Diaz has lived in Cuba and speaks Spanish. The relatives let him take pictures. But he must stay outside the fence. And he must never, ever speak to Elian.

At 5 a.m. on April 22, 2000, rumors swirl: a temporary accord may allow a visit with the boy's father. The rumors prove untrue. All at once Diaz hears heavy boots stampede the backyard. He grabs his camera, jumps the fence. A family friend lets him in the front door and locks it. Federal agents smash through the house. Diaz sees the relatives scream, mouths moving but bodies frozen.

"Where's the boy?" Diaz shouts. Someone shoves him into the bedroom. Donato Dalrymple, who plucked Elian from the sea, is trying to hide the boy. "What's happening?" Elian asks. "What's happening?" For the first time, Diaz speaks to Elian, tries to calm him down. Then agents kick open the door. One points a 9 mm submachine gun. Diaz takes the picture: a terrified child being seized by the federal government.

The lightning move by federal agents takes just 154 seconds.

Even today, long after the court rulings have sent Elian back to Cuba with his father, one thing remains a mystery to photographer Diaz. He can't figure out how he jumped the fence. "It may have been my pulsing adrenaline," he says. "But then again, I guess it was part of what I always do—I shoot pictures."

2001 Spot News
ELIAN
Alan Diaz

April 22, 2000, Miami, Florida
The Associated Press
Nikon D1 Digital Camera
Courtesy of The Associated Press

'I spent most of my commutes in tears'

A fire alarm screams at 4:30 a.m. Two sleepy freshman at Seton Hall University in South Orange, N.J., open the door of their third-floor room. They see only thick black smoke. Suddenly, Shawn Simons and Alvaro Llanos are crawling for their lives. Simons finds an exit, runs downstairs, his hands smoking. Llanos staggers into the lobby so badly burned his girlfriend doesn't recognize him.

Three people die in the Jan. 19, 2000, dorm fire. Fifty-eight others are injured. The Newark *Star-Ledger* stays on the story. After 10 days in a morphine-induced coma, Simons wakes up at the St. Barnabas Burn Center. Llanos' coma lasts nearly three months; more than half of his body is burned.

The families allow photographer Matt Rainey and staff writer Robin Gaby Fisher to spend eight months chronicling the pair's fight for life. But the first day, Rainey can't bring himself to take a picture of Llanos. "I didn't think he was going to make it," he says.

For Rainey, the visits are more than a job. "I spent seven days a week," he says, "usually 10 to 12 hours a day with the families; shot about 500 rolls of film. It was the most difficult project I ever worked on. I spent most of my commutes in tears most nights." Still, he says, he would do it again. "They changed me as a photojournalist. I'm more sensitive. Their positive outlook has inspired me and my family to know them as friends and not as people who look different. We are all very close."

When Rainey celebrates news of his Pulitzer in *The Star-Ledger* newsroom, first into his arms with congratulations are Simons and Llanos.

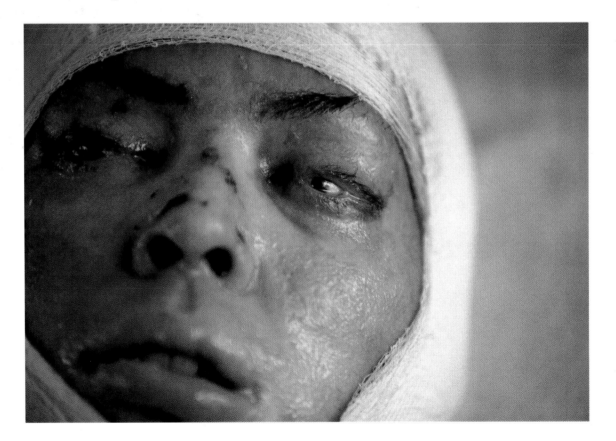

2001 Feature
AFTER THE FIRE
Matt Rainey

February 4, 2000 & April 17, 2000, Saint Barnabas Medical Center, Livingston, New Jersey

The Star-Ledger

Nikon F5, Nikon F100, Leica M6, Nikon 80-100mm lens, Fuji Super G, 400 ASA, 800 ASA

Courtesy of *The Star-Ledger*

'A small space where peace exists in a sea of war'

James Hill arrives in the legendary city of Mazar-i-Sharif to photograph the Qala Jangi fortress, site of fierce Taliban resistance to the invasion that freed Afghanistan. In the heart of the city, is the Shrine of Agrat Ali, home to the spirit of the son of the prophet Muhammad.

In the 16th century, 20 pairs of doves had been brought to the shrine from Nejev, where Ali is buried. People come to feed the doves as goodwill toward appeasing Allah. They believe that the doves remain there because Mazar is an oasis of spirituality. Yet, the doves leave when there is fighting and return when there is peace.

Says Hill: "Surrounded by the doves, everything seems calm. There is hope in their wings. It's a small space where peace exists in a sea of war."

New York Times photographer Vincent Laforet found his own dove as he looked for Afghan refugees in Pakistan. The camps are not accessible to the press, so LaForet went to the bus station on the Pakistan border and rode with the refugees to find a camp. The camps are in a no-mans-land surrounded by garbage dumps. Amid the chaos of the Punj Puti camp in Quetta, awash in refugees clamoring to be photographed, Laforet spots a barefoot Afghan girl, Shafia Helmand, standing against the wall of a mud hut.

"I turned around," Laforet says, "and she was staring at me. We made eye contact and the world seemed to stop for 15 seconds. She was the only quiet one. Watching the exchange, the crowd also became silent. They too knew she was special."

Vincent Laforet

2002 Feature
WAR AND PEACE
IN AFGHANISTAN
The New York Times staff

September–December 2001, Mazar-i-Sharif, Afghanistan; Quetta, Pakistan

The New York Times

Nikon D1H Digital Camera, 20–35mm F2.8 zoom lens; Cannon EOS D2000 Digital Camera, 17–35mm zoom lens

Courtesy of James Hill/*The New York Times*, and Vincent Laforet/*The New York Times*

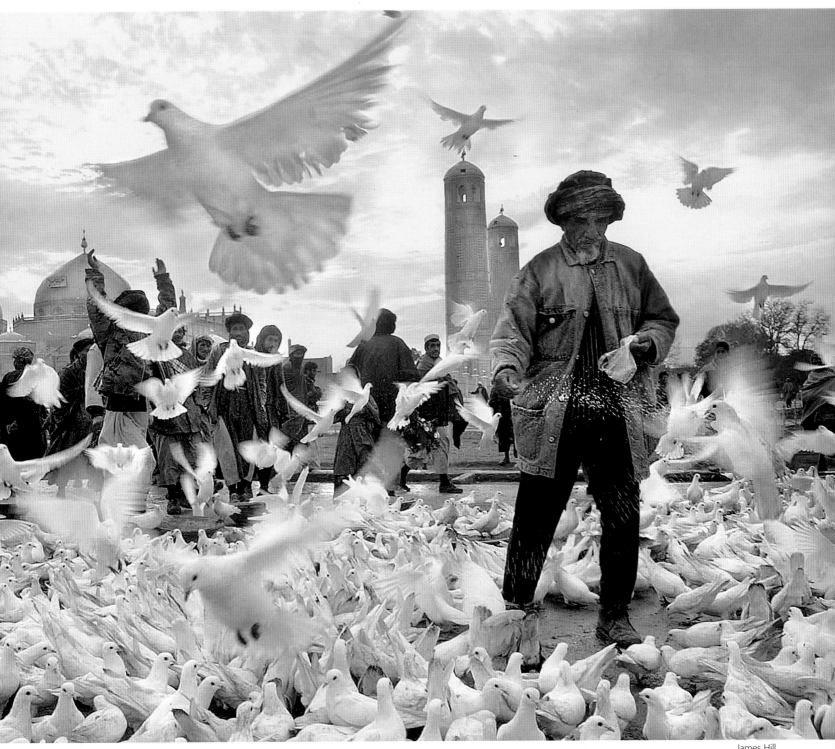

James Hill

'One shot at greatness and this was mine.'

Sept. 11, 2001, dawns clear, a great day for a morning walk. At 8:30 a.m., as artist and freelance photographer Steve Ludlum, strolls the Brooklyn waterfront, he sees black smoke pouring from the North Tower of the World Trade Center across the river. Sprinting, Ludlum runs home for his camera, finds a friend to drive him to the Manhattan Bridge to locate a good view of the World Trade Center.

Ludlum rests his zoom lens on a fence's iron railing. He adjusts his camera, unaware that United Airlines Flight 175 is headed straight for the South Tower. He doesn't see the plane hit, but a ball of fire appears in his viewfinder. "Bomb," he thinks, releasing the shutter.

His regular photo lab is too busy. Reluctantly he opts for a one-hour drugstore service. Ninety anxious minutes later, he opens the envelope. The negative is sharp. His next stop is *The New York Times.*

Ludlum reacts emotionally to the disaster that killed so many that day. He says, "An artist has one shot at greatness and this was mine."

Editor's Note: *The New York Times* staff photographers were among the first to arrive at the World Trade Center disaster scene. Because communications were disrupted, the *Times* photo editors had no way of knowing if their photographers were alive. After risking their lives to record the destruction of the World Trade Center, they fought through blinding smoke and falling debris to deliver their film to the *Times.* Steve Ludlum's photograph was submitted as part of the *Times"* portfolio.

2002 Breaking News

WORLD TRADE CENTER ATTACK
The New York Times staff

September 11, 2001, Brooklyn, New York

The New York Times

Nikon F4, 180 mm F2.8 lens, Kodak Gold ISO 800 film

Courtesy of Steve Ludlum/*The New York Times*

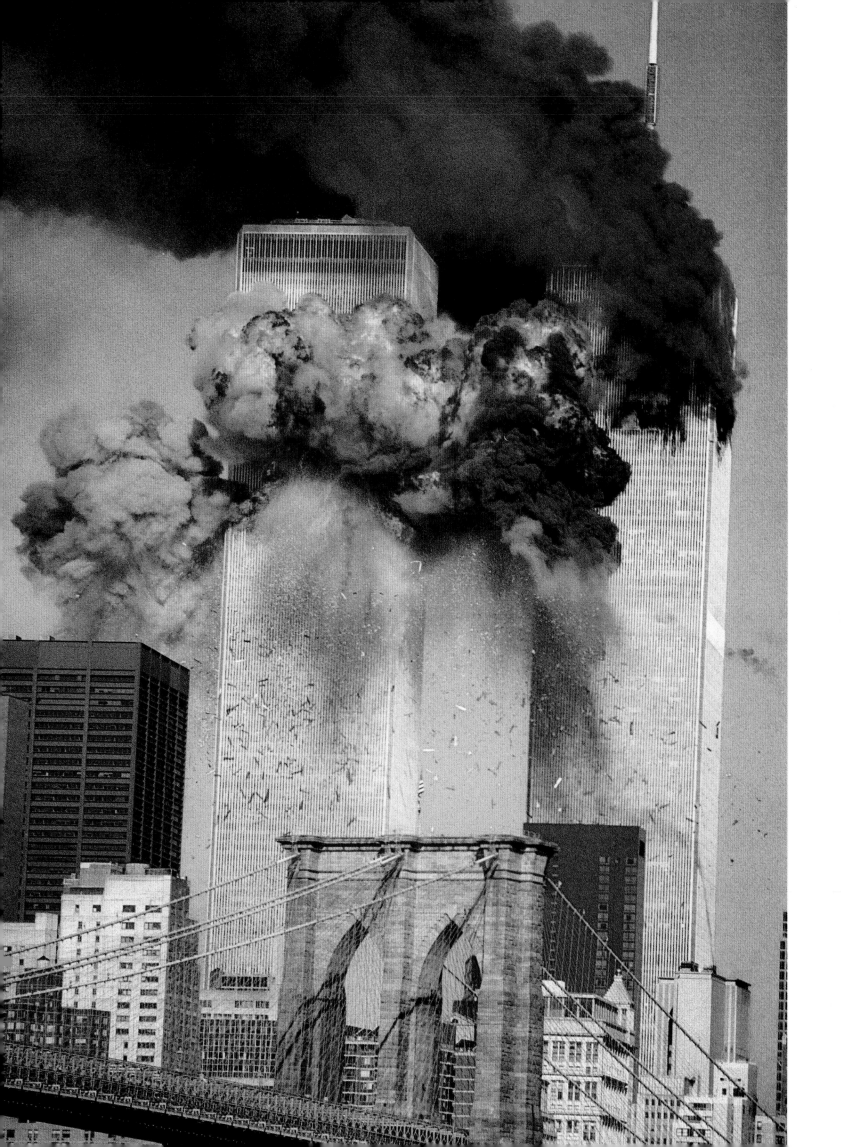

'The most perilous migration route I have ever seen'

Countless Mexican and Central American teen-agers, abandoned as infants when their mothers sought work in the United States, venture north each year, searching for their mothers. They travel by any mode available and risk being robbed, raped, beaten or killed. It's a journey through hell.

To chronicle that story, *Los Angeles Times* photographer Don Bartletti focused on Enrique, a 17-year-old Honduran who survived the journey. Through contact with his family, Bartletti followed Enrique's route, on buses through Guatemala, atop Mexican freight trains, and finally hitching a ride on an 18-wheeler. "The most perilous migration route I have ever seen," says veteran photographer Bartletti.

The freight trains were terrifying. Bartletti rode them for 1,500 miles, jumping from car to car, photographing hundreds of children who clung to the tops and sides. Some of them were maimed or killed when they were pulled under the wheels, swept off the

2003 Feature
ENRIQUE'S JOURNEY
Don Bartletti

August 24 & September 11, 2002,
Medias Aguas & Teotihuacan, Mexico
Testihuacan, Mexico

Los Angeles Times

Nikon F100, Various lenses, Kodak 400 film

Courtesy of the *Los Angeles Times*

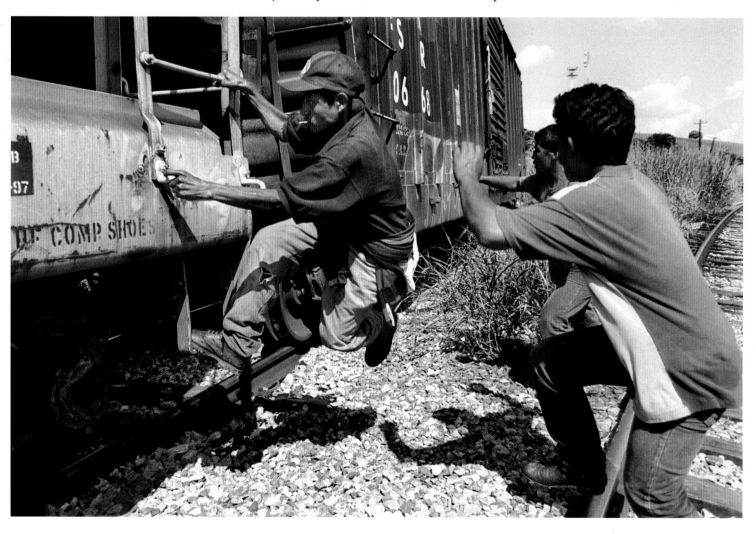

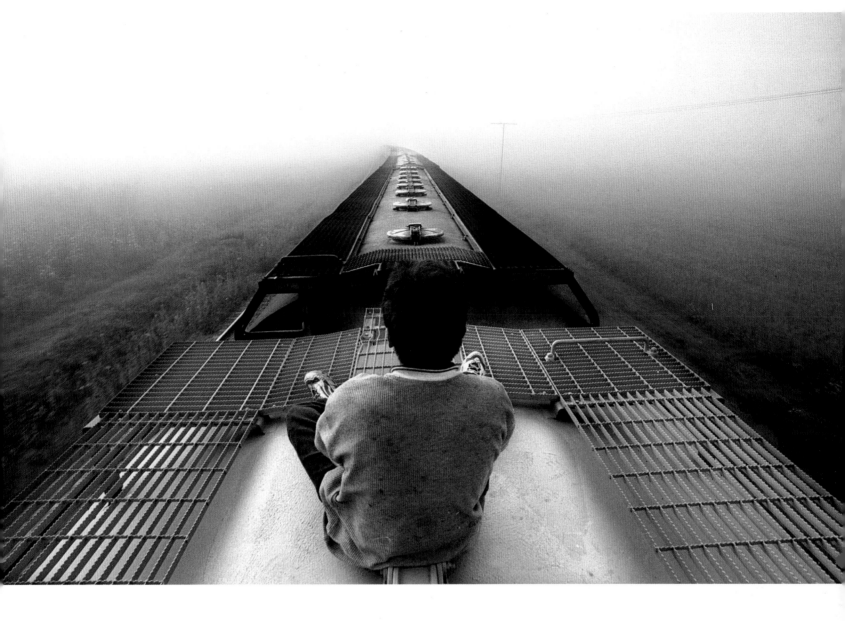

top by low-hanging branches or molested by bandits who rule the train tops. His camera captured sympathetic villagers tossing food and clothing to the cold and hungry travelers. As the young migrants made plans to slip into a new world, Bartletti was there, sleeping under cardboard on the wet river bank of the Rio Grande.

Enrique, a boy who was left behind by his mother, when he was 5 years old, was one of the lucky ones. Through letters sent to his family, he found his mother in North Carolina. She talked about the immense heartache of the 11 years she missed being with her son, who now lives with her. Enrique is working to save enough to smuggle his girlfriend, Maria, into the United States. If that happens, their infant daughter, Katherine, will be left behind in Honduras, beginning the cycle anew.

'He was in a sunset of fire and smoke'

On June 8, 2002, in the Hayman site near Tappan Gulch, in the tinder-dry Pike National Forest, Terry Barton, a longtime U.S. Forest Service employee, angrily burned a letter from her estranged husband. She knew she had violated the fire ban in the forest, as she extinguished the charred pages of the letter. She later returned to the site and discovered a fire raging out of control, which she reported as a campfire that had spread. But as the investigation unfolded, forensic evidence led investigators to question her story. Presented with the evidence, Barton recanted her story. She was arrested and charged.

More than 2,100 firemen fought the blaze, which ultimately destroyed 137,000 acres, 600 buildings and cost nearly 40 million dollars.

Steven G. Smith was one of the 15 photographers the *Rocky Mountain News* had on the fire line. Picking his way through the smoldering remains of a once glorious national forest, Smith found exhausted firefighter Daniel Crawford pausing to catch his breath after battling the Hayman Fire all day. "He was in a sunset of fire and smoke," said Smith.

The fire is over, but the fire area is still a dangerous place. Burned trees over thousands of acres will start to fall. Hard rains can cause flooding and mudslides, Rocks are loose because vegetation that held them in place has burned away.

A homeowner who lost her house said, "It's hard to believe that the words of a burned-out flame of a marriage ignited the largest fire in Colorado history."

2003 Breaking News
COLORADO'S
WILDFIRES 2002
Rocky Mountain News staff

June 11, 2002, north of Lake George, Colorado

Rocky Mountain News

Nikon DIH, 200 mm lens

Courtesy of *Rocky Mountain News*

Steven G. Smith

AFTERWORD

More than two million people have visited the Newseum in Arlington, Va.—the world's first interactive museum of news—since it opened in 1997. Our mission is to venture beyond the headlines of history to explain how and why newspeople do what they do. We hope this book, like the Newseum itself, will help the consumers of news better understand the business of news.

The Newseum is the largest operating program of The Freedom Forum, a nonprofit, nonpartisan, international foundation dedicated to free press, free speech and free spirit for all people. The foundation focuses on four main priorities: the Newseum, First Amendment issues, newsroom diversity and world press freedom.

As the 21st century begins, it seems particularly important to consider the rise of the image in the presentation of news. These Pulitzer Prize photographs chronicle that rise and emphasize its increasing emotional power. For their invaluable aid in preparing this collection, we thank the board of The Pulitzer Prizes.

In this book, as with many of our endeavors, we have tried to honor Joseph Pulitzer's journalistic advice: "Put it before them briefly so they will read it, clearly so they will appreciate it, picturesquely so they will remember it, and, above all, accurately so they will be guided by its light."

— JOE URSCHEL
Executive Director and
Senior Vice President
Newseum

THE PULITZER PRIZE PHOTOGRAPHS:
Capture the Moment
opened in exhibition at
Newseum/New York
on May 23, 2000

BIOGRAPHIES OF THE PHOTOGRAPHERS

EDWARD T. ADAMS
1969 SPOT NEWS AWARD
Born: June 12, 1933, in New Kensington, Pa.

Eddie Adams started out as a combat correspondent with the U.S. Marines. He went on to photograph 13 wars, including Vietnam, where he accompanied troops on 150 operations.

Adams won the Pulitzer Prize for a photograph of Gen. Nguyen Ngoc Loan executing a Viet Cong prisoner. The photograph turned many Americans against the war. It haunted Loan for the rest of his life. And it so disturbed Adams he considered turning down the Pulitzer. "I was getting money for showing one man killing another," said Adams. "Two lives were destroyed, and I was getting paid for it."

Adams would rather be remembered for his 1977 photos of refugees fleeing Vietnam by boat. Those pictures helped convince Congress and President Jimmy Carter to grant asylum to the "boat people."

Today Adams maintains a New York studio and works in journalism, corporate, editorial, fashion, entertainment and advertising photography. Since 1988, he has organized an annual photography workshop, where professionals welcome newcomers to the craft.

DON BARTLETTI
2003 FEATURE AWARD
Born: Dec. 29, 1947, in Philadelphia, Pa.

Except for a 1967 college class in photography, Don Bartletti is essentially self-taught. During 1970–71 as an infantry officer in Vietnam, he honed observational and survival skills that serve him to this day. Bartletti has been a photojournalist with the staff of the *Los Angeles Times* for the past 20 years. He began his career in 1972 at his hometown paper, *The Vista* (Calif.) *Press.* He later worked at the *Oceanside Blade-Tribune* and the *San Diego Union/Tribune.* He has covered stories throughout California, Mexico, Central and South America and the wars in Iraq and Afghanistan.

The 6-part series "Enrique's Journey," for which he won the Pulitzer Prize, touched him like few other projects. The prize is recognition of the single subject he has tirelessly chronicled over the past 25 years: the causes and effects of migration from Latin America to the United States.

Over his 31-year career, Bartletti has been given over 50 awards, most notably the Pulitzer Prize, the Robert F. Kennedy Award, the Polk Award, the Scripps-Howard Foundation Award, the Sidney Hillman Foundation Award and the National Photographers Press Association Award.

J. ROSS BAUGHMAN
1978 FEATURE AWARD
Born: May 7, 1953, in Dearborn, Mich.

In 1975, Ross Baughman became a professional photographer. Since then, he has been spat upon, shot at, stricken by encephalitis, had his arm broken by a drug dealer and spent six weeks in a Zambian prison.

Baughman was a 25-year-old contract photographer for The Associated Press when he won the Pulitzer Prize for photographs taken during the civil war in Rhodesia. Since then, he has covered 11 wars. His work has been published in *Life, National Geographic, Newsweek* and *Vogue.*

A founding member of Visions news agency, Baughman has conducted workshops on ethics in mass media at Columbia University, Rutgers, Dartmouth, University of Colorado and New York University.

He was director of photography at The Day Publishing Company and is currently photo editor of *The Washington Times.*

WILLIAM C. BEALL
1958 AWARD
Born: Feb. 6, 1911, in Washington, D.C.
Died: March 27, 1994

William Beall's photo of a policeman talking to a little boy at a parade was the most-applauded picture ever to appear in *The Washington Daily News.* FBI Director J. Edgar Hoover declared the photograph "worthy of a prize." It won a Pulitzer.

Beall started his career at 16, working for a photo agency. At age 22, he was a *Washington Post* photographer. Two years later, he joined *The Washington Daily News.* He was named chief photographer in 1940.

Beall was a combat photographer with the U.S. Marine Corps during World War II. He won the Air Medal in 1945 for his coverage of the battle for Okinawa. His credits include awards from the National Headliners Club, the United Press International Newspictures Contest and the National Press Photographers Association.

JOHN BLAIR
1978 SPOT NEWS AWARD
Born: Dec. 9, 1946, in Winchester, Ind.

John Blair was a stringer for United Press International when he took the Pulitzer Prize-winning photograph of an Indianapolis real-estate executive being held at gunpoint.

Three UPI photographers shot dozens of rolls of film at the standoff, and transmitted 15 pictures. When UPI submitted Blair's photo to the Pulitzer judges, it credited the wrong photographer. A review of the negatives revealed the picture was Blair's.

Blair went on to become photographer, chief writer, editor and publisher of the *Ohio Valley Environment.* Today, he shoots photographs, as well as video, for clients across the Midwest, and puts in "60 to 70 hours a week doing environmental work."

BOSTON HERALD AMERICAN STAFF
1979 FEATURE AWARD

When a blizzard ripped across New England in 1978, it took all the resources of the *Boston Herald* to photograph the disaster. The newspaper's Pulitzer Prize-winning coverage is credited to:

Paul Benoit	Ted Gartland
Dennis Brearly	Frank Hill
Kevin Cole	Bob Howard
Gene Dixon	Ray Lussier
Stanley Forman	M. Leo Tierney

MILTON E. BROOKS
1942 AWARD
Born: Aug. 29, 1901, in St. Louis, Mo.
Died: Sept. 3, 1956

Two of his brothers were news photographers. His father was a reporter. But it was football that got Pete Brooks into the news business. When *The Chicago Herald Examiner* published a photograph of one of Brooks' college football games, Brooks went to the newspaper offices to get a copy. A month later, he was an *Examiner* photographer. Brooks later worked for New York's *Daily News,* Paramount Newsreel and the *Chicago Daily News.* In 1928, he joined *The Detroit News.*

Brooks' picture of a fight among striking United Auto Workers won the first Pulitzer Prize for photography. With his $500 prize, Brooks bought a World War II U.S. Savings Bond: "Every cent goes into the war effort." The photo was also hailed by regional press associations and *Editor & Publisher.* Brooks left *The Detroit News* in 1953 to become a commercial photographer.

EARLE L. BUNKER
1944 AWARD
Born: Sept. 9, 1912
Died: Jan. 19, 1975, in Omaha, Neb.

Earl Bunker started in newspapers in 1929 at Nebraska's *Omaha Bee-News.* He joined *The World-Herald* in 1937. Colleagues considered him thorough and patient, a real "craftsman."

Bunker won the Pulitzer Prize for his photograph of a returning World War II hero greeting his family. Bunker's work also was recognized by The Associated Press, Encyclopedia Britannica and Graflex. Bunker spent the final 18 years of his career concentrating on color production.

KEVIN CARTER
1994 FEATURE AWARD
Born: Sept. 13, 1960, in Johannesburg, South Africa
Died: July 27, 1994, in Johannesburg

Kevin Carter spent most of his career photographing the unraveling of apartheid. He started with the Johannesburg *Sunday Express,* then moved to *The Star,* South Africa's largest daily newspaper. Carter and three other South African photojournalists (including 1991 Pulitzer winner Greg Marinovich) became known as The Bang-Bang Club, for their frequent forays into the townships to photograph deadly street fights.

Carter worked as chief photographer at *The Sunday Tribune* and *The Daily Mail and Guardian.* He started the photography department at *The Mail* in 1990.

Just days after Carter won the Pulitzer Prize, his best friend, Ken Oosterbroek, was killed photographing township violence. Carter became, in his words, "haunted by the vivid memories of killings and corpses and anger and pain . . . of starving or wounded children, of trigger-happy madmen." In 1994, Kevin Carter took his own life. He was 33.

MANNY CRISOSTOMO
1989 FEATURE AWARD
Born: Nov. 28, 1958, in Guam

Manny Crisostomo began his career at *The Pacific Daily News* in Guam. In 1982, he joined *The Detroit Free Press,* where he completed the Pulitzer Prize-winning series on students at Detroit's Southwestern High School.

In 1991, Crisostomo returned to Guam and founded *Latte Magazine,* which covers Guam and Micronesia. Crisostomo's publication credits include *Life, Time, Newsweek, Pacifica,* the *Los Angeles Times* and *The Honolulu Star Bulletin.* He has published four books: *Moving Pictures: A Look at Detroit from High Atop the People Mover, Main Street: A Portrait of Small Town Michigan, Legacy of Guam: I Kustumbren Chamoru* and *Guam from the Heavens.*

Crisostomo's photographs have been exhibited in Honolulu, Maui, American Samoa and Tokyo. He has received the Robert F. Kennedy Award and honors from the National Press Photographers Association, the Society of Newspaper Design, The Associated Press and United Press International.

BILL CROUCH
1950 AWARD
Born: Nov. 15, 1915, in Canon City, Colo.
Died: Dec. 27, 1997, in Placerville, Calif.

Bill Crouch started as an Associated Press Wirephoto operator in his home town. "I had never had a camera in my hand," he said. "But I got hold of a couple and began shooting pictures, and kept at it 'till I learned how." In 1944, after several AP postings, Crouch became a staff photographer at *The Oakland Tribune.* Except for a stint in the U.S. Marines during World War II, he shot photos for the *Tribune* until he retired. In addition to many regional and state awards, he was recognized by The National Press Photographers Association and Encyclopedia Britannica

An avid amateur pilot, Crouch loved to cover the Oakland Air Show. That's where he took the picture of the near-miss between a stunt pilot and an Air Force bomber that won the Pulitzer Prize.

FRANK CUSHING
1948 AWARD
Born: Aug. 10, 1915, in Roxbury, Maine
Died: March 17, 1975

Frank Cushing left high school at 16 to be a messenger for The *Boston Traveler.* One night, the photo editor asked the eager young apprentice if he was interested in becoming a news photographer. He was.

During World War II, Cushing was an aerial photographer for the U.S. Army Air Forces. He spent the rest of his career with *The Herald Traveler.* In 1947, Cushing took the picture of "the boy gunman" that won him the Pulitzer Prize. The photo also was recognized by The Associated Press, *Editor & Publisher* and Graflex.

In the late 1960s, Cushing retired from the *Traveler.* He went to work as a painter and later a foreman in the Fore River Shipyard.

MAX DESFOR
1951 AWARD
Born: Nov. 8, 1913, in New York City

"It's a bit of history . . . every time," said Max Desfor of his long photography career. Desfor started as a messenger at The Associated Press and worked his way up to staff photographer. He covered the Pacific Theater during World War II, then the independence of India and the creation of Pakistan. (India issued a postage stamp bearing Desfor's photograph of Jawaharlal Nehru and Mohandas Gandhi.) During the Korean War, Desfor took the photograph of fleeing Korean refugees that won him the Pulitzer Prize.

Desfor spent 14 years as an executive at The AP in New York, then became photo chief for AP in Asia. After 45 years with The Associated Press, Desfor retired. He then joined *U.S. News & World Report* as director of photos.

Desfor has been honored by The National Press Photographers Association, the White House News Photographers Association, Graflex, Kodak and *Editor & Publisher.*

ALAN DIAZ
2001 SPOT NEWS AWARD
Born: May 15, 1947, in New York City

In 1964, Alan Diaz moved to Cuba to live with his parents. He stayed 14 years, becoming a teacher and studying photography in his spare time. When he returned to the United States in 1978, he settled in Miami to teach English and work as a freelance photographer for The Associated Press. In 1994, Diaz joined the AP Miami bureau as a staff photographer. He won the Pulitzer for capturing the defining moment of the Elian Gonzalez custody struggle: federal agents raiding the house in the early morning hours to wrestle the boy away from his relatives.

JAMES B. DICKMAN
1983 FEATURE AWARD
Born: March 25, 1949, in St. Louis

James Dickman won the 1983 Pulitzer Prize for photographs he shot in El Salvador amid a "tremendous amount of danger. . . . 15- or 16-year-olds were carrying automatic weapons."

Dickman started his career at *The Denver Post,* then joined *The Dallas Times Herald,* where he did his Pulitzer work.

Since 1987, he has freelanced for *Life, Time, National Geographic, Fortune, Sports Illustrated* and other magazines. Once, Dickman spent three months living in a stone-age village in Papua, New Guinea, for *National Geographic.*

His credits include awards from Sigma Delta Chi, United Press International, The Associated Press, World Press and the National Press Photographers Association. He was a photographer on *Passage to Vietnam* and the *Day in the Life* book series.

MICHEL duCILLE
1986 SPOT NEWS AND 1988 FEATURE AWARDS
Born: Jan. 24, 1956, in Kingston, Jamaica

As a photographer at *The Miami Herald* , Michel duCille won two Pulitzer Prizes: with Carol Guzy in 1986, for their coverage of the eruption of the Nevado del Ruiz volcano in Colombia; and in 1988, for a photo essay documenting the crack cocaine problem in a Miami public housing project.

The crack cocaine project took seven months to photograph. "It became very emotional," said duCille. "I got pretty close to some of the people."

DuCille received a masters in journalism from Ohio University before joining *The Miami Herald.* Since 1988, he has been the picture editor of *The Washington Post.* DuCille has been recognized by the Robert F. Kennedy Journalism Award, the Society of Professional Journalists and The National Association of Black Journalists. His books include *Songs of My People, The African Americans* and *Americanos.*

JACK DYKINGA
1971 FEATURE AWARD
Born: Jan. 2, 1943, in Chicago

Chicago Sun-Times photographer Jack Dykinga saw himself as "a kid from the suburbs in the real world" when his career took him into the Illinois State Schools for the Retarded to win a Pulitzer Prize.

Now, Dykinga has committed himself to the natural world: His photographs focus on environmental issues in the southwestern United States and Mexico. In 1996, the Mexican government designated the Sierra Alamos, featured in Dykinga's book *The Secret Forest,* as both a national park and a U.N. Biosphere Preserve. That same year, President Clinton created Grand Staircase-Escalante National Monument, preserving the canyons featured in Dykinga's book *Stone Canyons of the Colorado Plateau.*

Dykinga's work has been published in *Arizona Highways, Time, Natural History, Outside, Audubon, Harpers, Sierra Club* and *National Geographic.* His most recent book, *Desert: The Mojave & Death Valley,* was a Book-of-the-Month Club selection.

RON EDMONDS
1982 SPOT NEWS AWARD
Born: June 16, 1946 in California

After Ron Edmonds won the Pulitzer Prize for his photographs of the assassination attempt on Ronald Reagan, the president invited Edmonds to the Oval Office. Photographers always ask him for "just one more picture," Reagan said. He offered to replay the shooting—but this time with a stunt man.

Edmonds started out at *The Honolulu Star-Bulletin,* where he became chief photographer. In 1978, he became bureau manager for United Press International in Sacramento, Calif. Since 1981, Edmonds has worked for The Associated Press, covering summits, inaugurations, shuttle launches, political races and all the Republican and Democratic national conventions since 1984.

He has been recognized by the World Press, the National Headliners, the Associated Press Managing Editors, the National Press Photographers Association, the Society of Professional Journalists and the White House News Photographers Association.

HORST FAAS
1965 AWARD AND 1972 SPOT NEWS AWARD
Born: April 28, 1933, in Berlin, Germany

Horst Faas survived a decade of covering the Vietnam War, prompting a South Vietnamese general to call him "the luckiest man alive."

Faas had known war since his childhood in Germany and Poland. In 1951, he went to work at the Keystone Photo Agency in Munich and Berlin. Four years later, he joined The Associated Press. He covered the war in the Congo and fighting in Algeria before AP sent him to Vietnam. In 1965, Faas won a Pulitzer Prize for his coverage in Vietnam.

Faas won his second Pulitzer in 1972 for photographs he and Michel Laurent took during the war in Bangladesh. Faas was the first photographer to receive the award twice. His many credits include the George Polk Memorial Award and honors from the National Press Photographers

Association, The Overseas Press Club, Associated Press Managing Editors and The International Center for Photography.

Faas continued with The Associated Press as a photographer, photo editor and administrator, and now works out of the London office. In 1997 and 1998, the Newseum exhibited work from the book he co-edited, *Requiem,* featuring the work of photographers who died in Vietnam and Indochina.

NATHANIEL FEIN
1949 AWARD
Born: Aug. 7, 1914, in New York City
Died Sept 26, 2000

Nat Fein grew up in New York when the city's myriad newspapers were just beginning to merge. He started his career at the *Journal American,* then joined the *Herald Tribune.* Fein taught himself to take pictures, began to free-lance, then convinced the *Herald Tribune* to hire him as a staff photographer.

After serving in the U.S. Army during World War II, Fein returned to the *Tribune,* where he took the Pulitzer Prize-winning photograph of Babe Ruth's final public appearance. Fein also worked for *Look, Life* and other magazines, taking "pictures people want to see." He won "closets full of awards" and photographed such well-known figures as Harry Truman, Albert Einstein and Eleanor Roosevelt.

After the *Herald Tribune* folded in 1966, Fein joined Orange and Rockland Utilities.

FRANK FILAN
1944 AWARD
Born: Dec. 7, 1904, in Brooklyn, N.Y.
Died: July 23, 1952

Frank Filan earned his nickname "Fearless Filan" during his years cruising the Pacific on a private ship, ghost-writing the adventures of the crew. Back on land, he became an office boy at the *Los Angeles Times,* then a staff photographer for The Associated Press.

Filan's blithe attitude toward disaster came from his penchant for escaping it. Working for The AP in Mongolia, he survived a jeep accident that killed two others. Back in California, he walked away from a plane crash that had no other survivors.

As he landed on Tarawa during World War II, Filan was matter-of-fact about the danger. "I knew the beach . . . was covered by a large number of machine guns . . . and sniper fire could be expected." On the island, Filan took the photograph that won the Pulitzer Prize, and saved the life of a Marine. He won a commendation from Admiral Chester W. Nimitz and the War Correspondents' Valor Medal from the National Headliners Club.

JOHN PAUL FILO
1971 SPOT NEWS AWARD
Born: Aug. 21, 1948, in Natrona Heights, Pa.

John Filo was a 21-year-old photojournalism student when he covered the shootings at Kent State University. After Filo won the Pulitzer, he received a telegram from Eddie Adams, his journalistic hero: "Congratulations on winning the Pulitzer Prize. Let's see what you can do tomorrow!"

What Filo did was become a shooter for The Associated Press, first in Chicago, then in Springfield, Ill. and Kansas City, Mo. Next, he joined *The Philadelphia Inquirer,* then became a photo editor at *The Sun* in Baltimore. Filo went on to spend two years with *Sports Illustrated,* became an assistant managing editor at the *Courier-Post* in New Jersey, then joined *Newsweek.* His current position is manager of photo operations for CBS Television.

BILL FOLEY
1983 SPOT NEWS AWARD
Born: Dec. 12, 1954, in Chicago

As a photojournalist, Bill Foley has worked and traveled in 46 countries. From 1978 to 1984, he covered the Middle East for The Associated Press, photographing the assassination of Anwar Sadat, the Israeli invasion of Lebanon and the bombing of the U.S. Marine barracks in Beirut. His 1982 photographs of the aftermath of a massacre at a Palestinian refugee camp won the Pulitzer Prize.

Foley has been a contract photographer for *Time* magazine. Since 1990, he has been a free-lancer. He does projects for the Children's Aid Society

and Save the Children Fund, and works as a still photographer on film and television productions.

In 1998, Foley taught a workshop for Palestinian students in Gaza and the West Bank. Early this year he taught a workshop in the United Arab Emirates.

Foley's credits include awards from the Committee to Protect Journalists, the National Press Photographers Association and The Associated Press Managing Editors. He is based in Tarrytown, N.Y.

STANLEY J. FORMAN
1976 AND 1977 SPOT NEWS AWARDS
Born: July 10, 1945, in Winthrop, Mass.

Stanley Forman loves breaking news. "When I hear a call, the adrenaline gets going," he says. "It's like being on top of the world."

Forman started out as a free-lance photographer, then went to work for the *Boston Herald American,* where he became the only photographer to win consecutive Pulitzer Prizes for spot news: The first for coverage of a tragic Boston fire, the second for photographing a confrontation at an anti-busing rally. Forman shared a third Pulitzer with the *Herald American* photo staff for its coverage of the New England blizzard of 1978.

Forman's photo credits include *Newsweek, Time, Life* and *Photography Annual.* He was a Nieman Fellow in Journalism at Harvard University. His work has been recognized by Sigma Delta Chi, the University of Missouri, the Headliners Club and World Press, among other groups.

Today Forman is an Emmy-winning news cameraman for WCVB-TV in Boston.

WILLIAM GALLAGHER
1953 AWARD
Born: Feb. 26, 1923, in Hiawatha, Kan.
Died: Sept. 28, 1975

During World War II, William Gallagher was a military photographer in North Africa and Asia. After the war, he signed on with the *Flint Sporting Digest.* He then joined the Flint *Journal,* winning state and national awards, including Graflex and The Associated Press.

On assignment for the *Journal,* Gallagher took his Pulitzer Prize-winning photograph of the hole in Adlai Stevenson's shoe. The picture inspired a Stevenson-for-president campaign pin in the form of a shoe with a hole in it. As a gift for Gallagher, Gov. Stevenson autographed the picture: "From a candidate who is really not holier than thou."

JOHN L. GAUNT JR.
1955 AWARD
Born: June 4, 1924, in Syracuse, N.Y.

John Gaunt spent three years in the U.S. Army Air Forces during World War II. His first journalism job was at *The South Bay Daily Breeze* in Redondo Beach, Calif. In 1950, he went to work for the *Los Angeles Times.* Gaunt was at his Hermosa Beach home getting ready for a mid afternoon shift at the *Times* when he heard yelling from the beach—and went out to take the Pulitzer Prize-winning photograph of a couple whose young son had disappeared in the surf.

Gaunt's photos garnered numerous honors from organizations such as The Associated Press Managing Editors and *Editor & Publisher.*

GERALD H. GAY
1975 SPOT NEWS AWARD
Born: Oct. 30, 1946, in Seattle

Gerald Gay wanted to be a photojournalist because of "the access that the camera and the press card gave you." Gay started out at *The Everett* (Wash.) *Herald.* In 1972, he went to work for *The Seattle Times,* where he took the Pulitzer Prize-winning photograph of firefighters resting after a fire, a shot that he said "talks about the American spirit."

Gay has been president of the National Press Photographers Association. He received the first Edward Steichen Award for news photography. He has worked for the *Los Angeles Times, New York Newsday* and *Maui News.*

Currently, Gay teaches high school students. For the past three summers, he has driven nearly 40,000 miles of the United States to document the people and the landscape of America's heartland.

KEN GEIGER
1993 SPOT NEWS AWARD
Born: Feb. 18, 1957, in Bremerton, Wash.

Ken Geiger's peripatetic childhood, traveling with his ship-builder father, prepared him for his journalistic career. When *The Dallas Morning News* "wanted someone to go to India or Thailand," he said, "I'd already been there three times. I knew the names of the streets."

Geiger started out in Texas with the *Austin American Statesman* before he joined *The Dallas Morning News.* He has covered war in Burma, terrorism in India, elections in Nicaragua and the Olympics in Spain, Norway and Atlanta. His photographs (with William Snyder) of the Barcelona games won the Pulitzer Prize in 1993.

Geiger's credits include awards from the Society of Newspaper Design, the Major League Baseball Hall of Fame, the National Headliners Club and The Associated Press Managing Editors.

Geiger is now a photo editor at *The Dallas Morning News,* where he keeps pace with digital technology, communications and color imaging.

TOM GRALISH
1986 FEATURE AWARD
Born: July 12, 1956, in Mt. Clemens, Mich.

When Tom Gralish was in high school at Clark Air Base in the Philippines, he photographed American POWs recently released from North Vietnamese prison camps. The man who sent the photos out over The Associated Press wire: 1951 Pulitzer winner Max Desfor.

Gralish worked for United Press International in Minneapolis, Dallas, Detroit and Kansas City before joining *The Philadelphia Inquirer* in 1983.

In 1986, he won the Pulitzer Prize for his photo series on the homeless in Philadelphia. Those pictures also won the Robert F. Kennedy Journalism Award.

Gralish became director of photography for the *Inquirer*'s Sunday magazine. He won first place for picture editing three years in a row in the Pictures of the Year competition. During the Persian Gulf War, Gralish was a Department of Defense pool photo editor in Saudi Arabia. In 1995, he decided to go "back on the streets." He is once again a staff photographer at the *Inquirer.*

STAN GROSSFELD
1984 SPOT NEWS AND 1985 FEATURE AWARDS
Born: Dec. 20, 1951 in New York

Stan Grossfeld has won two Pulitzer Prizes—one in 1984 for his pictures of war-torn Lebanon, another in 1985 for his coverage of the Ethiopian famine and of illegal immigrants crossing the Rio Grande.

Grossfeld started his career at *The Star-Ledger* in Newark, N.J. Two years later, he joined *The Boston Globe,* where he has been the chief photographer since 1983. Grossfeld has been recognized by The Associated Press and has been a four-time New England Photographer of the Year.

Grossfeld's experiences in Lebanon "started me on a crusade about children." He joined UNICEF and published a book of photographs, *Lost Futures: Our Forgotten Children.*

CAROL GUZY
1986 AND 1995 SPOT NEWS AWARD, 2000 FEATURE AWARD
Born: March 7, 1956, in Bethlehem, Pa.

Carol Guzy believes photojournalists face a constant challenge: to translate "people's most intimate moments—their joys and sorrows, their triumphs and tragedies." A registered nurse before she became interested in photojournalism, Guzy worked for *The Miami Herald* when she and Michel duCille won the 1986 Pulitzer Prize for their photographs of the aftermath of a volcanic eruption in Colombia. Guzy, who joined *The Washington Post* in 1988, has won two Pulitzers since: in 1995 for coverage of Haiti and in 2000 for Kosovo. Guzy is also a three-time White House News Photographers' Association Photographer of the Year. In addition, she's won the National Press Photographers Association's Newspaper Photographer of the Year Award, the Leica Medal of Excellence, the Overseas Press Club Citation of Excellence and the Robert F. Kennedy Journalism Award.

ERWIN H. HAGLER
1980 FEATURE AWARD
Born: Aug. 7, 1947, in Fort Worth, Texas

Erwin Hagler's family and friends call him "Skeeter." The nickname—drawled out of the word "mosquito"—was given to him as a baby. And it stuck.

Hagler learned his trade at *The Waco* (Texas) *News Tribune*. In 1972, he went to work for *The Fort Worth Star-Telegram*, and later *The Dallas Times Herald*. Hagler joined the staff of the *Herald's* Sunday magazine, where he "traveled all over the world doing a hodge-podge of different stories." His work has won regional, national and international awards.

After winning the Pulitzer Prize for his series on the lifestyle of the Texas cowboy, Hagler spent several years lecturing on and exhibiting his photographs. He has always stayed in touch with the cowboys.

ARNOLD HARDY
1947 AWARD
Born: Feb. 2, 1922, in Shreveport, La.

When Arnold Hardy bought his new Speed Graphic, the camera did not have a flash attachment. So Hardy designed one. But at the scene of the Winecoff Hotel fire in Atlanta, his flash bulbs failed. Finally, with his fourth and final bulb, Hardy took the picture that won the Pulitzer Prize.

Hardy was the first amateur photographer to win the Pulitzer. He did not attend the ceremony: He could not afford the bus ticket to New York. He also did not become a professional photographer. Instead, Hardy started a company designing mechanical and medical equipment. Now retired, he said, "I enjoy leisure and lots of it."

ROBIN HOOD
1977 FEATURE AWARD
Born: Sept. 22, 1944, in Chattanooga, Tenn.

Hoping to record his experiences with the U.S. Army in Vietnam, Robin Hood taught himself to take photographs.

When he got home to Tennessee, Hood showed his pictures to the *Chattanooga News-Free Press*. The *Press* hired him as a staff photographer. Six years later, Hood took his Pulitzer Prize-winning photograph of a disabled Vietnam veteran watching an Armed Forces Day parade.

In 1980, Hood became director of media services for Tennessee Gov. Lamar Alexander. In 1988, he co-founded Journal Communications. Today, he is president and publisher of Parker Hood Press in Franklin, Tenn.

Hood's books include *The Tennesseans: A People and their Land* and *Friends: Japanese and Tennesseans*. He also contributed to *Christmas in America* and *A Day in the Life of America*.

ROBERT H. JACKSON
1964 AWARD
Born: April 8, 1934, in Dallas, Texas

Bob Jackson studied business in college. After graduating, he veered back to his hobbies—photography and sports car racing—to become the official photographer for the Texas region of the Sports Car Club of America.

In 1960, the *Dallas Times Herald* hired Jackson as a staff photographer. He had been at the newspaper only a few years when he captured one of the most famous moments of the era: Jack Ruby shooting Lee Harvey Oswald. "I was sorry that it all happened," said Jackson, "but I'm glad I was able to record some of it."

In 1968, Jackson went to work for *The Denver Post*. He did another stint at the *Times Herald*, then free-lanced, before settling in at the *Colorado Springs Gazette*. Officially, Jackson has retired, but he plans to work part-time at the *Gazette* "until it ceases to be fun."

JOHN KAPLAN
1992 FEATURE AWARD
Born: Aug. 21, 1959, in Wilmington, Del.

In 1989, John Kaplan received the Robert F. Kennedy Journalism Award for his coverage of murder suspect Rodney Woodson. That same year, he was named National Press Photographer's Association Newspaper Photographer of the Year.

A Nikon/NPPA Sabbatical Grant allowed Kaplan to complete his Pulitzer Prize-winning photography series on the lives of 21-year-olds in the United States. Kaplan's goal: "To let the viewer make his or her own conclusions about the variety of lifestyles in our culture."

Kaplan has also been recognized for his writing. In 1996, his book, *Mom and Me*, was named one of the best books of the year by *Parents* magazine. Now an associate professor at the University of Florida, Kaplan also directs a journalism consulting group.

THOMAS J. KELLY III
1979 SPOT NEWS AWARD
Born: Aug. 8, 1947, in Hackensack, N.J.

Tom Kelly had mixed feelings about winning the Pulitzer Prize for his photographs of a family hostage crisis in Pottstown, Pa. But no matter what, he said, "I was a news photographer and I needed to be there."

Kelly began as a free-lance photographer for the *Montgomery Post* in Norristown, Pa. He became a staff photographer for *Today's Post* in Valley Forge before joining the *Pottstown Mercury*. He has been recognized by the National Press Photographer's Association, and has won other state and national awards.

Today, Kelly lives in Pottstown and works as a free-lance photographer.

DAVID HUME KENNERLY
1972 FEATURE AWARD
Born: March 9, 1947, in Roseburg, Ore.

After David Hume Kennerly won the Pulitzer Prize, he went right back onto the battlefield in Vietnam: "As I'm groveling in the mud, I'm thinking, 'I'm an idiot. I should at least stay alive awhile and enjoy the prize.'"

Kennerly was a White House pool photographer for United Press International. For UPI, he covered Vietnam, India, Pakistan and Cambodia. He won the Pulitzer Prize for photographs taken in those countries during 1971.

Kennerly was President Gerald R. Ford's personal photographer. He worked on five *Day in the Life* projects, as well as *A Passage to Vietnam*, a book and CD-ROM. He has contributed to *Time, Life, George* and most recently, *Newsweek*. His awards include World Press, the White House Press Photographers Association, the National Press Photographers Association and the Overseas Press Club.

Kennerly was also executive producer for NBC's Emmy-nominated "The Taking of Flight 847" and executive producer and co-writer on "Shooter," an NBC movie based on his book about photographers in Vietnam.

DALLAS KINNEY
1970 FEATURE AWARD
Born: Jan. 13, 1937, in Buckeye, Iowa

Growing up in farm country gave Dallas Kinney an appreciation for the migrant laborers he photographed for his Pulitzer Prize-winning series. Statistics were one thing, Kinney said, but the photos "turned out to be an insight into the people themselves."

Kinney started in Iowa at *The Washington Evening Journal*. In 1966, he joined *The Dubuque Telegraph-Herald* as staff photographer. After a stint at *The Miami Herald*, Kinney went to work for *The Palm Beach Post*.

At *The Post*, Kinney won his Pulitzer, as well as the Robert F. Kennedy Journalism Award. He spent a year with *The Philadelphia Inquirer*, then returned to *The Post*, where he became features editor.

Kinney is currently president of Concept Associates, a marketing and communications firm.

KIM KOMENICH
1987 SPOT NEWS AWARD
Born: Oct. 15, 1956, in Laramie, Wyo.

"Kim was born hot," a colleague once said. "His parents probably gave him a camera instead of a rattle." Fascinated with photography since childhood, Komenich joined California's *Contra Costa Times* right out of college.

Since 1982, he has been with *The San Francisco Examiner*. In 1987, his photographs of the fall of the Ferdinand Marcos regime in the Philippines won the Pulitzer Prize.

Komenich's honors include awards from World Press and the Society of Professional Journalists. His publication credits include *Time, Life, Newsweek, U.S. News & World Report* and *Fortune*. His work has appeared in *A Day in the Life of California, Christmas in America, Power to Heal, One Earth* and *The Mission Book*.

In 1993–1994, Komenich was a John S. Knight Journalism Fellow at Stanford University. For the past 10 years, he has taught at The San Francisco Academy of Art.

BRIAN LANKER
1973 FEATURE AWARD
Born: Aug. 31, 1947, in Detroit, Mich.

As a college student, Brian Lanker went to work for the *Phoenix Gazette*. In 1970, he joined the *Topeka* (Kan.) *Capital-Journal*, where his photographs of the birth of a baby won the Pulitzer Prize.

Lanker has been director of photography at the *Eugene* (Ore.) *Register-Guard* and contributing photographer at *Sports Illustrated* and *Life*. His photo exhibition, *I Dream a World: Portraits of Black Women Who Changed America*, toured internationally and became a successful photography book.

Lanker has been National Newspaper Photographer of the Year and was a winner in the World Press Photo competition. He currently divides his time between editorial and advertising still photography and motion picture writing and directing.

MICHEL LAURENT
1972 SPOT NEWS AWARD
Born: July 22, 1946, in Normandy, France
Died: April 28, 1975, near Xuan Loc, Vietnam

Michel Laurent was in his teens when he went to work for The Associated Press. He photographed the 1968 student uprisings in Paris, then the 1968 Soviet invasion of Czechoslovakia that same year.

In 1971, Laurent and Horst Faas photographed the torture of Pakistani prisoners in Bangladesh and won the Pulitzer Prize. The two agreed to pool their film, Faas said: "We wouldn't compete on who got the better bayoneting." For braving danger in the field, Laurent and Faas also won the Overseas Press Club's George Polk Award.

Laurent covered sectarian violence in Northern Ireland and the Vietnam War for AP, then joined the Gamma Agency, where he photographed the 1973 Yom Kippur War, the revolution in Ethiopia and the 1974 war in Cyprus.

He returned to Vietnam in 1975, just as the communists were launching their final offensive. On April 28, Laurent and another newsman were ambushed by North Vietnamese troops north of Saigon. Laurent died trying to rescue his wounded colleague. He became, at the age of 29, the last Western journalist to die in the Vietnam War.

MATTHEW LEWIS
1975 FEATURE AWARD
Born: March 8, 1930, in McDonald, Pa.

Matthew Lewis' father was a newspaper photo-engraver. His grandfather was a portrait photographer. Yet Lewis was a sandblaster — until the day his boss denied him a raise. Then "a thought struck me," he said. "I will become a photographer."

Lewis joined the public relations department of Morgan State College in Baltimore, and spent three years free-lancing for *The Afro-American*. In 1965, he became a general assignment photographer for *The Washington Post* and later *Potomac*, the newspaper's Sunday magazine. His *Potomac* portraits of Washington's most powerful citizens won the Pulitzer Prize.

Lewis became assistant managing editor of the *Post* photography department. Among the groups that have recognized Lewis: The White House News Photographers Association and the Newspaper Guild.

Now retired from the *Post*, Lewis is a part-time photographer for *The Thomasville* (Ga.) *Times*. He also practices portrait photography — like his grandfather.

ANDREW LOPEZ
1960 AWARD
Born: June 10, 1910, in Miraveche, Spain
Died: Oct. 30, 1986, in Inverness, Fla.

Andrew Lopez came to the United States from Spain as a boy. His first journalism job was delivering film for Acme News Pictures.

In 1942, Lopez became a photographer for United Press. During World War II, he was an armed forces photographer, covering the landing in Normandy, the battle of Paris and the invasion of Germany. Gen. Dwight Eisenhower awarded him the Medal of Freedom for rescuing U.S. soldiers.

After 18 years at UPI, Lopez won a Pulitzer Prize for photographs taken just before Fidel Castro loyalists executed a corporal in the defeated army of Cuban dictator Fulgencio Batista.

Lopez won numerous awards for his sports photographs, including one of boxer Rocky Marciano defeating Joe Louis.

GREG MARINOVICH
1991 SPOT NEWS AWARD
Born: Dec. 8, 1962, in Springs, South Africa

In the early 1990s, Greg Marinovich was a member of "The Bang-Bang Club," South African journalists who covered deadly township violence in the final days of apartheid. As a new freelancer with The Associated Press, Marinovich took photographs of a brutal tribal attack that won the Pulitzer Prize.

Caught in a township shootout in April 1994, Marinovich was severely wounded. His colleague, photojournalist Ken Oosterbroek, was killed.

Marinovich's career took him to The Associated Press in Israel, and then around the world, into countries such as Angola, Bosnia, Russia and India. His photography credits include *Time, Newsweek, The Guardian* of London and *The New York Times*. He has received awards from the Overseas Press Club, the United Nations and Leica.

Currently, Marinovich is a freelance photographer, writing a book on the South African hostel wars of the early 1990s.

ROCCO MORABITO
1968 SPOT NEWS AWARD
Born: Nov. 2, 1920, in Port Chester, N.Y.

Rocco Morabito was only 10 when he went to work as a newsboy at Florida's *Jacksonville Journal*. He was eventually promoted to home delivery district manager. Then came World War II. Morabito flew 34 missions as a ball-turret gunner before returning to the *Journal*, where he became a sports reporter and finally a photographer.

Morabito won the Pulitzer Prize for a photograph of a power company lineman giving a colleague mouth-to-mouth resuscitation. With the *Journal's* deadline just minutes away, Morabito radioed the paper: "You may want to wait for this. I think I've got a pretty good one."

Morabito's picture was the first to win the Pulitzer in the spot news category. If his editor was proud, he hid it well. "The next day," remembered Morabito, "the guy says 'So what you got for us today?'" Morabito is retired and lives in Florida.

YASUSHI NAGAO
1961 AWARD
Born: May 20, 1930, in Tokyo, Japan

Seconds after he took his Pulitzer Prize-winning photograph of the assassination of Socialist leader Inejiro Asanuma, Yasushi Nagao telephoned his newspaper, *Mainichi Shimbun*, to say he "had the picture."

Nagao joined *Mainichi*, a Tokyo daily newspaper, after graduating from college. He had been working there for eight years when he became the first foreign-born photographer to win the Pulitzer Prize. A year later, Nagao became a freelance photographer.

NEW YORK *DAILY NEWS* STAFF
1956 AWARD

When a bomber crashed into a suburban New York neighborhood, the *Daily News* dispatched a photographic team which produced Pulitzer Prize-winning coverage. The staff members include:

Al Amy	Bob Koller
Paul Bernius	Hal Mathewson
Ed Clarity	George Mattson
Jack Clarity	Fred Morgan
Tom Cunningham	Charles Payne
Jack Eckert	Ed Peters
Albert Fougel	Joe Petrella
Tom Gallagher	Sam Platnick
Ed Giorandino	Al Pucci
Phil Greitzer	Gordon Rynders
Charles Hoff	Nick Sorrentino
Frank Hurley	Paul Thayer
Walter Kelleher	Seymour Wally

FRANK NOEL
1943 AWARD
Born: Feb. 12, 1905, in Dalhart, Texas
Died: Nov. 29, 1966, in Tallahassee, Fla.

In 1941, The Associated Press sent Pappy Noel to cover World War II in the Pacific. He survived a Japanese torpedo, winning the Pulitzer Prize for a picture taken while drifting in a lifeboat in the Indian Ocean.

After a brief sojourn in the United States, Noel headed for Europe, where he continued his war coverage for The AP. In 1948, Noel photographed the war in Palestine and, after that, the Korean War. The Chinese captured Noel in Korea and he spent 32 months in a prison camp. AP colleagues managed to get a camera into the camp. Noel used it to photograph imprisoned American soldiers.

Before joining The Associated Press, Noel had been a news photographer in the United States, Mexico and Central America. After his wartime tours, he worked for The AP in New York and Florida.

RON OLSHWANGER
1989 SPOT NEWS AWARD
Born: Nov. 11, 1936, in St. Louis

Ron Olshwanger's business is wholesale furniture. But his passion has always been rescue work. For 20 years, Olshwanger served as the chief of the reserve police in St. Louis. He went on to head the Red Cross disaster service. He is currently director of a St. Louis County fire district.

Olshwanger has been on the scene of disasters—often with camera in hand—since he was 13 years old. He took his Pulitzer Prize-winning photograph of a young fire victim with a camera his wife gave him for Christmas. He used Walgreens film and developed it at a one-hour lab.

Olshwanger's wife died of cancer shortly after he won the Pulitzer. "I look at it as a final gift to my wife," he said. Olshwanger used the prize money to set up a fund for the young fire victim's impoverished mother.

LUCIAN PERKINS
2000 FEATURE AWARD
Born: Dec. 2, 1952, in Fort Worth, Texas

Lucian Perkins began his career as a student photojournalist majoring in biology at the University of Texas at Austin. In 1979, he received an internship at *The Washington Post*. Within the year, his striking pictures won him a National Headliners award for his photo essay of the first women admitted to the U.S. Naval Academy—and earned him a staff position at the *Post*. Perkins won the 1996 World Press Photo of the Year and the 1994 Newspaper Photographer of the Year awards. His first Pulitzer came in 1995, for his collaboration with *Post* reporter Leon Dash on a four-year study of the effects of poverty on three generations of a family in Washington, D.C. His international work includes tours of Russia, Bosnia, the West Bank and the Persian Gulf War. Perkins helped found InterFoto, an international photojournalism conference. His first book, "Runway Madness," looks inside the world of New York fashion.

DAVID PETERSON
1987 FEATURE AWARD
Born: Oct. 22, 1949, in Kansas City, Kan.

He was driving along and the car radio blared: "If David Peterson feels like he's a Pulitzer Prize winner today, that's because he is!" Peterson pulled over to call a colleague. They both cried over the phone.

Peterson started out as a free-lance photographer at *The Topeka Capital Journal*. He became a staff photographer before moving to Iowa to join the *Des Moines Register*. In the mid-1980s, Peterson applied for a Nikon/National Press Photographers Association grant to cover the farm crisis in depth. He took a sabbatical from the *Register* and spent three months taking the photographs that won the Pulitzer Prize.

In 1991, when the staff of the *Register* won the Pulitzer Prize for Public Service, Peterson shared in a second Pulitzer. He remains a staff photographer at the *Des Moines Register*.

CHARLES PORTER IV
1996 SPOT NEWS AWARD
Born: Aug. 21, 1969, in Anchorage, Alaska

Charles Porter was a credit officer at Liberty Bank in Oklahoma City when his photograph of a firefighter cradling a wounded baby at the Oklahoma City bombing won the Pulitzer Prize.

Porter credits 1982 Pulitzer winner John White of Chicago with advising him to "keep a loaded camera in my car at all times." Porter's camera was on the back seat when he went to retrieve it on the morning of the bombing.

Porter's photograph, distributed by The Associated Press, garnered numerous honors, including the British Picture Editor's Award and the National Headliners Award. Said Porter, "This picture represents... everyone who was involved in this tragedy. I wish it could have been a picture of Emmett Smith diving into the end zone." Today, Porter is a free-lance photographer.

LARRY C. PRICE
1981 SPOT NEWS AND 1985 FEATURE AWARD
Born: Feb. 23, 1954, in Corpus Christi, Texas

In 1980, Larry Price was the only American photographer to cover the execution of the former Liberian regime in Monrovia. His photographs won the Pulitzer Prize. Yet before that he had never traveled overseas. "I didn't even have a passport," he said. At the time, Price was a staff photographer with the *Fort Worth Star-Telegram*. Previously, he had been with the *El Paso Times*.

Price won his second Pulitzer Prize—for coverage of the civil wars in Angola and El Salvador—while working at *The Philadelphia Inquirer*. Today, the photographer works in Baltimore at *The Sun*.

Price's credits include The Overseas Press Club, World Press, The Pan American Press Association and The National Press Photographers Association. His work has been published in *Time, Newsweek, U.S. News & World Report, Audubon* and *National Geographic*. He has contributed to several *A Day in the Life* books.

MATT RAINEY
2001 FEATURE AWARD
Born: Aug. 14, 1966, in Denville, N.J.

He's traveled plenty, but Matt Rainey is proud to have lived and worked for most of his career in his home state of New Jersey. He started as a photojournalist in 1988, straight out of Rutgers University. Rainey toured five New Jersey dailies, running the photo departments at two of them, before settling in at *The Star-Ledger* in Newark in 1995. Winner of the 1998 New Jersey Press Photographer of the Year, Rainey won the Pulitzer for his touching photographs of Alvaro Llanos and Shawn Simons' long road to recovery after they nearly died in an early morning dorm fire at Seton Hall University. Rainey still keeps in close contact with the students. He lives with his wife and two children in Brick, N.J.

MARTHA RIAL
1998 FEATURE AWARD
Born: Sept. 12, 1961, in Pittsburgh

Martha Rial was a general assignment reporter for *The Pittsburgh Post-Gazette* for almost four years before she persuaded her editors to send her to central Africa to photograph refugees of Rwanda's ethnic warfare.

Since then, Rial has traveled to Cuba, Northern Ireland and the Balkans on assignment for the *Post-Gazette*. "I can leave my hometown in Pittsburgh," said Rial, "and see the world and be challenged in a new way."

Rial was a staff photographer at the *Ft. Pierce Tribune* in Florida and the *Journal Newspapers* in Alexandria, Va., before joining the *Post-Gazette* in 1994.

ANTHONY K. ROBERTS
1974 SPOT NEWS AWARD
Born: July 14, 1939, in Hawaii

Anthony Roberts was trying to get his photography business off the ground when he stumbled on a man trying to kidnap a young woman in a Hollywood, California parking lot. Roberts took photographs of the incident, his first news shots, and sold them to The Associated Press, which submitted them for the Pulitzer Prize.

Roberts became a freelance journalist and photographer, working for magazines, record companies and show-business personalities. He produced record albums in Nashville and worked as an actor under the stage name "Cal Roberts." Roberts is currently acting in the "OK Corral" shows in Tucson, playing the part of a Tombstone gunslinger. "I have a love affair with the camera," said Roberts. "I don't care which side I'm on."

JOHN R. ROBINSON
1952 AWARD
Born: June 19, 1907, in Des Moines, Iowa
Died: Sept. 28, 1972

John Robinson joined *The Des Moines Register* as an apprentice engraver. He became a staff photographer, covering the 1929 riot at Des Moines University and visits to Iowa by three American presidents. In 1940, Robinson teamed up with *Register* photographer Donald Ultang. A decade later, they became the first photography team to win the Pulitzer Prize — for their photographs of a racial assault during a Drake University-Oklahoma A&M football game.

During World War II, Robinson served three years with the Army Signal Corps on a photographic combat team in the South Pacific. Robinson's work also was recognized by the United Press International Newspictures Contest and Graflex.

ROCKY MOUNTAIN NEWS STAFF
2000 SPOT NEWS AWARD

The *Rocky Mountain News* photography staff won the Pulitzer Prize for its coverage of the Columbine High School shooting in Littleton, Colo. The staff included:

Glenn Asakawa	Steven R. Nickerson
Patrick Davison	Ken Papaleo
Rudolpho Gonzalez	Marc Piscotty
Steve Groer	Dennis Schroeder
George Kochaniec Jr.	Hal Stoelzle
Joe Mahoney	Essdras M. Suarez
Linda McConnell	Ahmad Terry
Cyrus McCrimmon	

ROCKY MOUNTAIN NEWS STAFF
2003 BREAKING NEWS

The *Rocky Mountain News* photography staff won the Pulitzer Prize for coverage of the Colorado wildfires. The staff included:

Maria J. Avila	Steven R. Nickerson
Barry Gutierrez	Ken Papaleo
Todd Heisler	Marc Piscotty
Matt Inden	Dennis Schroeder
Ellen Jaskol	Steven G. Smith
George Kochaniec Jr.	Hal Stoelzle
Joe Mahoney	Ahmad Terry
Linda McConnell	

HECTOR RONDON
1963 AWARD
Born: 1933, in Venezuela

Before Hector Rondon turned 21, he'd been a taxi driver, a glass-factory worker, a plumber and a semi-pro baseball player. Then his brother-in-law got Rondon interested in photography. The young man of many talents went to work for *La Republica* in Caracas, Venezuela.

While covering a military rebellion, Rondon photographed a priest comforting a wounded rebel soldier. The picture won the Pulitzer Prize. Because of the dangers Rondon faced, the photograph also won the George Polk Award.

JOE ROSENTHAL
1945 AWARD
Born: Oct. 9, 1911, in Washington, D.C.

Joe Rosenthal took one of the most famous photographs of World War II, but only after both the U.S. Army and the Navy had rejected him as a military photographer because his eyesight was impaired. Rosenthal saw action when The Associated Press sent him to the Pacific. On Iwo Jima, he shot the flag-raising photograph that won the Pulitzer Prize. The image generated controversy because the now-famous flag was put up to replace a smaller flag. Some argued the event was staged for the benefit of the camera. Repeatedly, Rosenthal explained that it was not.

Rosenthal's career began in San Francisco with the Newspaper Enterprise Association. He was chief photographer and manager for Times Wide World Photos before it was taken over by The AP. After the war, Rosenthal became a *San Francisco Chronicle* photographer.

TOSHIO SAKAI
1968 FEATURE AWARD
Born: March 31, 1940, in Tokyo, Japan
Died: Nov. 21, 1999, in Kamakura, Japan

While still in college, Toshio Sakai worked in the darkroom at United Press International. After graduation, he became a UPI photographer. Inspired by Kyoichi Sawada's Pulitzer Prize-winning work, Sakai volunteered to cover the Vietnam War. In May 1967, he photographed an American infantry unit taking a brief respite from battle and won the first Pulitzer Prize for feature photography.

From 1977 to 1985, Sakai was UPI's chief Far East photographer. He also free-lanced for *Newsweek, Time* and Reuters. In 1986, Sakai joined The Associated Press in Tokyo. Three years later, he left The AP and founded his own company, Woodstock, Inc. In 1980, Sakai published a book of photographs, *Refugees: Love and Death at the Border.*

KYOICHI SAWADA
1966 AWARD
Born: Feb. 22, 1936, in Aomori, Japan
Died: Oct. 28, 1970, in Laos

Kyoichi Sawada started out in a camera shop on a U.S. military base in Japan. He joined United Press International, and soon became news picture editor in Tokyo. Sawada was so desperate to cover the Vietnam War he went there on vacation. His photos impressed UPI and they sent him to Saigon.

In Vietnam, Sawada was a daredevil cameraman, willing to go anywhere, anytime, to get a good picture. "His talent," a colleague remembered, "was for telling the story in terms of people." In 1966, Sawada's photograph of Vietnamese families fleeing U.S. bombers won the Pulitzer Prize. Sawada's work was recognized by the World Press Photo Contest and the Overseas Press Club; he also won a U.S. Camera Achievement Award.

In October 1970, Sawada volunteered to take UPI's new Phnom Penh bureau chief, Frank Frosch, out to assess the war in Cambodia. Viet Cong ambushed the two journalists and executed them. Sawada was 34 years old.

VIRGINIA SCHAU
1954 AWARD
Born: Feb. 23, 1914, in North Sacramento, Calif.
Died: May 29, 1989, in Santa Rosa, Calif.

Virginia Schau was the first woman and the second amateur to be awarded the Pulitzer Prize in photography. Her pictures were also the first not taken with a professional camera. Schau snapped her photographs of the Pit River Bridge rescue with a simple Brownie Box camera, using the last two images on an old roll of film.

WILLIAM SEAMAN
1959 AWARD
Born: Jan. 19, 1925, in Grand Island, Neb.
Died: Dec. 6, 1997, in St. Louis Park, Minn.

As a high school student, William Seaman worked part time in a photo studio. After graduation, he became a *Minneapolis Star-Tribune* photographer. He worked at the newspaper until it closed in 1982.

His photograph of a little boy killed in a traffic accident won the Pulitzer Prize. Seaman called the day he took the picture "one of my worst . . . because of the tragedy that was involved."

Seaman loved sports photography and won several national awards. Originally, he wanted to study art, but switched to photography because he could "press a button and get a picture a lot faster." In his retirement, he took up oil painting.

SCOTT SHAW
1988 SPOT NEWS AWARD
Born: Sept. 17, 1963, in Danville, Ill.

When rescuers brought Jessica McClure up out of a Texas well after 58 hours, Scott Shaw shot seven frames of film. One captured it all: the rescuers looking at Jessica. Shaw said "it was almost like you said, 'OK, on the count of three, look at her.'" They all did, and Shaw won the Pulitzer Prize.

At the time, Shaw was staff photographer at *The Odessa American* in Texas. Before that, he worked at *The Paragould Daily Press* in Arkansas. Currently, Shaw is a staff photographer at *The Plain Dealer* in Cleveland. Scott has won more than 200 local, regional, state and national awards, including the National Press Photographer's Association award and The Associated Press Managing Editor's Competition.

MONETA J. SLEET JR.
1969 FEATURE AWARD
Born: Feb. 14, 1926, in Owensboro, Ky.
Died: Sept. 30, 1996, in New York City

Moneta Sleet Jr. always said he was an activist first, a journalist second. He was deeply involved in the civil rights movement. "I wasn't there as an objective reporter," he said. "I had something to say."

Sleet graduated from New York University with a master's degree in journalism. He worked at *The Amsterdam News* and *Our World* magazine. In 1955, he became a staff photographer at *EBONY*. Sleet covered the 1963 civil rights march on Washington, D.C., and the 1965 march from Selma to Montgomery, Ala. (He said he covered 100 miles during the 50-mile Selma march because of the extra walking he did to take photos.)

In 1969, Sleet won the Pulitzer Prize for his photograph of Coretta Scott King at her husband's funeral. Sleet was the first African-American to win the prize.

Sleet photographed many African-American celebrities and almost every black head of state in Africa. An exhibition of his work included photos of Muhammad Ali, Haile Selassie, Stevie Wonder, Jomo Kenyatta and Billie Holiday.

WILLIAM SNYDER
1991 FEATURE AND 1993 SPOT NEWS AWARDS
Born: July 1, 1959, in Henderson, Ky.

William Snyder has won three Pulitzer Prizes, all at *The Dallas Morning News*.

In 1989, he shared a Pulitzer Prize in explanatory journalism for a team effort detailing how the National Transportation Safety Board conducted an air-crash investigation.

Snyder won a Pulitzer in 1991 for photographs taken in Romanian orphanages. In 1993, he shared a Pulitzer with Ken Geiger for their coverage of the Barcelona Summer Olympics. Remembered Snyder: "Trying to convey the horrible conditions orphans live in and trying to convey the effort and glory of the Olympics . . . I'm proud of the fact that I can do both."

At age 14, Snyder began his career as a photographer for his hometown newspaper. He worked at *The Miami News* before joining the staff of *The Dallas Morning News* in 1983. Snyder has traveled across Russia on the Trans-Siberian Railroad and photographed and lectured in the Czech Republic and Romania. He was a journalism fellow at the University of Michigan in 1994-1995. He currently is photo editor at *The Dallas Morning News*.

STEVEN STARR
1970 SPOT NEWS AWARD
Born: Sept. 6, 1944, in Albuquerque, N.M.

Steven Starr started his photojournalism career at the *San Jose Mercury-News*. In 1967, he joined The Associated Press. He was an AP photographer in Albany, N.Y., when he photographed gun-toting Cornell University activists and won the Pulitzer Prize

Starr left the AP to start a photography business in Miami. In 1985, he joined the Picture Group Photo Agency. Next, with other photographers, he started SABA agency in New York. For four years, Starr was SABA's Los Angeles bureau manager and photographer. He now runs Starr & Starr Creative Partners with his wife, Marilynne. They live in Colorado Springs.

ANTHONY SUAU
1984 FEATURE AWARD
Born: Oct. 16, 1956 in Peoria, Ill.

Anthony Suau was a *Denver Post* photographer when he won the Pulitzer Prize for photographs he took during the Ethiopian famine and for a Memorial Day picture of a widow hugging her husband's tombstone.

Suau next went to work for Black Star photo agency, then became a contract photographer for *Time* magazine. Now freelance, he works with 10 different international photo agencies.

In 1996, Suau was awarded the Robert Capa Gold Medal for his photographs of the Chechnyan war in Russia. He wrote a book about that war, and a second book on genocide in Rwanda.

In 1999, the Newseum exhibited photos from Suau's latest book, *Beyond the Fall*, covering change in Eastern Europe and the former Soviet Union from 1989 to 1999. The work also will be shown in Europe and Russia.

THE ASSOCIATED PRESS STAFF
1992 SPOT NEWS AWARD

For photographs of the attempted coup in Russia and the ensuing collapse of the communist regime, The Associated Press won the 1992 Spot News award. Photographers include:

Olga Shalygin	Boris Yurchenko
Liu Heung Shing	Alexander Zemlianichenko
Czarek Sokolowski	

THE ASSOCIATED PRESS STAFF
1993 FEATURE AWARD

The Associated Press photographers who won a feature award for coverage of the 1992 presidential campaign include:

J. Scott Applewhite	Marcy Nighswander
Richard Drew	Amy Sancetta
Greg Gibson	Stephan Savolia
David Longstretch	Reed Saxon
Doug Mills	Lynne Sladky

THE ASSOCIATED PRESS STAFF
1995 FEATURE AWARD

For its photographs chronicling the horror of ethnic violence in Rwanda, The Associated Press won a feature photography award. Photographers include:

Javier Bauluz

Jean-Marc Bouju

Jacqueline Arzt Larma

Karsten Thielker

THE ASSOCIATED PRESS STAFF
1999 FEATURE AWARD

The Associated Press photo staff won the 1999 feature photography prize for its photographs of the President Bill Clinton/Monica Lewinsky scandal and the ensuing impeachment hearings. Photographers include:

J. Scott Applewhite

Roberto Borea

Khue Bui

Robert F. Bukaty

Ruth Fremson

Greg Gibson

Ron Heflin

Charles Krupa

Wilfredo Lee

Dan Loh

Joe Marquette

Doug Mills

Pablo Martinez Monsivais

Stephan Savoia

Susan Walsh

THE ASSOCIATED PRESS STAFF
1999 SPOT NEWS AWARD

In 1999, The Associated Press photo staff won the Pulitzer Prize for a portfolio of images following the embassy bombings in Kenya and Tanzania. Photographers include:

Sayyid Azim

Jean-Marc Bouju

Khalil Senosi

John McConnico

Dave Caulkin

Brennan Linsley

THE COURIER-JOURNAL & LOUISVILLE TIMES STAFF
1976 FEATURE AWARD

The Courier-Journal & Louisville Times photography staff won the Pulitzer Prize for its coverage of school busing in Louisville, Ky. The coverage is credited to:

Cort Best

Michael Coers

Stan Denny

Melissa Farlow

C. Thomas Hardin

Tom R. Hayes

Bud Kamenish

Frank Kimmel

Charles William Luster

Bryan L. Moss

Richard Nugent

Paul Schuhmann

Pam Spaulding

Larry R. Spitzer

Robert Steinau

William Strode

Keith Williams

THE NEW YORK TIMES STAFF
2002 BREAKING NEWS

The New York Times photographers who won a breaking news award for coverage of the 2001 World Trade Center disaster include:

Suzanne DeChillo

Angel Franco

Ruth Fremson

Kelly Guenther

George Gutierrez

Ed Keating

Justin Lane

Chang Lee

Steve Ludlum

Brian Manning

Keith Meyers

Andrea Mohin

Krista Niles

Nancy Siesel

THE NEW YORK TIMES STAFF
2002 FEATURE NEWS

The New York Times staff photographers who won the Pulitzer Prize for their coverage of the war in Afghanistan include:

Steve Crowley

Ruth Fremson

James Hill

Vincent Laforet

Chang Lee

THE OAKLAND TRIBUNE STAFF
1990 SPOT NEWS AWARD

Oakland Tribune photographers who won the Pulitzer Prize for coverage of the 1989 Loma Prieta earthquake in the San Francisco Bay Area include:

Tom Duncan

Pat Greenhouse

Michael Macor

Matthew Lee

Paul Miller

Angela Pancrazio

Reginald Pearman

Gary Reyes

Ron Riesterer

Roy H. Williams

THE ORANGE COUNTY REGISTER STAFF
1985 SPOT NEWS AWARD

Winning a Pulitzer Prize for its coverage of the 1984 Olympics in Los Angeles was *The Orange County Register* team of:

Rick Rickman

Brian Smith

Hal Stoelzle

JACK R. THORNELL
1967 AWARD
Born: Aug. 29, 1939, in Vicksburg, Miss.

When Jack Thornell joined the U.S. Army, he was set to go to radio repair school. But a mix-up found him assigned to photography school instead.

After the Army, Thornell went to work for the *Jackson* (Miss.) *Daily News*, then on to The Associated Press. His first AP assignment: Cover Mississippi's first day of school desegregation. One of his photographs made the front page of *The New York Times*.

In 1966, Thornell photographed the shooting of civil rights activist James Meredith and won the Pulitzer Prize. Thornell vividly remembered clicking the shutter release as Meredith fell to the ground, screaming for help. "I couldn't do that any more," said Thornell, now retired in Metairie, La. "I'd have to throw down the camera and stop the bleeding."

HARRY A. TRASK
1957 AWARD
Born: Sept. 15, 1928, in Massachusetts
Died: December 10, 2002

With his ever-present cigar, dark-blue beret and London Fog raincoat, *Boston Traveler* photographer Harry Trask was a familiar figure around Boston. He started out as a messenger at the newspaper, working his way up to staff photographer. At age 29, Trask found himself whizzing 75 feet above the surface of the Atlantic in a single-engine plane, snapping the photos of the sinking Andrea Doria that won the Pulitzer Prize.

Trask retired from the *Herald Traveler* in 1972 and became a teacher. He designed a secondary-level graphic arts curriculum for the Boston school system. Retired for a second time, Trask spends a good deal of time fishing.

DAVID TURNLEY
1990 FEATURE AWARD
Born: June 27, 1955, in Fort Wayne, Ind.

David Turnley is proud of having won the Pulitzer "for work chronicling one of the most important years at the end of the 20th century." Turnley's 1989 photographs portrayed the Tiananmen Square massacre in China and the fall of communism in Eastern Europe.

From 1980 to 1998, Turnley was a *Detroit Free Press* photographer. He was a Nieman Fellow at Harvard University and produced a CNN documentary, *The Dalai Lama: At Home in Exile,* which was nominated for an Emmy Award. Today, Turnley is international executive producer of Corbis Documentaries in New York.

Turnley has been honored by the World Press Photo Foundation, the Overseas Press Club and the National Press Photographers Association. His books include *Why Are They Weeping? South Africans Under Apartheid* and *The Russian Heart.* He collaborated with his brother Peter Turnley on *Moments of Revolution: Eastern Europe* and *Beijing Spring.* David and Peter Turnley's photographs were exhibited at the International Center of Photography in New York City with an accompanying book, *In Times of War and Peace.*

NEAL ULEVICH
1977 SPOT NEWS WARD
Born: June 18, 1946, in Milwaukee

As a photo editor and photographer for The Associated Press, Neal Ulevich spent nearly two decades in Asia. He covered the Vietnam War, and was later based in Tokyo, Beijing and Bangkok.

After taking his Pulitzer Prize-winning photographs of student lynchings in Bangkok, Ulevich returned to his office to discover that many of his colleagues didn't believe what he'd seen. "Rather than argue," he remembered, "I adjourned to the darkroom."

Ulevich served as AP's regional photo editor in Japan, and was later an AP photographer in Beijing, one of the few foreign photojournalists accredited by China's communist government.

In 1990, Ulevich returned to the United States and joined an AP team helping newspapers switch to digital reception of news photos. He currently works for the research and development unit of AP communications in Denver.

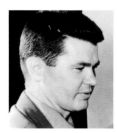

DONALD T. ULTANG
1952 AWARD
Born: March 23, 1917, in Fort Dodge, Iowa

Donald Ultang was a commercial photographer, then a freelancer for *The Cedar Rapids Gazette,* before joining the staff of *The Des Moines Register.*

In 1942, he took up flying, serving in naval aviation during World War II. After the war, Ultang convinced the *Register* to buy a small airplane, which he and photographer John Robinson flew to college sports events around the Midwest. In 1951, they flew to Stillwater, Okla., where they photographed a racial assault during a college football game that won them the Pulitzer Prize.

Ultang's photographs appeared in *Collier's, Fortune, Time, Holiday* and *Life* magazines. He has won numerous state and national awards. His work has been exhibited at the Museum of Modern Art in New York City.

In 1958, Donald Ultang resigned from the *Register* to pursue a business career. In 1991, he published his collection of photos, *Holding The Moment.*

PHOTOGRAPHER UNNAMED
1980 SPOT NEWS AWARD

In 1979, an Iranian newspaper photographer secretly took pictures at the execution of 11 alleged enemies of Ayatollah Khomeini. An Associated Press employee in Iran obtained a photo from the newspaper and sent it out over the AP wire. The photograph won the Pulitzer Prize.

But the photographer, fearing for his life, has never been identified. The 1980 Spot News award is the only Pulitzer Prize awarded to an unnamed photographer.

HUYNH CONG UT
1973 SPOT NEWS AWARD
Born: March 29, 1951, in Long An, Vietnam

Nick Ut started taking photographs for The Associated Press at age 16, just after his older brother, AP photographer Huynh Thanh My, was killed in the Vietnam War.

Ut vividly remembers the moment Kim Phuc, the "napalm girl," ran toward him to make the picture that won the Pulitzer Prize. "I saw many children screaming," he said. "I saw the bomb dropping. It's the picture of the war."

Before delivering his film to the AP, Ut took Kim Phuc to the hospital. At the AP bureau, the photo provoked debate: Should they send a picture of a naked girl out over the wire? Horst Faas ordered the photo transmitted.

Nick Ut was wounded three times in Vietnam. He has worked for The Associated Press in Tokyo, South Korea and Hanoi. He is now an AP photographer in Los Angeles.

PAUL VATHIS
1962 AWARD
Born: Oct. 18, 1925, in Jim Thorpe, Pa.
Died: August 2, 2002

Paul Vathis has photographed a pope, a queen and heads of state the world over. But he is most proud of the Pulitzer Prize-winning shot of John F. Kennedy and Dwight D. Eisenhower at Camp David. "I remember the exact moment," he said. "I quickly raised my long lens and shot." At first, his editors at The Associated Press rejected the picture because Vathis had photographed the two presidents from behind. The editors relented, and the picture moved over the wires.

Vathis learned his trade aboard a World War II bomber: Part of his job as tail gunner was to photograph whatever the aircraft had just bombed. After the war, Vathis went to work for The Associated Press as a Wirephoto operator. Three years later, he became a full-time AP photographer, a position he holds today.

SLAVA VEDER
1974 FEATURE AWARD
Born: Aug. 30, 1926, in Berkeley, Calif.

Sal Veder got into journalism by telling a reporter on his small-town newspaper, "I could write better than the people they had doing the job." He could, and the newspaper hired him. After working as a reporter and photographer on several California newspapers, Veder took a job at the *Tulsa* (Okla.) *World.* He then returned to California and went to work for *The Oakland Tribune.*

Veder was a staff photographer for The Associated Press when he won the Pulitzer Prize for a picture of an American prisoner of war returning from Vietnam. Photographing the returning soldiers was a lot like shooting a baseball game, Veder said. "Everything looks routine and then suddenly all hell breaks loose."

Now retired, Veder lives in California and volunteers with the California Department of Forestry and Fire Protection.

PAUL WATSON
1994 SPOT NEWS AWARD
Born: July 13, 1959 in Etobicoke, Toronto, Canada

Paul Watson had already been a reporter for *The London Free Press* and *The Vancouver Sun* before he spent two years teaching English in Malawi, Africa. He came back to earn a master's in International Affairs from Columbia University, then went to work for *The Toronto Star,* covering stories in Eritrea, Romania, Angola, the Mideast and the Sudan.

In 1992, Watson became *The Toronto Star*'s African bureau chief. He spent months in Somalia, eventually taking the photographs of the corpse of a U.S. soldier that won the Pulitzer Prize. Without graphic pictures, Watson thought, "people oversees would not understand how brutal this war is."

In 1995, Watson became the *Star*'s Asia bureau chief, based in Hong Kong. He is currently bureau chief for the *Los Angeles Times* in Vienna.

Watson is a five-time winner of the Canadian National Newspaper Award. He has also won the Overseas Press Club's Robert Capa Gold Medal.

ANNIE WELLS
1997 SPOT NEWS AWARD
Born: March 24, 1954, in Arlington, Va.

Annie Wells wanted to be a scientist before she got hooked on photography. Her career took her to the *Herald Journal* in Logan, Utah, *The Greeley Tribune* in Colorado and *The Associated Press* in San Francisco before leading her to the Santa Rosa *Press Democrat* .

At the *Press Democrat,* Wells won the Pulitzer Prize for photographs of a young girl trapped in a raging Northern California creek during flood season. She remembered: "The picture ran six columns. The phone rang off the hook. The next morning, I was up at six o'clock to photograph more floods."

Wells has been honored by the Ruben Salazar award, the Society of Newspaper Design, the National Press Photographers Association and the Robert F. Kennedy Journalism Award. Her pictures are in the permanent collection of the National Museum for Women in the Arts in Washington, D. C.

Wells is now a photo editor and photographer at the *Los Angeles Times.*

STEPHANIE WELSH
1996 FEATURE AWARD
Born: June 27, 1973, in Quantico, Va.

The youngest woman to win the Pulitzer Prize in photography, Stephanie Welsh was still a student at Syracuse University when she photographed a ritual circumcision in Kenya.

Welsh, a free-lancer, "wanted to give people some understanding of the practice and why it still goes on." Her photographs were distributed by Newhouse News Service, and she donated part of her Pulitzer Prize money to organizations that are trying to curb the practice of ritual female circumcision.

Welsh was a staff photographer at *The Palm Beach Post* in Florida. She is currently doing graduate work at Yale University.

JOHN H. WHITE
1982 FEATURE AWARD
Born: March 18, 1945, in Lexington, N.C.

John White starts each day with the attitude that has guided his 30 years as a photojournalist. "I have a responsibility to inform, entertain, enlighten, inspire . . . My greatest picture is always out there."

White joined the *Chicago Daily News* in 1969. In 1978, the *Daily News* folded and he joined *The Sun-Times*. It was there he shot a portfolio of a year in the life of Chicago that won the Pulitzer Prize.

White's credits include awards from United Press International, the Inland Daily Press Association, the Newspaper Guild and the Chicago Association of Black Journalists. He teaches photojournalism at Columbia College in Chicago, and has published two books: *The Final Journey* and *The Man Bernadine*, based on the life of Archbishop John Carter Bernadine.

CLARENCE S. WILLIAMS
1998 FEATURE AWARD
Born: Jan. 22, 1967, in Philadelphia, Pa.

Clarence Williams has thought a lot about his Pulitzer Prize-winning photographs of "orphans of addiction." "The art of it . . . is to realize how important the issue is," said Williams, "to make images that take the ethnicity out of the debate. It's not about black or Puerto Rican addicts, it's about little kids whose parents are addicts."

Williams started his career as a journalist at Times Community Newspapers in Reston, Va. He was a METPRO photographer before joining the *Los Angeles Times* in 1995. Among his national awards are those from the National Press Photographers Association and Nikon.

He is currently a staff photographer at the *Los Angeles Times.*

MICHAEL S. WILLIAMSON
2000 FEATURE AWARD
Born: June 8, 1957, in Washington, D.C.

Michael Williamson was raised in several foster homes before settling with a permanent foster family in his early teens. He joined *The Washington Post* in 1993. He previously worked at *The Sacramento Bee* (1975 to 1991) and taught at Western Kentucky University (1991 to 1993). In 1994 he won the Crystal Eagle Award, which recognizes photography that has had a documented effect on society. He won the award for a 15-year project on homelessness in America. His work on the homeless yielded three books, co-authored with Dale Maharidge: "And Their Children After Them," which won the Pulitzer Prize for non-fiction in 1990, "Journey to Nowhere: The Saga of the New Underclass" and "The Last American Hobo." Williamson shared a second Pulitzer Prize in 2000 with colleagues Carol Guzy and Lucian Perkins for their coverage of Kosovo, Yugoslavia. In 1995, the National Press Photographers Association named Williamson "Photographer of the Year." He lives in Silver Spring, Md., with his wife, Michelle, and two daughters.

TARO YAMASAKI
1981 FEATURE AWARD
Born: Dec. 19, 1945, in Detroit, Mich.

The inmates at Michigan's Jackson State Prison thought Taro Yamasaki was powerful martial artist. "I was Japanese with a ponytail," said Yamasaki. "They assumed I was walking around without a guard because I could protect myself." He couldn't. But he got his Pulitzer Prize-winning photographs anyway.

Yamasaki was an assistant kindergarten teacher, a cab driver, a carpenter and fashion photographer's assistant before joining *The Detroit Free Press.* Since 1983, he has been a free-lance photographer for *Time, Life, People, Sports Illustrated, Fortune* and *Forbes.* Yamasaki also has taught classes at Michigan University School of Art and Design.

ALEXANDER ZEMLIANICHENKO
1997 FEATURE AWARD
Born: May 7, 1950, in Saratov, Russia

Sasha Zemlianichenko joined The Associated Press in Moscow in 1990. He has traveled extensively throughout the former Soviet Union, covering struggles within the new republics. He was one of five AP photographers who won the 1992 Pulitzer Prize for photos of the attempted Russian coup. Zemlianichenko also was a finalist in the 1995 Pulitzer competition for his photographs of the war in Chechnya, Russia.

Zemlianichenko's Pulitzer Prize-winning photo of Russian leader Boris Yeltsin dancing at a rock concert also won The Associated Press Managing Editors feature prize.

Cyma Rubin is a producer, director, writer and president of Business of Entertainment, Inc., New York. She produced the Tony Award-winning Broadway production of "No, No, Nanette;" "Greaser's Palace," named an outstanding film of the year at the London Film Festival; movies for CBS; was the New York producer for the Pulitzer Prize photography exhibitions in Japan and South Korea; and she produced and directed "Moment of Impact: Stories of the Pulitzer Prize Photographs" for Turner Network Television, which received the 1999 Emmy and Telly awards for best documentary.

Eric Newton started as a copyboy at *The Oakland Tribune,* rising to become the paper's top editorial executive. The *Tribune* won a Pulitzer Prize for photography for coverage he led of the 1989 Loma Prieta earthquake. Newton was managing editor of the Newseum, and was its first news historian. Today, he is director of journalism initiatives for the John S. and James L. Knight Foundation.